FRED DAVIS

Fashion, Culture, and Identity

THE UNIVERSITY OF CHICAGO PRESS
Chicago & London

The University of Chicago Press, Chicago 60637
The University of Chicago Press, Ltd., London
© 1992 by The University of Chicago
All rights reserved. Published 1992
Paperback edition 1994
Printed in the United States of America
12 11 10 09 08 07 06 05 04 03 9 8 7 6 5

ISBN: 0-226-13809-7 (pbk.)

Library of Congress Cataloging-in-Publication Data

 Davis, Fred, 1925–1992
 Fashion, culture, and identity / Fred Davis.
 p. cm.
 Includes bibliographical references and index.
 1. Costume—Social aspects. 2. Fashion—Social aspects.
 3. Gender identity. 4. Group identity. I. Title.
 GT525.D38 1992
 391—dc20 91-44012
 CIP

Fashion, Culture, and Identity

In memory of

HERBERT BLUMER (1900–1987)

from whom I took courage to treat

seriously topics thought frivolous by

American sociology

Contents

Acknowledgments

In the decade or so it took for this work to reach fruition I acquired many debts of authorship whose brief acknowledgment here can in no way recompense in adequate measure the interest, aid and support extended me by the persons, organizations and institutions I am about to mention. I apologize for this and trust that the parties can be as forgiving of the deficiency as they were generous in the time, thought, and resources they made available to me.

There is, first, my debt to the several dozen persons in the apparel trades, the fashion press and allied fields in San Diego, Los Angeles, and New York whom I interviewed. My promise of anonymity to them is not in the least intended to slight the experience and wisdom they shared with me and on which I have drawn extensively throughout this work.

The Research Committee of the Academic Senate, University of California, San Diego provided me with several small grants that greatly facilitated my research. I thank the faculty members who served on that committee at the times the grants were made. It also gives me particular pleasure, and occasions the happiest memories, to be able to thank the Rockefeller Foundation for having awarded me in 1989 a month's Resident Fellowship at its Bellagio Study and Conference Center in Italy where I wrote a chapter of this book and gathered notes for another. More idyllic circumstances in which to think and write, while being kept aloft intellectually in the invigorating company of a cross-section of scholars and artists from all fields, could not, I am certain, be devised by any Utopian planner.

I owe a very special debt of gratitude to several persons without whose friendship and assistance major portions of the research entailed in this study would not have been initiated or completed. These are Robert Bass of the apparel firm J'Envie, New York, Susan Kaiser of the Division of Textiles and Clothing, University of California, Davis, Joan Kron, former editor of Avenue magazine, New York, and Raymonde Moulin, director of the Centre de Sociologie des Arts, Paris. I trust they may find in this work reason not to rue the generous offerings they made to it.

Dorothy Gaffney, a former undergraduate at the University of California, San Diego, and Sheila Hittleman-Sohn, presently a doctoral candidate in the Department of Sociology there, worked diligently with me on different facets of the research. I thank them both. My wife Marcella, whose workaday knowledge of things vestmental is exceptional, helped me over many an informational or conceptual hurdle which otherwise would have proved a barrier. I need only add my appreciation for the constancy of her encouragement to signal the important influence she has had on this work.

I wish also to make a special point of thanking the following apparel firms for their kindness in granting me gratis permission to reproduce in these pages photographs from their sales collections: Jerell Inc. (Dallas), Perry Ellis International (New York), Smith & Hawken (Mill Valley, Calif.), Talbots (Hingham, Mass.) and Tweeds Inc. (Edgewater, N.J.).

Acknowledgment is due the following for having published what are earlier versions of some chapters in this book. *Chapter 1:* "Clothing and Fashion as Communication," in Michael R. Solomon, ed., *The Psychology of Fashion* (Lexington, Mass.: Heath, 1985); *chapter 3:* "Clothing, Fashion and the Dialectic of Identity," in Carl Couch and David Maines, eds. *Communication and Social Structure* (Springfield, Ill.: Charles C. Thomas, 1988); *chapter 4:* "Of Maids' Uniforms and Blue Jeans: The Drama of Status Ambivalences in Clothing and Fashion," in *Qualitative Sociology* 12, no. 4 (Winter 1989); *chapter 5:* "Identity Ambivalence in Clothing: the Dialectic of the Erotic and the Chaste," in David Maines, ed. *Social Organization and Social Process, Essays in Honor of Anselm Strauss* (New York: Aldine de Gruyter, 1991).

Finally, no words other than those borne witness by the very

text that follows are necessary to establish my profound, now almost an entire working life's, indebtedness to the person to whom I dedicate this book, the late Professor Herbert Blumer. His fascination with fashion first inspired me as a young sociology graduate student at the University of Chicago in the late 1940s and it was my special good fortune to be able to continue to draw from that fount over our many years of colleagueship at the University of California.

Fred Davis

La Jolla, California
January 1992

1 Do Clothes Speak? What Makes them Fashion?

It is only shallow people who do not judge by appearances. The true mystery of the world is the visible, not the invisible.

Oscar Wilde

That the clothes we wear make a statement is itself a statement that in this age of heightened self-consciousness has virtually become a cliché. But what is the nature of the statements we make with our clothes, cosmetics, perfumes, and coiffures, not to mention the other material artifacts with which we surround ourselves? Are such statements analogous to those we make when we speak or write, when we talk to our fellows? In short, as the novelist Alison Lurie (1981) has recently claimed, though hardly demonstrated, is clothing not virtually a visual *language*, with its own distinctive grammar, syntax, and vocabulary? Or are such statements more like music, where the emotions, allusions, and moods that are aroused resist, as they almost must, the attribution of unambiguous meanings such as we are able to give the objects and actions of everyday life: this chair, that office, my payment, your departure? If the latter is the case, it is perhaps incorrect to speak of them as statements at all. Or can it be that clothes sometimes do one and sometimes the other, or possibly both at the same time—that is, make clear reference to who we are and wish to be taken as while alternatively or simultaneously evoking an aura that "merely suggests" more than it can (or intends to) state precisely?[1]

1. No finer rendering of dress's capacity to suggest a good deal more than it states exists than Robert Herrick's (1579–1674) poem "Delight in Disorder":

A sweet disorder in the dress	Ribbands to flow confusedly:
Kindles in clothes a wantonness:	A winning wave, deserving note,
A lawn about the shoulders thrown	In the tempestuous petticoat:
Into a fine distraction:	A careless shoe-string, in whose tie
An erring lace, which here and there	I see a wild civility:
Enthrals the crimson stomacher:	Do more bewitch me, than when art
A cuff neglectful, and thereby	Is too precise in every part.

(Taken from *The Oxford Book of English Verse*, edited by Sir Arthur Quiller-Couch. New York: Oxford University Press, 1941.)

Cultural scientists must address these questions (as they have not thus far) if they are ever to make sense of a phenomenon that has periodically intrigued them, less for its own sake, unfortunately, than for the light they thought it could shed on certain fundamental features of modern society, namely, social movements, social stratification, and mass-produced tastes. I speak, of course, of fashion and some of its many facets: its sources in culture and social structure, the processes by which it diffuses within and among societies, the purposes it serves in social differentiation and social integration, the psychological needs it is said to satisfy, and, not least of all, its implications for modern economic life. But oddly, one facet sociologists have not fastened on—nor for that matter have psychologists or anthropologists to any appreciable extent—is that which joins the makers, purveyors, and consumers of fashion, namely, its meaning. By meaning, I refer to the images, thoughts, sentiments, and sensibilities communicated by a new or old fashion and the symbolic means by which this is done (Davis 1982). Such analytic neglect strikes me as analogous to watching a play whose dialogue is kept from us but whose gross gestural outlines, scenery, and props we are permitted to observe. Although we are likely to come away with some sense of what is going on—whether it is comedy, tragedy, or melodrama; whether it concerns love, murder, or betrayal—we would have only the vaguest idea of the whys and wherefores. In the case of the sociological interest in clothing and fashion, we know that through clothing people communicate some things about their persons, and at the collective level this results typically in locating them symbolically in some structured universe of status claims and life-style attachments. Some of us may even make so bold as to assert what these claims and attachments are—"a tramp presuming the hauteur of a patrician," "nouveau riche ostentation masking status anxiety"—but, as in the voiceless play, the actual symbolic content that elicits such interpretations eludes us. Lacking such knowledge, we can at best only form conclusions without quite knowing how we derived them; this is something we often have to do in everyday life, but by itself it hardly satisfies the requirements of a science.

THE CLOTHING CODE

In the past decade or so certain newer intellectual currents in the social sciences and humanities have begun to offer hope for penetrating this gap in the sociological analysis of fashion, if not for altogether filling it. I refer to the burgeoning—some would say, not altogether unjustifiably, omnivorous—field of semiotics, in particular to its seminal notion of *code* as the binding ligament in the shared understandings that comprise a sphere of discourse and, hence, its associated social arrangements. Following Eco ((1979), then, I would hold that clothing styles and the fashions that influence them over time constitute something approximating a code. It is a code, however, radically dissimilar from those used in cryptography; neither can it be more generally equated with the language rules that govern speech and writing. Compared to these clothing's code is, as the linguist would have it, of "low semanticity." Perhaps it can best be viewed as an incipient or quasi-code, which, although it must necessarily draw on the conventional visual and tactile symbols of a culture, does so allusively, ambiguously, and inchoately, so that the meanings evoked by the combinations and permutations of the code's key terms (fabric, texture, color, pattern, volume, silhouette, and occasion) are forever shifting or "in process."[2] The anthropologist and linguist Edward Sapir (1931, 141) with characteristic insight noted this about fashion more than fifty years ago:

> The chief difficulty of understanding fashion in its apparent vagaries is the lack of exact knowledge of the unconscious symbolisms attaching to forms, colors, textures, postures, and other expressive elements of a given culture. The difficulty is appreciably increased by the fact that some of the expressive elements tend to have quite different symbolic references in different areas. Gothic type, for instance, is a nationalistic token in Germany while in Anglo-Saxon culture, the practically identical type known as Old English . . . [signifies] a wistful look backward at madrigals and pewter.

2. Levine (1985) argues that Western social thought and social science have over the centuries developed an almost institutionalized aversion toward dealing in analytically constructive ways with ambiguity. This may help account for the proclivity of many social scientists, in particular modern structuralists like Lévi-Strauss and Barthes, to so readily assimilate clothing communication into the axiomatic structure of Saussure's linguistic model.

Clearly, while the elements Sapir speaks of do somehow evoke "meanings"—moreover, meanings that are sufficiently shared within one or another clothes-wearing community—it is, as with music, far from clear *how* this happens.[3] Associative linkages to formal design elements (e.g.: angularity = masculine; curvilinear = feminine) are obviously involved (Sahlins 1976, 189–92), as are linkages to occasions (e.g.: dark hue = formal, serious, business; light hue = informal, casual, leisure) and to historical frames of reference (e.g.: bindings, stays, and corseting = Victorian, pre–female emancipation; loose fit, reduced garment volume, exposed skin = the post–World War I modern era). There are, though, as McCracken (1985a) has so tellingly demonstrated in his research, no fixed, rule-governed formulas, such as exist for speech and writing, for employing and juxtaposing these elements. The correspondence with language is at best metaphoric and, according to McCracken, misleadingly metaphoric at that. Schier (1983) states the matter nicely in his criticism of Roland Barthes's *The Fashion System*: "There is certainly something to the idea that we say things with what we choose to wear, though we must not press too hard to find a set of rules encoded in every choice."[4] Chast's cartoon drawing lights on the same point even more tellingly.

Temporally, too, there is reason to be cautious about ascribing precise meanings to most clothing. The very same apparel ensemble that "said" one thing last year will "say" something quite different today and yet another thing next year. Ambiguity, there-

3. Some indication of how such meanings are accomplished, albeit within a rather narrow sphere of apparel accessory design, is given by Brubach (1989c, 67) in her report on fashions in sunglasses: "Mikli [a sunglasses designer] has just finished designing a collection for Ray-Ban's international division—five sunglasses frames intended as a feminine alternative to the Macho classics. The shapes are upswept and less severe, suggestive of the way the eyes turn up at the corners when a person smiles; the lines are curved rather than straight; and the contours are sculptural, not flat like those of the Wayfarer [an earlier, highly successful, "masculinized" Ray-Ban style]. Mikli says it's possible to change *le regard* altogether, to give a face an entirely different expression—an expression of violence, of sensuality, of sweetness, or whatever one chooses. So that, even though the eyes are hidden, by the act of reproducing the shape of the eye in some exaggerated form sunglasses can reconstitute *le regard* and remodel the face."

4. Like Barthes, Descamps (1979) creates elaborate taxonomic schemes to decode, with spurious precision I would hold, exactly what clothing and fashions "mean."

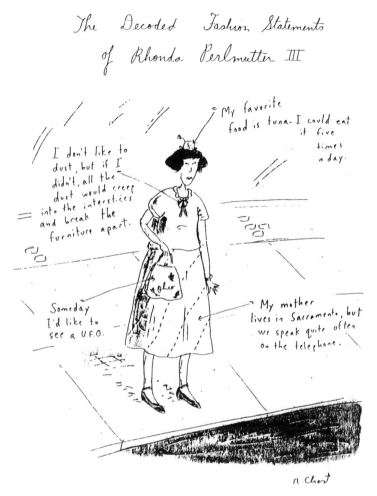

Drawing by R. Chast; © 1988 The New Yorker Magazine, Inc.

fore, is rife in what could be considered the contemporary dress code of Western society and is, as we shall see, becoming even more so.

To this condition of awesome, if not overwhelming, ambiguity, I would add three other distinguishing features of the clothing-fashion code, although many more could in fact be cited.[5]

5. For example, whereas speech messages unfold continuously as the speaker moves from one utterance to another, a clothing ensemble is capable of but a single

Enninger (1985), for example, lists as many as thirty-one. First, it is heavily context-dependent; second, there is considerable variability in how its constituent symbols are understood and appreciated by different social strata and taste groupings; and third, it is—at least in Western society—much more given to "undercoding" than to precision and explicitness.

Context-Dependency

Even more so, perhaps, than the utterances produced in everyday face-to-face interaction, the clothing-fashion code is highly context-dependent. That is, what some combination of clothes or a certain style emphasis "means" will vary tremendously depending upon the identity of the wearer, the occasion, the place, the company, and even something as vague and transient as the wearer's and the viewers' moods. Despite being made of identical material, the black gauze of the funeral veil means something very different from that sewn into the bodice of a nightgown. Similarly, the leisure suit that "fits in so nicely" at the outdoor barbecue will connote something quite different when worn to work, especially if you happen not to live in southern California.

High Social Variability in the Signifier-Signified Relationship

While the signifiers constituting a style, an appearance, or a certain fashion trend can in a material sense be thought of as the same for everyone (the width of a lapel, after all, measures the same in Savile Row as in Sears) what is *signified* (connoted, understood, evoked, alluded to, or expressed) is, initially at least, strikingly different for different publics, audiences, and social groupings: for the conservative as against the experimentally inclined, for the

message, however complex, until such time as the wearer decides to change clothes. Viewed differently, speech, unless captured in writing, fades quickly, whereas clothing holds its meaning over the duration of an encounter. Moreover, as the late Herbert Blumer (1984) reminded me in response to an early version of this chapter I had sent him, "while clothing may 'speak,' it seems rarely to engage in dialogue. The give and take in the adjustment of meaning (which is the mark of dialogue) does not seem to take place in the presentations of clothing; while clothing may say something, it is scarcely involved in conversation."

fashion-wise as against the fashion-indifferent, for the creators of fashion and their coteries as against its consumers, including even relatively sophisticated consumers. In short, while certainly not rigidly castelike in its configuration, the universe of meanings attaching to clothes, cosmetics, hairstyles, and jewelry—right down to the very shape and bearing of the body itself (Fraser 1981, 215–19; Hollander 1980)—is highly differentiated in terms of taste, social identity, and persons' access to the symbolic wares of a society.

Indeed, as the first social scientists who wrote on the subject were quick to declare (Sapir 1931; Simmel 1904; Tarde 1903; Veblen 1899), it is precisely the differentiated, socially stratified character of modern society that fuels the motor of fashion and serves as the backdrop against which its movements are enacted. In my opinion these writers, Veblen and Simmel in particular, placed *too* exclusive an emphasis on social class differentiation as the basis for fashion motivation. Still, they must be credited for their lively recognition that clothing styles and fashions do not mean the same things to all members of a society at the same time and that, because of this, what is worn lends itself easily to a symbolic upholding of class and status boundaries in society.

That the same cultural goods connote different things for different groups and publics applies equally, of course, to almost any expressive product of modern culture, be it the latest avant-garde painting, a high-tech furniture piece, an electronic music composition, ad infinitum. In the symbolic realm of dress and appearance, however, "meanings" in a certain sense tend to be simultaneously both more ambiguous and more differentiated than in other expressive realms. (This holds especially during the first phases of a new fashion cycle, as I shall illustrate in a moment.) Meanings are more ambiguous in that it is hard to get people in general to interpret the same clothing symbols in the same way; in semiotic terminology, the clothing sign's signifier-signified relationship is quite unstable. Yet the meanings are more differentiated inasmuch as, to the extent that identifiable thoughts, images, and associations crystallize around clothing symbols, these will vary markedly, most certainly at first, between different social strata and taste subcultures (Gans 1974).

Take, for example, the rather masculine, almost military styles

that were fashionable among some women in the mid-1980s: exaggerated shoulder widths tapering conelike to hems slightly above the knee. It is, I believe, difficult even now to infer quite what this look meant to the broad mass of fashion consumers. Several different interpretations were possible initially, and it was only after the fashion was well launched that some partial synthesis seemed to emerge from among competing interpretations as symbolically dominant, i.e., an appropriation of masculine authority, which at the same time, by the very exaggeration of its styling, pointedly undercut any serious claim to masculinity as such.

But whatever consensus may have been arrived at eventually, the broad shoulder–inverted cone look was bound to be perceived and responded to quite differently by the coteries, audiences, and publics to which it was exposed. For cosmopolitan fashion elites it appears to have signified a kind of gender-inverted parody of military bearing. Suburban, fashion-conscious socialites, on the other hand, were repelled at first by the severity of the silhouette, which was seen as a visual affront to the conventions of femininity. Many professional and career women, however, took favorably to the style because it seemed to distance them from unwelcome stereotypical inferences of feminine powerlessness and subservience. Judging by lagging retail sales, though, many mainstream middle-class homemakers regarded this same "look" as irrelevant at best, ugly and bizarre at worst. What meaning the style held for women factory and clerical workers is hard to infer. Assuming they became aware of it at all, it may have been devoid of meaning for them altogether, although nonmeaning in something that for others is pregnant with meaning is itself a kind of meaning in absentia.

Undercoding

That clothing styles can elicit such different responses from different social groups points to yet another distinguishing feature of the clothing code and the currents of fashion to which it is subject. That is, except for uniforms, which as a rule clearly establish the occupational identity of their wearers (see Joseph 1986), in clothing, as in the arts generally, undercoding (the phonetic proximity to *underclothing* here is perhaps not altogether infelicitous) is especially important in how meanings are communicated. Ac-

cording to Eco (1979, 135–36), undercoding occurs when in the absence of reliable interpretative rules persons presume or infer, often unwittingly, on the basis of such hard-to-specify cues as gesture, inflection, pace, facial expression, context, and setting, certain molar meanings in a text, score, performance, or other communication. The erotic message we carry away from the poet Herrick's "erring lace," "careless shoe-string," and "cuff neglectful" is perhaps as good an example of undercoding in dress as can be found.[6]

At the same time it would be a mistake to assume that the undercoding of clothing and fashion is necessarily inadvertent or the product of an inherent incapacity of the unit elements constituting the code (fabric, color, cut, texture) to signify as clearly as do words or icons. (Again, the wearing of uniforms attests to clothing's ability to register clear meanings for persons wishing to establish an unambiguous role identification for themselves.) Rather, the point is that in the main the clothing-fashion code much more nearly approximates an aesthetic code than it does the conventional sign codes, such as information-oriented speech and writing, semaphore, figures and charts, or road and traffic signs, employed in ordinary communication. As Culler (1976, 100) has so trenchantly observed:

> The reason for the evasive complexity of these [aesthetic] codes is quite simple. [Conventional sign] codes are designed to communicate directly and unambiguously messages and notions which are already known. . . . But aesthetic expression aims to communicate notions, subtleties, [and] complexities which have not yet been formulated, and therefore, as soon as an aesthetic code comes to be generally perceived as a code (as a way of expressing notions which have already been articulated), then works of art tend to move beyond it. They question, parody, and generally undermine it, while exploring its mutations and extensions. One might even say that much of the interest

6. Another charming example of undercoding in the realm of clothing and its capacity to imply a great deal on the basis of minimal cues is offered by Gisele d'Assailly in her book *Ages of Elegance* (Paris: Hachette, 1968). There she reports that Marie Antoinette and her entourage would often refer to items of dress in such metaphors as "a dress of *stifled sighs* covered with *superfluous regrets;* in the middle was a spot of *perfect candour come-and-see* buckles; . . . a bonnet decorated with *fickle feathers* and streamers of *woebegone eyes*" (italics in original, 139; quoted in Rosencranz 1972, 287.)

of works of art lies in the ways in which they explore and modify the codes which they seem to be using.

What Culler does not say, and what is of special interest to the sociologist, is that such code modifications do not occur spontaneously, as if wholly and mysteriously dependent on some magical ferment called "aesthetic expression." Beyond the purely technical opportunities and limitations affecting an art or craft's ability to initiate some rather than other code modifications (Becker 1982), there also are the manufacturers, publicists, critics, merchandisers, and innovators (some of whom truly are artists) in whose interests it is to launch, inhibit, or otherwise regulate the transmission of code modifications from creators to consumers. Not that, as some Marxists would have it, all that happens in this connection can be attributed reductionistically to some conspiratorial, self-serving, profit-driven alignment of structurally interdependent economic interests. Still, to overlook the impress of such interests on what goes on from the moment of creation to that of consumption would be tantamount to attributing a persistent efficacy to free-floating ghosts.[7]

That undercoding is powerfully implicated in aesthetic expression would seem irrefutable. And to the extent that the fashion aspect of clothing can be viewed as aesthetic expression, which by and large it must, it is incumbent on us to try to understand better how fashion as such does and does not relate to what I have more generally termed the "clothing code."

FASHION AND THE CLOTHING CODE

Thus far I have claimed that, vague and elusive as its referents ("signifieds" in semiotic talk) may be when compared to ordinary speech and writing, what we wear, including cosmetics, jewelry, and coiffure, can be subsumed under the general notion of a code. This means that within that broad arc termed "contemporary

7. Consider in this connection the many flops recorded in fashion history, that is, failed attempts by designers, manufacturers, publicists, etc., to foist a new style on the public. The most recent of some notoriety was perhaps that of the publisher of *Women's Wear Daily*, John Fairchild, to marshal the considerable authority of his publication in behalf of the decisively rejected "midi look" of the early 1970s.

Western culture," a great deal of sign conventionalization obtains in clothing as it does in the arts and crafts generally. Hence, different combinations of apparel with their attendant qualities are capable of registering sufficiently consistent meanings for wearers and their viewers. (In today's world, a tennis outfit will never be mistaken for formal dress or a Nehru jacket for laborer's attire, much as the occasional eccentric may insist she or he means it to be taken that way.)

In referring to qualities, I have in mind such clothing features as fabric, color, texture, cut, weight, weave, stitching, transparency, and whatever else makes a difference in how the garment or its surrounding ensemble of apparel is responded to in a community of clothes-wearers. What qualities do and do not make a difference in how clothing is responded to in a "clothes community" can, up to a point, be conceptualized in terms analogous to the phonetic/phonemic distinction in linguistics. The essential distinction, however—what most distinguishes clothing as a mode of communication from speech—is that *meaningful* differences among clothing signifiers are not nearly as sharply drawn and standardized as are the spoken sounds employed in a speech community (see Hawkes 1977, 23–28).

To formulate matters as I have here is essentially to say no more or less than that clothing's meanings are cultural, in the same sense that everything about which common understandings can be presumed to exist (the food we eat, the music we listen to, our furniture, health beliefs, in sum, the totality of our symbolic universe) is cultural. Or as George Herbert Mead (1934) might have phrased it, the clothing we don calls out essentially, if not precisely (the difference is significant, though I shall not dwell on it here), the same images and associations in ourselves as it does in others, even granted that from time to time and from group to group different values will attach to them. For example, the shoulder-length hair of the male hippie, which for him and his friends connoted unisex liberation, for his more conventional contemporaries signified perverse androgyny and ostentatious slovenliness. But even such varying interpretations of the same grooming item or overall look are meaningful, provided each party understands where, in the vernacular, "the other is coming from," as most often each does.

If, then, there exists among a society's members a sufficiently

shared perception of "how to read" different items, combinations, and styles of clothing, where does fashion come into the picture? Is *fashion* merely another way of designating some distinctive style or, more generally yet, as Robert and Jeanette Lauer (1981, 23) define it, "simply the modal style of a particular group at a particular time . . . the style which is considered appropriate or desirable?" The problem with these definitions and a host of others like them is their failure to differentiate adequately fashion per se from the consensually established clothing code (conventionalized signifiers, accepted canons of taste, etc.) operative in a society at a particular time. That some sort of difference exists between the operative code and those elements we term "fashion" is, to be sure, hinted at in even these definitions when they speak of a modal or prevalent style, implying thereby some succession of styles over time. But the implication for fashion is lost through the failure to discriminate between what happens during the last phases of a fashion cycle, when a style has already become part of the common visual parlance, and what happens at the beginning of the cycle, when the new style typically jars, or at least bemuses, us. Precisely this difference, of course, underlies the familiar insight that a fashion that has been accorded wide acceptance is, ironically, no longer fashionable.

Clearly, any definition of *fashion* seeking to grasp what distinguishes it from style, custom, conventional or acceptable dress, or prevalent modes must place its emphasis on the element of *change* we often associate with the term. (The word itself, according to the *Oxford English Dictionary*, derives from the Old French and originally meant, as it still does today in one of its usages, "to make" in the sense of "fabricate.") And at the level of communication, by *change* we necessarily imply, as the linguist Saussure insisted (MacCannell and MacCannell 1982, 10), some shift in the relationship of signifier and signified, albeit always bearing in mind that in dress the relationship between *signifiers* and the referents, attributes, or values thereby *signified* is generally much less uniform or exact than in written or spoken language. In any case, *fashion*, if it is to be distinguished from *style* and numerous other of its neighbor terms, must be made to refer to some alteration in the code of visual conventions by which we read meanings of whatever sort and variety into the clothes we and our contempor-

aries wear. The change may involve the introduction of wholly new visual, tactile, or olfactory signifiers, the retrieval of certain old ones that have receded from but still linger in memory (Davis 1979), or a different accenting of familiar signifiers; but change there must be to warrant the appellation *fashion*.

This, I concede, skirts the issue of exactly how extensive such changes must be for us to speak of fashion rather than, for example, a modal style or the accepted dress code. Do the apparently slight modifications from season to season in hem length, waist or hip accenting, shoulder buildup, or lapel width represent code modifications of sufficient magnitude to justify the designation *fashion?* Our intuition says no, but it would be unwise to be too arbitrary with respect to the question. In the lived world of everyday dress, clothing design, and merchandising there is, perhaps inevitably, a good deal of uncertainty in the matter depending in no small part on whose interests are served by proclaiming the code modification a new fashion and whose by resisting such a proclamation. Among those coteries and publics for whom it is terribly important to be thought of as fashion trendsetters, the tendency will, of course, be to invest even minor changes with fashion significance. Among those more indifferent to fashion and those who cultivate a fashionably out-of-fashion stance (Kinsley 1983), the tendency will be to deny or discount those code modifications that manage to steal into one's wardrobe. Ideally, from a phenomenological as well as sociological point of view, one would want to restrict the word *fashion* to those code modifications that, irrespective of their apparent character, somehow manage on first viewing to startle, captivate, offend, or otherwise engage the sensibilities of some culturally preponderant public, in America the so-called middle mass. It is their acceptance or rejection of a code modification that will determine whether it succeeds as fashion or merely passes from the scene as a futile symbolic gesture.

FASHION AND SOCIAL IDENTITIES

What propels the clothing code modifications I take to be fashion? Whence does the impulse spring? What in Western civilization has kept it alive for better than six hundred years? Is it, as many main-

tain, merely a device for relieving boredom? Or is it, as others would have it, a self-perpetuating capitalist cultural conspiracy, an insidious institutionalized scheme for reaping the profits attendant to a planned obsolescence of wardrobes?

There is some, though not much, truth to both the boredom and profit-driven conspiracy explanations.[8] (One finds elaborate reformulations of them throughout the theoretical literature of the social sciences.) What both explanations, and others I will take up later, sorely neglect, or at best grossly underestimate, is the importance of yet another factor in the complex social process we call "fashion," that labyrinthine passage whereby an idea in the designer's head is translated ultimately into the purchases and pleasures of the consumer. I have in mind social identity and its role in eliciting, channeling, and assimilating fashion's code modifications. By social identity, I mean much more than the symbols of social class or status to which some sociologists are inclined to restrict the concept. I include within the concept's purview any aspect of self about which individuals can through symbolic means communicate with others, in the instance of dress through predominantly nondiscursive visual, tactile, and olfactory symbols, however imprecise, and elusive these may be. In any case, the concept of social identity points to the configuration of attributes and attitudes persons seek to and actually do communicate about themselves (obviously, the two are not always the same).

How, then, do social identities relate to fashion? While space precludes comprehensive development of the thesis here, I would begin by noting that although we ourselves are actively (and, a good deal of the time, self-consciously) engaged in the construction and articulation of our social identities—we are not passive

8. Briefly, both explanations can be laid to rest by merely considering the following. If, as we have every reason to believe, boredom is universally part of the human condition, why is the fashion cycle so exclusively a product of Western civilization? It is absent from premodern folk and tribal societies; nor, for that matter, did it exist in other high cultures and civilizations of the past like those of ancient Egypt and China. As for the profit-driven conspiracy theory, this would be more persuasive were it not for the resounding fashion flops the putative conspirators manage to bring off on a fairly regular basis. At minimum it would appear that those they conspire against have some very telling things to say on whether they will or will not follow a new fashion. Social identities, I would hold, provide the frame for understanding what such "telling" is about.

recipients of identities ascribed to us by some remote abstract entity terms "society"—there are nevertheless strong collective currents that impinge on our sense of self at different times during our lives and at different historical moments (Stone 1962). That is to say, because we are subject to many of the same conditions of life, a great many of us experience in our persons similar yearnings, tensions, concerns, and discontents, which, regardless of how we apprehend them, seek some form of expression. It is in this sense that our identities can be spoken of as sharing a strong collective component (Klapp 1969).

I would hold with Blumer (1969a) that it is to these collective facets of our social identities that fashion addresses itself. And fashion can do so profitably (in both an aesthetic and pecuniary sense) because our social identities are rarely the stable amalgams we take them to be. Prodded by social and technological change, the biological decrements of the life cycle, visions of utopia, and occasions of disaster, our identities are forever in ferment, giving rise to numerous strains, paradoxes, ambivalences, and contradictions within ourselves. It is upon these collectively experienced, sometimes historically recurrent, identity instabilities that fashion feeds. The designer-artists who initiate fashion intuit somehow the currents of identity instability pervading a people and seek through the artful manipulation of the conventional visual and tactile symbols of clothing presentation to lend expression to them, or alternatively to contain, deflect, or sublimate them. To do so is necessarily to alter the clothing code in one or another way so that at some level of consciousness, if only subliminally, new, psychologically satisfying reflexivities can be evoked from potential wearers of the fashion.

From what is taken by most scholars to be the beginnings of an institutionalized fashion cycle in the West, namely, fourteenth-century Burgundian court life, up to the present, fashion has repeatedly, if not exclusively, drawn upon certain recurrent instabilities in the social identities of Western men and women.[9]

9. Some students, though, Steele (1988, 18–19) among them, locate the beginnings of fashion in the "protocapitalist" Italian city states of the early Renaissance, whence it is said to have spread to the Burgundy court. The problematic dating may reflect historical uncertainties in distinguishing the beginnings of fashion from the beginning of an institutionalized fashion cycle.

Among the more prominent ambivalences underlying such fashion-susceptible instabilities are the subjective tensions of youth versus age, masculinity versus femininity, androgyny versus singularity, inclusiveness versus exclusiveness, work versus play, domesticity versus worldliness, revelation versus concealment, license versus restraint, and conformity versus rebellion. Fashion's code modifications seem constantly to move within and among the symbols by which clothing encodes these tensions, now highlighting this, muting that, juxtaposing what was previously disparate, inverting major to minor and vice versa. But by whatever operation, when successful, fashion manages through symbolic means to resonate exquisitely with the shifting, highly self-referential collective tensions and moods abroad in the land. Indeed, in so doing it more than lends expression to them; it helps shape and define them as well.

fashion seems to toy with social concerns couture could be argued addresses this but also creates escapism

2

Identity Ambivalence, Fashion's Fuel

For the truth of the matter is that people have mixed feelings and confused opinions and are subject to contradictory expectations and outcomes, in every sphere of experience.

Donald N. Levine, *The Flight from Ambiguity*

I n the previous chapter I held that collective identity ambivalence is an important cultural source of the code changes in clothing that are fashion. I suggested further that this generalized cultural source is also a key resource for fashion designers in the practice of their craft. Inasmuch as the chapters to follow—on ambivalences of gender, social status, and sexuality—draw repeatedly on this formulation, I think it useful here to expand on these ideas so the reader may better judge the claims put forth in those chapters.

AMBIGUITY AND AMBIVALENCE

Although the two terms are accorded rather distinct dictionary definitions (*ambiguity* alludes to multiple meanings, while *ambivalence* points more to contradictory and oscillating subjective states), they are commonly confounded in everyday speech.[1] Along with Donald Levine (1985), however, who takes cultural scientists to task for compulsively striving to resolve or eradicate ambiguity rather than mining the conceptual richness often buried within it, I view this as an instructive confusion. In conflating the two terms we betray the condition that the states the terms mean to differentiate are in fact intimately related existentially, i.e., one is so constant a companion of the other they are hard to tell apart. So, while the multiple meanings of *ambiguity* may arise from any of a variety of sources—phonemic resemblances, shifting contexts, cultural variability, evasive intent, or euphemism—ambiguity is so

1. The principal definition for *ambiguity* in *Webster's Third New International Dictionary* is "admitting of two or more meanings, . . . being understood in more than one way, . . . referring to two or more things at the same time." That for *ambivalence* is "contradictory emotional or psychological attitudes . . . continual oscillations . . . uncertain as to which approach, attitude or treatment to follow."

regularly the by-product of ambivalence as to be subjectively indistinguishable from it. "Our words divide as our selves divide" states the case.

If this is true of speech and writing, where, after all, rules of syntax and pronunciation regulate the discharge of meaning, it is, paradoxically perhaps, even more pronounced in clothing communication. The very allusiveness and ambiguity I have claimed to be endemic in clothing communication seems, possibly *because* of its semantic incapacities, to encourage creativity in the delineation and expression of ambivalence, albeit subconsciously or unwittingly much of the time.[2] Because of ambivalence's "natural" ties to the multiple meanings that are ambiguity, the opposing pulls one feels over *how* to dress translate, at the level of perception, into mixed, contradictory, conflicting, or, at the very least, inchoate identity messages.

I shall in the course of the next several chapters offer many examples of ambiguity in dress. For now, though, it is important to appreciate that ambiguity falls well short of meaninglessness, that state in which we draw a blank from the symbols (although, strictly speaking, they would no longer qualify as symbols) put before us. Ambiguity, or rather our experience of it, recognizes the possibility of alternative, contradictory, or obscure interpretations. And it is upon this recognition that any number and variety of ingenious equivocations, calculated duplicities, and artful conceits come to be constructed in everyday life as much, perhaps, as in art itself (Eco 1979, 262–63; Empson 1953).

Given the existence of a rich lexicon of textile materials and garment forms, with the historical and cultural imagery attaching to them, dress, and the fashion impulse in particular, are quite adept at rendering ambiguity. Certainly the capability extends far enough to permit clothes wearers to be highly reflexive in their resort to ambiguity, as, for example, were Chanel's wealthy clients when she urged them to wear cheap costume jewelry as a way of signaling disdain for arriviste posturing (Gray 1981). (Of course, once the fashion for costume jewelry came to be widely accepted—

2. The familiar observation that persons' dress often reveals more about their psychological state than they can or wish to put into words is of a piece with this general point.

that is, when those other than old-wealth patricians took to displaying it—then real jewelry reassumed its primacy as a status symbol.)[3]

The propagation in dress of problematic meanings that is ambiguity is, as I have indicated, inextricably intertwined with the subjective states of ambivalence that tear at the identities we mean to convey to others. What, then, is the nature of such ambivalence, these "contradictory emotional or psychological attitudes . . . continual oscillations . . . uncertain[ty] as to which approach . . to follow" (*Webster's Third New International Dictionary*)? How does it relate to the social identities we communicate through dress—"social" in the sense of commonly shared impressions of who and what we are?

It may well be the case, as Nietzsche in *The Will to Power* would have it, that the human condition is inherently ambivalent, i.e., subject to those "contradictory emotional or psychological attitudes [and] continual oscillations" of which the dictionary speaks. Some contemporary authors (Thom 1984) see it as the essential psychic grounding on which historically derived social and cultural contradictions come to be built. Others, Freud (1918) among them, while hedging on the question of origins nonetheless regard ambivalence as so fundamental in human experience as to be virtually indistinguishable from a biologically determined condition. For Simmel (1950) the idea of ambivalence, in tandem with closely associated concepts of dualism and polarity, lies at the very heart of his sociology of social forms and consistently informs his analysis of modern culture. Indeed, the very subject of this book, fashion, is analyzed by Simmel (1904) as the social by-product of the opposition of processes of conformity and individualism, of unity and differentiation, in society.

Aside from whether ambivalence is an existential given or not, there are more interesting questions: What are humans ambivalent about? Why are they more ambivalent about some things than others? Merely to raise these questions takes us well beyond the

3. It should be noted that this sort of calculated, ambiguity-laden "violation" of an established code lies at the very heart of fashion change and occurs quite commonly in the arts generally (Culler 1976). Paradoxically, it can in the long run, as when real jewelry in time reassumes its primacy as a status symbol, act to reinvigorate established codes.

realm of the biological and, for that matter, that of individual psychology or personality. We are necessarily thrust as well into the realm of culture, the symbolically ordered meaning system upon and through which social interaction takes place (Geertz 1973). For ambivalence is ambivalence about *something,* and that something is almost invariably a *social object:* some artifact, thought, belief, image, practice, goal, etc., invested with *meaning;* that is to say, something about which we can communicate via gesture, expression, ornament, emblem, sign, and, what most distinguishes humans from other animals, language.

Of the infinitude of social objects about which persons can feel ambivalence, that which looms over all else, both in terms of prevalence and salience, is, I would hazard, the *self.* As George Herbert Mead (1934) might have formulated the condition, because of our ability to take the self as an object what occurs typically is a multivoiced inner dialogue through which we contemplate and evaluate some action, thought, plan, or desire of the self. Extrapolating further from the interdependencies Mead posited among mind, self, and society, the more complex and heterogeneous the society from which the voices comprising the inner dialogue are drawn, the more likely it is that ambivalence will occur. Reflecting different sentiments, standards, and values from the diverse spheres of cultural experience to which the self has been exposed, the inner voices are likely to clash or, at the very least, talk past each other. Whom do I wish to please, and in so doing whom am I likely to offend? What are the consequences of appearing as this kind of person as against that kind? Does the image I think I convey of my self reflect my true innermost self or some specious version thereof? Do I wish to conceal or reveal? . . . and so forth. We are all too familiar with the oscillations and *dis-*ease these identity uncertainties evoke in one's self.

IDENTITY AMBIVALENCE

It can be said that in very large part our identities—our sense of who and what we are—take shape in terms of how we balance and attempt to resolve the ambivalences to which our natures, our times, and our culture make us heir (Strauss 1959). And while its primeval purpose may have been to protect us from the elements,

clothing comes to share in the work of ambivalence management as much as does any other self-communicative device at our disposal: our voices, body postures, and facial expressions and the material objects we surround ourselves with (Goffman 1959). How clothing does this, however, is perhaps less simple than it is obvious. Obviously, because clothing (along with cosmetics and coiffure) comprises what is most closely attached to the corporeal self—it frames much of what we see when we see another—it quite naturally acquires a special capacity to, speaking somewhat loosely, "say things" about the self (Stone 1962). Dress, then, comes easily to serve as a kind of visual metaphor for identity and, as pertains in particular to the open societies of the West, for registering the culturally anchored ambivalences that resonate within and among identities.

As visual metaphor the clothing that is dress (one should perhaps distinguish between the two) is capable of communicating many things including something as subtle, for example, as the wearer's reflexive awareness of what is being "said."[4] Thus, much clothing, particularly that presuming a high degree of fashion consciousness, brackets as with quotation marks its statements for the sake of rendering by indirection quite different meanings from those apparent at first glance. (This borders on what Kenneth Burke [1959] has aptly termed "perspective by incongruity.") For example, in the next chapter's discussion of gender ambivalence I point out how, through stylistic exaggeration and oversizing, women undercut surface messages of masculinity in the very act of appropriating men's items of clothing for themselves.

What, then, are the identity ambivalences of the West that dress and fashion have encoded over the centuries and with which they cavort symbolically to this day? In principle these ambivalences may derive from just about anything implicating the self about which people feel this way and that, torn, of mixed mind, at sixes and sevens, etc. Thus they could encompass an almost infinite range of identity representations from food choices to religious

4. Although it is more precise than necessary for most discussions of the topic, the term *clothing* might reasonably be restricted to the garments themselves, whereas *dress* could better be made to refer to the distinctive properties of particular assemblages of garments, i.e., the practices and expectations regarding their combination and wearing venues.

practices, and there have been moments in history when dress has grappled with both of these.[5] In the main, however, the identity ambivalences that have most often found their way into the West's discourse of dress concern those representations of self that address core sociological attributes of the person, the so-called *master statuses* (i.e., age, gender, physical beauty, class, and race), for which Western culture itself has scripted directives and valuations often at variance with each other, as, indeed, it has in regard to these very attributes.

Viewed from a different vantage point, historically persistent ambivalences of this magnitude can be thought of, to borrow a seismological metaphor, as cultural *fault lines*. Much as the subterranean torsions along the earth's fault lines give rise from time to time to temblors and quakes, so do culturally induced strains concerning who and what we are find symbolic expression in dress and the pulsations of fashion. But unlike temblors and quakes, changes in dress and fashion do not happen of their own accord. Human agency, in the form of fashion designers, a vast apparel industry, and a critically responsive consuming public, is necessary in order to bring them to pass. Obvious as this may seem, it is often lost sight of by the many writers who view the succession of fashions as somehow fated or ineluctably driven by the *Zeitgeist*'s flux.

FASHION AND IDENTITY AMBIVALENCE

As for fashion specifically, while it must of necessity work within the broad parameters of a relatively well established and familiar clothing code, it turns for fresh inspiration to tensions generated by identity ambivalences, particularly to those that, by virtue of cultural scripting and historical experience, are collective in

5. In the nineteenth century, following Beau Brummel, the dress of dandies came to be closely associated with a gourmetlike punctiliousness in dining. More recently, a predilection for wearing running, gym, and athletic garb throughout the day is usually taken to signify an ideological commitment to natural, organic, and health foods as well. Women's dress in contemporary Iran and elsewhere in the Muslim world has become inseparable from declarations of religious orthodoxy and political loyalty.

character. Ambivalences over how to enact our gender roles, our social class identification, and our sexuality, though by no means exhaustive of the range of collectively experienced identity ambivalences in Western society, have certainly figured prominently in it. Though in these pages I do not venture in a sustained way beyond these three, in themselves they furnish more than enough evidence of the biplay of identity ambivalence and dress.

Regardless, howeer, of the ambivalent chord it means to strike, fashion seeks constantly to get those attuned to its symbolic movements to alter their virtual identities (Goffman 1963), to relinquish one image of self in favor of another, to cause what was until then thought ugly to be seen as beautiful and vice versa. In effect, then, the fashion element in clothing communication consists of the visual-tactile-olfactory code changes wrought by fashion's exercise. This helps explain the new and different ways fashion causes persons and their surroundings to *appear* to us, however superficial the relationship of the altered appearance to those more permanent, less plastic aspects of self by which we are recognized by and known to others. As stated earlier, fashion as a concept must be distinguished from the conventions of clothing communication per se, a distinction sometimes neglected even in scholarly writings on the subject. In all societies clothes serve to communicate more or less standardized meanings about their wearers, but not all societies subject wearers to the periodic alterations of meaning effected by fashion.

My claim that fashion trades on identity ambivalence should not, obviously, be taken to mean that the symbolic "solutions," "syntheses," "compromises," "adjustments," etc., offered by it are permanent or even long-lasting. Like fashions themselves, these are more ephemeral than enduring. The ambivalences involved are usually too labile and deeply rooted in Western culture to succumb to such easy symbolic resolution.

By way of illustration, consider the recent history of the "dress for success" women's style, which came into vogue in the 1970s as more and more women sought jobs in business and the professions. The mode called for feminizing an otherwise cloned masculine image—signaled by suit jacket and matching, well-below-the-knee, tailored skirt—through wearing such apparel as silk

blouses accented by large, flowing bow ties or ruffled collars and blouse fronts.[6] By the mid-1980s, this ensemble no longer seemed capable of sustaining whatever male (career) versus female (sexual object) gender ambivalence it had managed to adjudicate. By then it had come to be denigrated as "a uniform," thereby tilting it disconcertingly, silk blouse and all, toward the male side of the ambivalence polarity. Its visual/symbolic force was dissipated, and new emblemata had to be found for assuring men, and career women themselves, that it was "still a woman" who inhabited its sexually distancing business front. The creation and reinvention of such emblemata is, of course, the business of fashion.

Fashion, then, would have a good deal less to draw upon were it not for the identity ambivalences—of gender, of age, of class, to touch on only the "master statuses"—which have been structured more deeply and dynamically into the cultural fabric of Western civilization than elsewhere. Indeed, this may account for why more stable and static societies of both the past and the present, in which identities of person and place are on the whole more sharply etched than in the West, have remained relatively immune to the sway of fashion. There are, to be sure, scholars who claim to detect phenomena akin to fashion among other peoples and in past civilizations.[7] None, however, carries the claim so far as to maintain that fashion—in the sense of a *continual,* largely *uninterrupted,* and ever more *institutionalized* succession of stylistic changes in dress, adornment, and decorative design generally—has existed anywhere other than in the postmedieval West.

There is also, surprisingly, unusual consensus (if not unanimity) among scholars (Batterberry and Batterberry 1977; Bell 1947; Hollander 1980; Konig 1973) in tracing the beginnings of fashion, in its stricter sense as spoken of above, to late medieval court life.[8] A few are specific to the point of locating fashion's provenance in the

6. The herald of this style was John T. Molloy, whose *The Woman's Dress for Success Book* (New York: Warner, 1977) gained great popularity at the time.

7. Polhemus and Procter (1978), for example, tell of a New Guinea tribe in which changes in the color of feather headdress are adopted every few years. They are unclear, however, on what lies behind this. Neither do they point to any other item of tribal dress or decoration in which this sort of change occurs on a regular basis.

8. See Steele's rendering (1988, 18–19), mentioned in note 9 to chapter 1.

court of Philip the Fair of Burgundy, who reigned from 1285 to 1314. Understandably, these students are vague in accounting for its exact start then rather than sooner or later.

Whether fashion scholars choose to be this specific or not, all tend to opt for the plausible historical explanation that fashion's rise in the West had much to do with the emergence at about this time of a town bourgeoisie to rival feudal aristocracy's secular monopoly of wealth, power, and display. The late medieval period was also a time when, in the wake of the last Crusades, the fabric and gem riches of the East began to spread through Europe. Burgundy sat at the crossroads of the trade routes along which the riches were shipped. This naturally gave it privileged geographical access to the luxurious goods with which the ensuing status rivalries of town bourgeoisie and feudal aristocracy were to be enacted. But as we shall see in a subsequent chapter, the invidious enactment of social class identities via clothing (and life's other material goods, for that matter) has over succeeding centuries assumed many more complex symbolic forms than that of sheer *display* of the costly wares in one's possession.

3 Ambivalences of Gender: Boys will be Boys, Girls will be Boys

A girl should be a tomboy during the tomboy age, and the more of a tomboy she is the better.

Joseph Lee, turn-of-the-century founder of the Playground Association of America

THE ASYMMETRY OF CROSS-GENDER CLAIMS

The history of Western fashion is marked by a profound symbolic tension arising from the desire, sometimes overt though more often repressed, of one sex to emulate the clothing and associated gender paraphernalia of the other.[1] Until well into the eighteenth century the habit of cross-gender emulation in dress was, if anything, somewhat more pronounced on the male side in the privileged classes than on the female (Brenninkmeyer 1963). (The common people were for the most part excluded from fashion's orbit until the nineteenth century.) In general, however, fashionable dress for both sexes shared, as a perusal of books on costume history makes plain, a great deal more than would be true later.

Since the industrial revolution, at which point males came increasingly to fall under the visual constraints of a somber work ethic, the tendency, of course, has been for masculine versus feminine ambivalence in clothing to reveal itself almost exclusively on the female side as women have opted periodically—and during certain periods with great fervor—to incorporate into their personas insignia of male status and masculinity. The catalogue of devices by which this has been accomplished is almost without end; by way of example, I offer only a casual listing here: top hats, bowler

1. The epigraph is from Paoletti and Kregloh (1989, 39). Echoing a principal theme of this chapter, the authors at once add, "Cross dressing or equivalent gender-bending behavior among young males won no similar endorsements."

hats, fedoras, sailor hats, Basque berets, ordinary men's shirts, button-down oxford shirts, T-shirts, neckties, bow ties, ascots, crew sweaters, black leather motorcyclist jackets (sometimes studded), waistcoats, plus fours, heavy rough tweeds, severe tailoring, padded and exaggerated shoulders, military jackets and insignia, boys' haircuts (including short, bobbed, and unruly hair), bald scalp, no makeup, tattooing, underemphasized breasts, jodhpurs, bermuda shorts, riding crops, men's walking sticks, tightly rolled men's black umbrellas, jumpsuits, men's footwear (including basketball shoes, wing-tips, and opera pumps), suspenders, and, finally, the quintessential male garment, trousers—be they slacks, jeans, or part of a three-piece suit.[2]

❦ Since the early nineteenth century, men for their part have flirted only sporadically, and then rather timorously, with the possibility of adopting clothing or other gender-specific items in any way suggestive of femininity. The so-called peacock revolution of the early 1970s, which for a short time paralleled, though on a much smaller scale, the truly radical alterations in women's dress (e.g., pants, braless blouse wear, short hair, jeans) amounted to little more than a turning to brighter colors, a receptiveness to patterned apparel and softer fabrics worn more loosely on the body and, generally, a slightly greater informality in business and after-hours dress. Within a decade, however, even these modest departures from conventional attire were largely abandoned by middle- and upper-class men as the dark-hued three-piece business suit again asserted its symbolic dominance in the male's wardrobe. An attempt by a reputed *enfant terrible* of French couture, Jean-Paul Gaultier, to introduce sarongs and pants-skirts (open-legged trousers with a skirt panel in front) in his fall 1984 men's collection was greeted with reactions ranging from indifference, at best, to

2. It is revealing that whereas most items of male attire adopted by women have been viewed with indulgence or amusement after their initial shock value has worn off, the same cannot be said of trousers. George Sand was ostracized for wearing them in mid-nineteenth century Paris, as was Marlene Dietrich in "polite circles" almost a century later. Even more telling, perhaps, is that following their mass adoption by women in the wake of the women's movement of the late 1960s numerous fashionable hotels, restaurants, and other public accommodations barred entrance to women wearing them.

outright ridicule (Duka 1984). Interestingly, even as he introduced them, Gaultier, by way of assuring interested buyers (of whom apparently there were none) he was not out to feminize men, is quoted as stating, "I'm not saying men and women should look alike. It won't be like the Sixties, where they had the same haircut and everything. They'll share the same wardrobe, but they'll wear it differently. Men will stay masculine and women feminine" (Brantley 1984b).[3]

That the very idea of men's "fashions" smacks of insinuations of femininity and/or homosexuality is attested to by the skittish reception accorded the first men's boutiques—they were so named—opened in Paris by Pierre Cardin in the late 1950s. According to a prominent American designer I interviewed, it was facetiously remarked at the time that the men's clothes sold there "looked like the sort Marlene Dietrich would wear. His boutiques turned out to be a lot more popular with chic women than with men."

A NOTE ON ANDROGYNOUS DRESS

An intriguing refinement of fashion's historic propensity to exploit the masculine versus feminine instability in gender identity is the periodic resort to androgyny as a way of addressing the problem. Over the past century and a half, though more overtly in the period since the First World War, androgynously toned fashions have from time to time held sway, having reached their zenith in the unisex stylings popular from the late 1960s to mid-1970s (Gottdiener 1977). (Some unisex shops absolutely refused to make any gender distinction in the clothes hanging from their racks.) A similar flurry, this time actually spoken of in the fashion

3. This is but one of a vast class of such statements I elsewhere term "fashion's rhetorical consolations," i.e., statements, usually from designers and the fashion press, that deny or minimize the identity threat posed by a new fashion. Their aim, of course, is to reassure potential buyers that their most preferred images of self will in no significant way be compromised by wearing the new fashion. Thus the world of fashion at one and the same time celebrates and trivializes the acts to which it owes its very existence.

press as *androgynous*, occurred in the early to mid-1980s, mostly, however, by way of "punk" influences from the streets rather than from explicitly ideological gender concerns as such.

Strictly speaking, true androgyny would involve a melding or muting of gender-specific items of apparel and appearance so thorough as to obliterate anything beyond a biological "reading" of a person's sex (e.g., presence or absence of facial hair, a bosom, a narrowed waist in relation to hip size). In other words, apart from such visible biological characteristics, the clothing and other costuming borne by the person would have "nothing to say" on the matter of gender or sexual role. Clearly, so-called androgynous fashions in the West have never, as Paoletti and Kidwell (1989, 160) emphasize, attained so radical a condition; nor can we assume it was ever the intent of their creators for them to do so. The symbolic aim of these fashions is to dramatize cross-gender tensions, not resolve them.

Despite the by no means trivial significance of androgynous symbols for how men and women will respond to each other, two features in particular belie the authenticity of any full-blown declaration of androgyny.[4] First, as with the masculine versus feminine identity tension generally, the items meant to represent androgyny are, in terms of their gender-associated origins and allusions, located much more often on the male side of the gender division than on the female. Short hair, toned-down makeup, trousers, men's suit and shirt stylings, ties, and suspenders are the devices designers have classically resorted to when wishing to register androgynous as opposed to gender-specific meanings for women. By contrast, the only putatively androgynous insignia in recent times that have to any significant extent been adopted by men were the longer hair stylings, hand purses, and beaded ethnic necklaces and bracelets of the now largely abandoned hippie-inspired unisex stylings of the late 1960s and early 1970s. The recent vogue for earring wear among teenage boys and some young adult males may, perhaps, point symbolically to some future blurring of gender lines. As of this writing, however, the style is still very far from being incorporated into the sartorial mainstream. Its

4. Steele (1985), for example, maintains that androgynous touches have traditionally been employed in fashion to heighten, not to desexualize, the erotic allure of women's clothing.

confinement within the teenage subculture and certain "fringe" groups, most notably gays and rock musicians, while not without cultural significance, attests to the continuing strong male gender barrier toward all paraphernalia evocative of femininity.

The essentially asymmetrical weighting of androgynous fashion claims is further apparent when on closer inspection it is recognized that such claims almost always honor pre- and early adolescent boyishness rather than anything approximating a truly asexual or hermaphroditic state.[5] Again one sees typically the same array of masculine items, although this time favoring the symbolically preadult age grades: the slightly tousled boyish haircuts, snap brim caps, Eton jackets, button-down shirts, loose-fitting wool slacks, striped school ties, wide suspenders, etc. Small wonder then that feminists, rather than viewing current androgynous styles as symbols of sexual equality, regard them suspiciously as but another subtle sexist device for muting the egalitarian demands emanating from the women's movement. Under the symbolic pretense of deemphasizing gender distinctions, the boyish androgynous look, it is alleged, serves at one and the same time to appeal to latent homoerotic impulses in men and to assuage fears over a loss of power to women. It is as if the androgynous look whispered: "These women dressed like men are really not that at all. They're more like immature boys."[6]

DRESS, GENDER, AND MODERN HISTORY

Why the cross-sex traffic in the opposite sex's insignia has been so decidedly one-sided since the early nineteenth century, and why prior to that it was more nearly equal, have proved intriguing questions for costume historians, feminist scholars, and fashion

5. Similar points are made by Hollander (1985) although, rather than on gender issues, she places greater emphasis on the prepubescent, more purely erotic incitements believed by some analysts to adhere to androgyny. She also claims there has over the past few decades been, especially in the public media world of entertainment celebrities, a good deal more—moreover, culturally significant—borrowing of female dress and adornment symbols by males than I have allowed for here.

6. The same point is made by Bordo (1990). See her insightful essay for an extended discussion of the role of the "lean and slender" androgynous look in contemporary gender politics.

theorists. Indeed, costume historians (Laver 1937) have argued that in fashionable circles prior to the nineteenth century gender distinctions in dress were not nearly as strongly marked as they have become since. In the eighteenth century, both men and women of the aristocracy, and of the upper Bourgeoisie who emulated it, were equally partial to ample displays of lace, rich velvets, fine silks, and embroideries, to highly ornamented footwear, to coiffures, wigs, and hats of rococo embellishment, and to lavish use of scented powders, rouges, and other cosmetics (Los Angeles County Museum of Art 1983). In short, the male was as colorfully plumed as the female and, as in the avian kingdom, often more so.

Scholars (Bell 1947; Brenninkmeyer 1963; Konig 1973) differ somewhat in their analyses of what it was that brought about so sharp a divergence in the ways men and women dressed after the eighteenth century. But all concur that it was tied in some fundamental way to the decline of European aristocracy and the corresponding ascendancy of the bourgeoisie, a movement that, though much accelerated by the French Revolution, was well underway before 1789. Protestant-oriented values of hard work, sobriety, frugality, and personal economic advancement figured prominently, of course, in the structural transformation of European society (Weber 1947). Perhaps it was essentially the desire of the bourgeoisie to reflect these moral attitudes in what they wore that accounted for men and women coming to dress so distinctively. For then, as even now to a lesser extent, the sexes did not have equal access to workbench, marketplace, and office. If nothing else, pregnancy, child rearing, and an unending round of household chores saw to that. And with such parallel developments as the industrial revolution and a more democratic polity, both of which served to highlight the Protestant work ethic, it fell to the adult middle-class male to serve as the visible embodiment of the ethos animating the great social transformation then taking place. Accordingly, men's dress became the primary visual medium for intoning the rejection of "corrupt" aristocratic claims to elegance, opulence, leisure, and amatory adventure that had been so elaborately encoded into pre-nineteenth century dress.[7] Through fashion, means were found to

7. The elegant corruptions signaled by pre-nineteenth century aristocratic dress are portrayed with great visual flair and verisimilitude in two films from the

signal man's symbolic adherence to the austere values of the new age. Men's dress became more simple, coarse, unchangeable, and somber, sartorial tendencies that in many respects survive to the present. Not that women's dress remained unaffected by these structural changes in European society—e.g., gowns and other outer apparel became more modest and less opulent, coiffures less edificelike, the use of cosmetics less blatant—but the alterations were not nearly so radical, probably because woman's social role had not changed to the same extent as had man's. Bell (1947, 92–93) summarizes these developments thus:

> The differentiation between the dress of men and that of women which begins through a variation in development throughout the eighteenth century and culminates in the schism of the nineteenth century arises from the fact that the exhibition of wealth in men no longer depended upon a demonstration of futility; this change was made possible by the emergence of a wealthy manufacturing class. On the other hand, the women of this class, having no employment and being entrusted with the business of vicarious consumption, continued to follow the sartorial laws already in existence.

By the time of Victoria's ascension in 1837, clear and well-bounded gender distinctions had been established for men's and women's dress. Analogous in certain respects to the dichotomy Bernstein (1964) posits for working- and middle-class language use in contemporary Britain, it was as if men had come to be consigned a highly *restricted* dress code, whereas women were permitted to retain much of the *elaborated* code that had evolved for them over prior centuries. The restricted character of men's dress code derived principally, as I have noted, from the overweening centrality accorded work, career, and occupational success for male identity; so much so that for many decades to come, especially in the middle classes, clothing was almost unavailable as a visual means for men to express other sides of their personalities.

As is often the case when some few ends are pursued single-mindedly to the near exclusion of all else, the code's symbolic integrity (with its unrelieved emphasis on matters of work and liveli-

late 1980s, *Dangerous Liaisons* and *Valmont*, both based on an eighteenth-century novel by Choderlos de Laclos, *Les Liaisons Dangereuses*.

hood) was easily threatened by anything other than the most incidental allusion to nonvocational facets of self. Hence, men became sensitive and squeamish over incorporating into their wardrobes any item of clothing remotely suggestive of femininity, passivity, or indolence. This same single-mindedness probably also accounts for the glaring absence since the nineteenth century of humor in adult male dress, a quality women's dress managed to retain and on occasion to cultivate anew.[8] Witness in this connection the now-famous witty asides of Chanel (cheap costume jewelry with severely tailored suits) and Schiaparelli (hats shaped like shoes) from their couture of the 1920s and 1930s. More recently, obvious parody and playfulness are to be found in the women's clothing of, among others, such designers as Jean-Paul Gaultier, Franco Moschino, the late Perry Ellis, and the firm of Esprit.

The differential evolution of male and female dress in the modern era is not, as many think, the result of historical accident with each dress form going its own way, as it were, once its basic pattern is set down. On the contrary, the restricted code of post-eighteenth century men's dress and the elaborated code of women's are of a piece; together they comprise a coherent sign system, which seeks to ratify and legitimate at the deepest, most taken-for-granted levels of everyday life the culturally endorsed gender division of labor in society. Thus, in so steadfastly narrowing its symbolic allegiance to values of work and career, conventional middle-class male dress signals its privileged access to the source of economic and political power in industrial and postindustrial society, namely, occupational success and the income and prestige deriving therefrom. That much more than "mere appearances" are involved in clothing's gender signalings is a point nicely made in an amusing incident cited by the Langs (1961, 473, quoting Young 1937, 187):

8. Exception must be made for the ritualized and special ceremonial occasions on which men are permitted to do "funny things" with their appearance and clothing: Halloween, fraternity rushings and hazings, ballpark displays of team loyalty, holiday parades, etc. But these are symbolically well segregated from the serious, work-oriented activity of everyday life in which business suits and other "no-nonsense" clothes are expected to prevail.

An officer of the Federal Reserve Bank, asked what was adequate compensation for wearing his wife's hat to the office some morning, first answered, "Fifty thousand dollars." Then, after thinking it over for a moment, he said, "it would have to be as much as he could expect to earn the rest of his life, since afterward he could never expect to hold a position of financial responsibility again; and in the end he concluded that no price would be enough for the loss of prestige entailed."

But dress encodings (via sight, smell, and touch) are, we know, more subtle than to remain fixed on some crude, unrelieved declaration of male gender dominance, leaving matters at that. A concomitant systemic feature of the interplay of men's restricted dress code and women's elaborated code in the modern era is that while the expressive range of the former is greatly circumscribed, that of the latter sustains and, through fashion, builds upon a rich symbolic repertoire. As Bell (1947) and others before him (Simmel 1904; Veblen 1899) observed, with the rise of the urban bourgeois family a man's wife and daughters, themselves usually lacking title and other primary bases for high social status—they did not hold "important positions" in the world, they were discouraged from participating in politics and government—came through their clothing, interior decorating, and other consumer activities to serve as the expressive vehicle for announcing the status claims of the family and of its male breadwinner in particular.

The expressive constriction encoded on the male side, therefore, was well compensated for by the license granted women to decorously and artfully proclaim some credible status rank for the family. Women could then permit their dress considerably more symbolic scope and play, which the novelties and ambiguities of fashion were always near at hand to cater to. At the same time, women, having to manipulate a more complex code, could more easily (through mismatches, exaggerations, neglect or obsessive preoccupation with detail, etc.) "make mistakes" and be thought gauche, fussy, dowdy, vulgar, or whatever, as the reigning canons of taste at the time may have ruled. (There was, and remains, a good deal less opportunity for men to "make mistakes" in dress.) But paradoxically, a woman's mistakes in dress could be socially set aside more easily, just as, on the other side of the coin, her sar-

torial virtuosity could more quickly be discounted. For in the end, all knew that her wardrobe, however well or poorly it succeeded in impressing others, was but an indirect reflection of status, not the primary claim to it, which in the middle-class scheme of things resided finally in the man's occupational status and, in that connection usually, the wealth possessed by the family.

Greater expressive scope, more freedom to improvise, and, ironically, a corresponding widening of the social margin for performance error have, then, framed woman's dress code much more than they have man's. That is why the wife of the federal bank officer quoted above could probably much more easily wear his hat in public than he could hers. It is probably also why since the eighteenth century the cross-gender traffic in clothing has been so heavily one-sided, from men to women rather than the reverse. A plaything for the one could prove symbolic suicide for the other.

LIMITS OF CROSS GENDER CLOTHING CLAIMS AND DECEPTIONS

Notwithstanding fashion's frequent encouragement to women to borrow items and modes of men's dress, the norms of Western society demand that gender identity be grounded finally in some irreducible claim that is clearly either male or female, not both or some indeterminate middling state. To forestall discrediting insinuations of "butch lesbianism" or "gay transvestism," Western dress codes operate to blunt any too blatant appropriation of the opposite gender's identity.[9] It is characteristic, therefore, for cross-gender clothing signals, even the more common and variegated women's borrowings from men, to be accompanied by some symbolic qualification, contradiction, jibe, irony, exaggeration, etc., that in effect advises the viewer not to take the cross-gender representation at face value. A striking case in point is the 1970s "Annie Hall look" with its comic undercutting of claims to masculinity

9. Exhibitionistically festive cross-dressing, popular in some clandestine circles, breaches this divide, of course (see Pomerantz 1991). The public disposition to view the practice as deviant or perverse, however, attests to the continuing normative force for sustaining some irreducible gender-distinguishing representations in dress.

A scarf headband sustains gender identity. © *Doug Menuez/Reportage. Courtesy of Smith & Hawken*

A 1991 version of the 1970s Annie Hall look. *Courtesy of Tweeds, Inc.*

through a gross oversizing of the men's clothes worn by the female. There is also the boyish accenting of the androgynous look, noted above, meant to mitigate for women a too radical departure from accepted gender identifications. Innumerable other examples, both visual and testimonial, from the most subtle to the most blatant, can be cited.[10] Those that follow are chosen at random and follow no particular logic:

10. Today's women's fashions are littered with this sort of gender ambiguity and ambivalence. The profusion of such signs speaks simultaneously, I would sug-

- Included in the Metropolitan Museum of Art's 1983 exhibition hon- ○ oring the work of Yves St. Laurent are mannequins wearing men's formal, black-tie evening wear. One mannequin wears a frilly lace blouse beneath her tuxedo jacket; another displays a scandalous transparent chiffon blouse. (Dionne 1983)

- "The basic sources of inspiration for [the designer] Ungaro are mili- ○ tary uniforms and the elaborate garb of the 18th century dandy. But these styles are so transmuted by ruffles and combinations of luxurious fabrics that they become the epitome of ultrafeminine dress. Ruffles decorate the shoulders, hips and, especially, the hemline, where they audaciously frame the legs." (Morris 1987b)

- "Even when she is still a bit hard-edged, as at Thierry Mugler and Claude Montana (the only two designers who have shown so far who still stress strong shoulders in otherwise excellent collections), the New Girl is soft, too. At Mugler, she even wears floral chiffon blouses and dramatic body-baring pastel nightgowns criss-crossed with straps to accentuate the body." (Gross 1986b)

- In a similar vein, an established Los Angeles designer I interviewed spoke of her growing distaste for the "frilly, feminine things for which I'm known" and of her desire to be "more realistic and minimalist in the clothes I design. . . . I get a little nauseous with all these visions of women in wilting lace things." But later in the interview, reflecting on what she had said earlier, she remarked laughingly, "I'm sure there's still a little frou-frou left in me. I mean, how can you resist a ruffle once in a while?"

- The renowned Italian designer Giorgio Armani is known to be par- ○ ticularly partial to slanting his women's fashions toward masculinity. Referring to his Milan showing of fall 1984, a reporter writes, "This racy collection is tempered by a snappy sense of paradox. As Armani says, 'I don't like unqualified femininity, there needs to be something to balance it.' In that spirit, he throws a man-style navy blazer over silk shorts, pairs a cropped midriff-flashing blouson pullover with pinstriped flannel slacks, cuts jackets that are straight in front with womanly curves in back." (W magazine 1984)

gest, to a certain collective contrition felt by many men over the historic assignment of women to subordinate social roles and, at another level, men's fear that gender roles may be altered too drastically, too soon.

- A fashion trademark of the American designer Ralph Lauren is the feminizing of the men's tweed hacking jackets he designs for women by showing them worn over ruffle-collared or lace embroidered blouses.

It is worth noting in this connection that through a structured parallelism of spatial and semantic metaphors the oppositions of over-under, inner-outer, and top-bottom often come to serve as formats for encoding the identity ambivalences, contradictions, and ambiguities one wishes to convey concerning one's gender (or, for that matter, one's age, social status, or sexuality as well) (Hollander 1980). In addition to several such examples given above, there is the fetching if overemphatic one offered by Lurie (1981, 245) in her discussion of the topic:

> The woman in the sensible gray wool suit and the frilly pink blouse is a serious hard-working mouse with a frivolous and feminine soul. If, on the other hand, she wears a curvy pink silk dressmaker suit over a plain mouse-gray sweater, we suspect her of being privately preoccupied or depressed no matter how charming and social her manner.

"DRESS FOR SUCCESS" OR "DRESS FOR SEX"

As suggested earlier, the area of social life that has in recent years been extraordinarily productive of gender ambivalences in dress is that of women entering the labor force, particularly as it pertains to women pursuing careers in business and the professions. The identity dialectic that is triggered here and animates the ambivalence derives ultimately, of course, from the historic division of sexual roles in the culture of the West. Without belaboring the point, this, as any child soon comes to know, essentially equates maleness with occupation, breadwinning, authority, and the exercise of instrumental capacities, and femaleness with sexual allure, domesticity, child rearing, subordinate status, and expressive display. And it is because these heavily gender-driven attributes are so effectively, though subtly, inscribed in the vestmental codes of the West that special problems are posed, equally for the social order as for women who seek acceptance, equality, and authority in formerly all-male or nearly all-male preserves.

The polarities of over/under, loose/tight as metaphors for identity ambivalence. *Courtesy of Tweeds, Inc.*

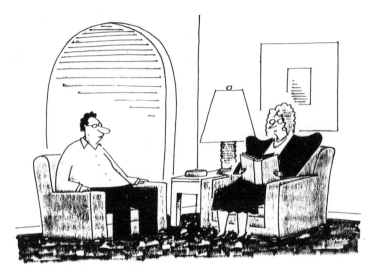

"You're home now, Adele. Why don't you take off your shoulders?"

Drawing by M. Stevens; © 1990 The New Yorker Magazine, Inc.

In practical terms the identity issue such women must negotiate—it is one all women, and men, will have to negotiate if gender roles are ultimately to be redefined—is that of deemphasizing the more purely feminine, eroticized, and domesticated, components of their dress without at the same time inviting the social losses likely to result from a too thorough divestment of feminized attire (e.g., wearing pants in lieu of a skirt or dress; abandoning makeup, earrings, bracelets, etc.; allowing visible facial, underarm, or leg hair).

Theoretically there is no need for women in business and the professions to opt for masculine dress insignia. They could conceivably move in a unisex direction that is avowedly neither masculine nor feminine (consider surgical gowns). However, the cultural linkage of "male = work, career, skill mastery, authority" is so formidable, it is not at all surprising that this is the symbolic trajectory the identity negotiation assumes. This, of course, is what underlies the women's "dress for success" outfit of the 1970s advocated by John Molloy (1977) and innumerable other sartorial consultants: dark-hued, comparatively severe, man-styled jacket and straight, lowered-hemline skirt accompanied by attaché case;

A typical "Dress for Success" ensemble, ca. 1990. *Courtesy of Talbots*

in all, a figure suggesting masculinity but leavened by such feminine touches as silk blouses, soft bow ties, earrings, clutch handbags, manicured nails, and Chanel-style link necklaces and belts. As Kennedy Fraser (1981, 228) was to describe the gender ambivalence underlying the woman's dress-for-success scheme:

> If one had to sum up the current vision of executive womanhood—it is a simplification, because designers have widely differing interpretations of the theme—one would have to begin with a fairly strictly tailored suit. This prototypical tailored suit has a straightish skirt, with a hemline ending around the knees. The jacket has shoulders that are often padded or otherwise enlarged. But, as if pulling back from any austerity or masculinity inherent in this silhouette, designers add to it exaggeratedly feminine accessories: frivolous and impractical hats; shoes with recklessly high, thin heels; and unusual gloves.

Clearly, the professional woman's sartorial compromise, if it can be spoken of as such, is one that, because of the sharply dichotomous gender typing, not only retains numerous identity instabilities but also gives rise to new ones. On the one hand, the fear of negating femininity is so pronounced that vestmental means, both subtle and blatant, are constantly being sought to reassure career women and their alters that no *serious* gender defection has occurred. A fashion note in a metropolitan daily gives voice to a typical sentiment:

> For Lore Caulfield [a Los Angeles designer of lingerie] there's no contradiction in making lingerie and being a feminist. . . . Many women—especially those who must *dress for success*—wear sexy underwear as an antidote to their career clothes, she says. "This is additional proof that women are really developing themselves and expressing their own sexuality," she explains. (Abrams 1983)

Along the same lines, a Los Angeles designer I interviewed spoke of how admiring the "lady judges" and women executives who bought his expensive two-piece dress suits were of the "feminine touches" he managed to work into his designs. He attributed this to their wish to soften the austere presence associated with their work roles.

On the other hand, further complications and ambiguities are introduced should career women move too far—what is "too far"

is likely to vary with the occupation and its work site—toward "softening" (i.e., feminizing) conventionally accepted dress-for-success presentations.[11] The maddeningly contradictory consequences that can ensue from a reversion to femininity in the workplace are nicely touched on in this excerpt from a *New York Times* life-style column on women's hair length:

> Psychologists say that in the work place, longer hair sends a message to management.
>
> "Longer hair," Professor Waters said, "can signal the men to not be nervous boys, we're not after your jobs, even though the women may indeed be after their jobs. It's a message of femininity and softness—not weakness, mind you. It's a way of pacifying the enemy."
>
> But Professor Jackson noted a possible double bind. "A woman who is less of a threat may be perceived as less of a competitor, which could hinder her ascent up the corporate ladder," she explained. "Yet, if she is seen as less of a threat, men may be inclined *not* to hinder her ascent." (Slade 1987)

Issues of "professionally correct" hair length aside, many career women themselves, most especially, perhaps, feminists, come in time to flail at a dress style that reduces individuality to a stereotypic formula. Of course, mounting a revolt because of this is made easier once the person feels secure enough in her profession, as was the case with the ex-stockbroker author of the following extract:

> Later I got a job trading currency options. It was an important position. I started playing around with large sums of money. Suddenly I realized something about those [boardroom-style] suits. I hated them, I still do.
>
> They are uncomfortable. They are ugly. The bow ties make you

11. In general, professions with a strong tradition of decorum whose practitioners are subject to high public exposure (e.g., law, banking, and finance) are likely to be less tolerant of deviations, feminized or otherwise, from accepted gender compromises in dress than are professions less bound, either through circumstance or tradition, by these expectations (e.g., the arts and academia). Women in medicine and certain of the engineering professions constitute an interesting intermediate case. Work-site uniforms like lab coats, smocks, and surgical gowns seem to encourage a degree of liberality in the choice of whatever other clothes are worn to work.

look gift-wrapped. They are designed to hide your figure, as though your figure has anything to do with your brains, competence or productivity.

So when I got to be a trader I rebelled. If I was capable of managing millions of dollars, I reasoned, I was capable of doing it in whatever clothes I felt most comfortable in. (Goldstone 1987)

It is, of course, exactly the suppressed feelings of dress discomfort and distaste such as Goldstone harbored to which fashion designers seek to appeal and give symbolic expression in their designs. But doing so activates yet another source of identity instability for women seeking via dress to effect gender redefinitions for themselves in the workplace. For, as I have pointed out, clothing fashions in the modern world have been preponderantly *women's* fashions. To the extent that modern woman's gender socialization has made her highly receptive to the manipulations of self-image fostered by fashion, she can in like measure be only weakly attached to the stereotypic gender qualifications and cross-sex symmetries struck by dress-for-success and like assemblages. Even as they mute with fingernail polish and silk bow ties what a good many men still view as strident symbolic claims to an equal place in the vocational sun, such ensembles gravitate toward a stasis of gender representation at variance with the very impulse of fashion. For it is of the essence of fashion to rankle at the fixed and settled, no matter how worthy the symbolic purposes served by the dress of the day. Brubach (1990b) gives vent to the disenchantment awaiting those too long wedded to the tried and true in dress:

And for the rest of us the fashion-free world that seemed so promising fifteen years ago is getting to be a little monotonous, with the people who outfit themselves in "classic" clothes—the modernist uniform, which, having never been in fashion, will never be out of it—beginning to look like wallflowers and spoilsports, standing aloof from the times, refusing to participate.

The dilemma, therefore, is that to subject the dress-for-success posture (whatever version of it is favored!) to the play of fashion is to tamper with, and perhaps seriously compromise, the symbolic purpose at its core. This is to convey the impression that, because they now dress more like their male counterparts, women are in fact men's equal when it comes to such valued on-the-job at-

tributes as ambition, determination, skill mastery, levelheadedness, etc. (recall Goldstone's quoted comments). A salient part of this message is the tacit disavowal of the fickleness and capriciousness often associated with fashion, which, in turn, is seen as falling so exclusively to women.

The other horn of the dress-for-success dilemma constrains women to switch to Western man's restricted dress code as they abandon in large part their elaborated dress code, which they have lived with for centuries and many, including prominent feminists (see Wilson 1985), claim to enjoy. This entails sacrificing the many possibilities for symbolic elaboration, innovation, and improvisation that women's dress repertoire presently includes and men's does not. On purely aesthetic grounds, then, there is considerable resistance to doing so. Women's reluctance in this connection probably also accounts for what many of them regard as the ludicrous prescriptiveness of the dress-for-success ensemble (Lurie 1981, 26), i.e., the many "musts," "shoulds," and "nevers" that punctuate the advice of Molloy (1977) and other career dress advisors.

Contributing further to the latent instability of the dress-for-success gender compromise is that ideologically, too, many women—as is typical of members of all political minorities once their "consciousness is raised"—take umbrage that their ticket of admittance and token of acceptance into the business and professional worlds enjoins them to bedeck themselves with the symbolic wares of those worlds, especially if, as in this case, such wares were once the exclusive insignia of those who have dominated them. "Why should we have to recast our image into that of men's in order to secure those job rights that are naturally ours?" they ask.

In imagination it is possible to conceive of "wearer-friendly," unisex-leaning apparel that, without embracing the gender markings of masculinity, eliminates the nuances of frivolity, incapacity, seduction, and domesticity that have traditionally adhered to women's dress. Indeed, as I discuss in chapter 8, some dress reformers, most notably Amelia Bloomer in the mid-nineteenth century and certain Russian constructivists in the 1920s, tried their hand at exactly this. The conspicuous lack of success their efforts met with—in the market, if not necessarily in terms of design—is

testimony to the cultural depth of the quotidian discourse that still (and probably for some time to come) infuses the world of work with the gender signs of masculinity and other, mostly lesser, worlds with those of femininity.

CONCLUSION

Ambivalent orientations toward gender identification even now, as they have in the past, play a profound role in Western dress and in the symbolic buffeting to which fashion forever subjects it. I would repeat that whatever other forces may be said to move fashion—economics, sex, boredom, invidious class distinctions—it draws much of its perduring inspiration from the identity dialectics generated in states of ambivalence, that of gender being but one among several that have figured prominently in Western cultural history since the late medieval period. Quite obviously ambivalences of social class, sexuality, age grade, and much else about which men and women are of more than one mind have also etched their way into Western codes of dress and the alterations effected in them through fashion. Moreover, because these ambivalences spring from the cross-flows and clashes of the basic cultural categories that structure our lives, they are deeply moral and, most certainly, collective in character. As such, they form the existential canvas upon which fashion designers (and other artists, too, of course) seek to impress their interpretations and new encodings. As I will sketch out at length in chapters 6 and 7, when successful these in turn lead to a progressive collective transformation in mass taste and habit (Blumer 1969a), which then lays the basis for what is termed the "fashion cycle."

4 Ambivalences of Status: Flaunts and Feints

Beware of all enterprises that require new clothes.

Henry David Thoreau

A t the risk of perpetuating a popular sociological prejudice to the effect that the symbolic dimension of clothing is concerned *only* (or, in some catechisms, *ultimately*) with social class, I mean here to further ground the notion of culturally encoded identity ambivalences by examining what is nonetheless a most prominent and persistent ambivalence in Western dress (going back, indeed, to the fashion cycle's late medieval beginnings), namely, that of social status. From an interactionist perspective this ambivalence may be viewed as a polar dialectic of, on the one side, status *claims* and, on the other, status *demurrals*. The ensuing existential tension of symbolically claiming greater or lesser social status than can properly be regarded as one's "due" (see Goffman 1951) serves prototypically to illustrate again how ambivalence in general operates in dress and fashion.

POLARITIES OF STATUS

Women should dress as plainly as their maids.
Coco Chanel

But, of course, for this to have its intended effect women must first have maids, or at the very least convey the impression they are the sort who would have maids. And what better way to do this than to dress as if one had a maid? But to dress "as if" is somehow different than dressing like the maid one is supposed to have, which, after all, is what Chanel tells women to do. And so forth and so on, almost ad infinitum.

Like other identity tensions that seek an outlet in dress, social status, too, soon succumbs to a dialectic of endless reflexivities spawned by a host of every-shifting ambivalences regarding matters of wealth, worldly attainment, and social position. And, as is the case with identity polarities in general, it is this ambivalence

that affords dress and fashion endless opportunity for innovation and variation. Besides, then, brashly asserting or solemnly rejecting a claim to social superiority, for those versed in its codes—as most of us are, more than we realize—dress can modestly disavow, resolutely play down, disclaim via parody, insinuate through understatement, equivocate shamelessly, etc. Not that anyone, or hardly anyone, wishes to taken for Nobody, but conveying an impression with clothing that one is Somebody is neither as easy nor as obvious as it may at first seem.

Class and Status in the Study of Fashion

We turn here, then, to the swirl of sartorial ambiguities fostered by identity ambivalences of social status. Before doing so, however, it is of more than incidental interest to note that in the scholarly study of fashion clothing's role in effecting invidious class and status distinctions has been accorded preeminent importance. This emphasis is apparent even in fashion historians' treatment (Batterberry and Batterberry 1977; Hollander 1980; Konig 1973) of the very beginnings of an institutionalized fashion sensibility in the West, generally thought to be, as noted earlier, in court life of the late thirteenth and fourteenth centuries.

It was about this time that the fabric and gem riches of the East, which spread through Europe in the wake of the Crusades, came increasingly, despite strong pietistic opposition from the church, to serve as symbolic vehicles for invidious status competition among the nobility and between them and an emerging town bourgeoisie. For many a fashionable person of the time, especially in attendance at some ceremonial occasion, it was almost literally a case of wearing one's wealth on one's back. By the fourteenth century clothing had come to be so intimately associated with status assertions and pretensions that sumptuary laws were enacted throughout Europe, which forbade commoners from displaying fabrics and styles that aristocracy sought to reserve for itself. While such laws usually had little effect—by then bourgeois ladies were dressing as elegantly as princesses (Hollander 1980)—they remained on the statute books in many places until well into the eighteenth century. Compliance with or evasion of sumptuary laws per se notwithstanding, the quality and cut of clothes worn in

public were of prime importance in establishing the social standing of individuals and their families.[1]

In light of this background, and perhaps because European dress had lent itself to rendering class distinctions for centuries, it is small wonder that to the extent sociologists and other social scientists interested themselves in the topic at all—Simmel, Veblen, and, more recently, Bourdieu come most readily to mind—they would place inordinate emphasis, to the exclusion of nearly all else, on the status differentiation functions of fashion.[2] Thus Simmel (1904), despite brilliant insights into the social psychology of fashion, posits in the end a classic "trickle-down" theory to describe the processes of emulation by which new fashions pass from the upper classes to the lower. In the course of their descent through the status hierarchy they are watered down and "vulgarized." As a result they lose their ability to register appropriate status distinctions and soon come to be regarded by the upper classes as unfashionable and "in bad taste." In this manner the conditions are set for a new fashion cycle to be launched.

Veblen (1899), as we know, pointed to how excessive expenditure on clothing and other finery, not to mention the built-in obsolescence achieved through functionally useless changes in fashion, served mainly to institutionalize the conspicuous consumption, waste, and leisure practices of the wealthy. With these the upper class could symbolically establish its superiority over persons of lesser means. Along similar lines, though more subtly, Bourdieu (1984) argues that "matters of taste," including certainly a well-honed fashion sensibility for distinguishing the chic from the tacky, comprise in large part the inherited "cultural capital" of dominant social classes in modern society. The privileged

1. In a fascinating work Lofland (1973, 29–91) characterizes public life in the preindustrial European city as being ruled by an "appearential ordering"; that is, despite great heterogeneity in social origins and economic circumstance, inhabitants of a city located each other as social actors almost exclusively in terms of appearance, i.e., the clothes and costuming they wore. Following industrialism, a "spatial ordering" (i.e., the different geographic locales the different social classes found themselves in at different times of the day, week, and year) assumed greater importance in the work of social location.

2. The *sans culottes* of the French revolution (literally "without breeches" but taken metaphorically to distinguish republicans from the silk-breeched aristocracy) are a particularly dramatic instance of this (Bush and London 1960).

possession of such capital, along with its judicious expenditure day in and day out in a thousand small ways, explains how dominant classes manage to reproduce themselves from generation to generation.

Sociologically appealing as this emphasis may seem, it is not one I share. Numerous telling rebuttals to an exclusively class-based theory of fashion are to be found in the literature (Blumer 1969a; Konig 1973; Wilson 1985; chapter 6 in this book) and cannot, given what is already a lengthy digression, be gone into here. Suffice it for present purposes merely to note that although what people wear and how they wear it can, indeed, reveal much regarding their social standing, this is not all that dress communicates, and under many circumstances it is by no means the most important thing communicated. To erect, therefore, a set of theoretical premises that comprehends but this sole dimension of clothing communications results in, much as if one deliberately set out to hobble language itself, an analytical impoverishment of a rich medium of human communication. With all due regard, then, for what Simmel, Veblen, Bourdieu, and others have taught us about the status differentiation functions of fashion and finery, what follows should not be read as confirmation of their theoretical positions. Rather, it should be viewed as exemplifying clothing's' cultural capacity to articulate yet another of the many existential ambivalences (a strategic one, to be sure) that pervade modern life.

To Be Me or Not Me

> The poorer kids want to look rich, and the richer kids want to look poor.
> a New York teenager to Sara Rimer, 1985

It is appropriate to begin with the possibly unanswerable query of what in Western culture accounts for ambivalence in registering status claims. Why do not all of us all of the time heed the admonition of Mr. Bialystock, a Mel Brooks's character in the film *The Producers*, who, peering from the window of his seedy theatrical office at the opulence of the Broadway theater crowd below, bellows, "That's right, if you've got it, flaunt it!" Part of the answer may have to do with simple considerations of social logistics. Were everyone constantly trying to claim superior status via opulence

of dress, immaculateness of grooming, and glitter of jewelry, the symbolic worth of such status markers would soon undergo—as indeed often happens—marked devaluation, thereby defeating the invidious ends they meant to serve. Some tacit regulatory mechanism affecting the occasions and manner of status display must therefore be brought into play if the game of invidious status competition is to retain even a modicum of symbolic integrity. In short, persons cannot be thrusting their best front forward at all times.

Ambivalence-generating constraints of this order on unabashed declarations of social superiority would seem to apply, in varying degree to be sure, to primitive and non-Western societies as much as to our own. Even the textbook exemplar case of status rivalry run amok, the potlach of the Kwakiutl wherein rivals exchange ever more prodigious gifts to a point of absolute impoverishment, is confined to but a few ceremonial occasions over the course of time.

The failure of social controls to check the excesses of purely invidious display can, as in our own society, unfortunately, have dire consequences well beyond the "merely symbolic." Recent newspaper stories reporting sharp increases in urban youth violence and homicide motivated by the desire to display expensive clothing attest to the problem. Lead paragraphs from two such accounts supply dramatic evidence.

> CHICAGO, Feb. 5—A 19-year-old youth who was slain Saturday for his fashionable warm-up jacket is the latest victim of what seems to be an increasingly pervasive kind of urban crime: robberies by young people willing to kill for clothes. . . .
>
> In Chicago and other cities, including Detroit, New York and Los Angeles, such incidents not only underscore the degree to which street crime and violence are now endemic to life in the inner city, but also serve as a perverse measure of the hottest local fashion trend. (Schmidt 1990)

> BALTIMORE—When 15-year-old Michael Thomas left home for school last May, he couldn't have been prouder. On his feet, thanks to his mother's hard work, were a pair of spanking new Air Jordans—$100 worth of leather, rubber and status that to today's youth are the Mercedes Benz of athletic footwear.
>
> The next day it was James David Martin, 17, who was strolling

down the street in Thomas' new sneakers, while Thomas lay dead in a field not far from his school. Martin was arrested for murder. . . .

Across the nation, parents, school officials, psychologists and even some children agree.

They say that today's youngsters, from New York's poverty ridden South Bronx to Beverly Hills, have become clothes fixated. They worry over them, compete over them, neglect school for them and sometimes even rob and kill for them. (Harris 1989)

An even more recent newspaper account (Goldern 1991) reports on the violence that has accompanied the adoption by inner-city youth gangs of the jackets and other team insignia of such NFL teams as the L.A. Raiders and Cleveland Browns.

These are, to be sure, extreme manifestations of the quest for status via clothing. Well short of such extremes, even were we to assume unlimited material resources for invidious display, much more than sheer numbers or the logistics of social exchange is involved in the aversion felt in Western culture toward too public, frequent, or obvious displays of social superiority. As with ambivalence toward the erotic (chapter 5), this can perhaps be traced ultimately to the ascetic element in the Judeo-Christian *Weltanschauung* with its praise of personal modesty, its other-worldly deference to the spiritual ennoblements of poverty, its mistrust of wealth, material possessions, and secular achievement. Inevitably, these historically persisting, if far from realized, values of Western civilization, cannot but influence us when, however indifferently or thoughtlessly, we try to decide on what to wear. Not that the issue of who we are and wish to be taken for is posed for us on each and every occasion in such stark and abstract terms. Rather, as with so many of the mundane decisions of life, these deeply embedded sentiments of the Judeo-Christian tradition find their secular equivalents in such lesser expressive postures as modesty, reticence, understatement, diffidence, etc. These, of course, are well inscribed symbolically in the prevailing dress codes of the West.[3]

Ironically, however, in the neverending dialectic of status claims

3. A recent men's fashion note (Hochswender 1991c) speaks to the point: "When designers make more clothes for the woods than for the nightclub, something is up. Burliness, honesty, naturalness and integrity—these are the qualities American men's wear designers celebrated in their fall showings last week. The new ideals were embodied in the reverse chic of a plaid hunter's jacket, the zippered

and demurrals, modesty and understatement in attire often come to be viewed as truer signs of superior social status than lavish displays of finery and bejeweled wealth. These latter, as we know, are usually taken as indicative of status posturing or, at best, a nouveau riche station. Such subtleties do not, of course, escape the notice of those who have a keen eye for status markers and, while lacking the wherewithal for opulent display, retreat to studied understatement in the hope of being taken for persons who because they've "got it" do *not* have to "flaunt it."

Even where new money excites a taste for ostentatious display, the impulse will often be resisted for fear that yielding to it will call down the opprobrium of being "vulgar nouveau riche." However, in its convoluted reflexivities fashion finds ways of grappling with this existential dilemma as well. The American designer Ralph Lauren, for example, himself a person of modest social origins, has built a vast manufacturing and retail empire on what has virtually become his trademark, making new wealth look like old (Coleridge 1988). Whether his fashions actually accomplish this—his "town and country" toned advertisements do not mention fashion as such but refer to achieving a certain life-style—is, needless to say, hard to determine.

When it comes to dress, then, it may fairly be said that vulgarity is often more sincere than reticence. Recall in this connection Chanel's disingenuous advice to her wealthy clients to dress "as plainly as their maids" and to wear cheap costume jewelry. She is also reputed to have advised them to wear real jewelry "as if it were junk."

Ostentation versus Understatement

The sartorial dialectic of status assumes many voices, each somewhat differently toned from the other but all seeking, however unwittingly, to register a fitting representation of self, be it by overplaying status signals, underplaying them, or mixing them in such a fashion as to intrigue or confound one's company. There is, first, the polar alternatives that perhaps underlie all variations in

workingman's sweater or the salesman's reversible balmacaan raincoat. In men's fashion, the predatory elegance of the white-collar criminal has had its day."

status representation, namely, proclaiming wealth or pretending poverty, often felt as the tension of ostentation versus understatement. Chanel's famous "little black dress" dating from the late 1920s is a classic instance of insinuating social superiority through the device of bedecking oneself in the raiments of penury. The fashion writer Anny Latour characterized this as "the art of dressing simply . . . and paying a great deal of money for the pleasure." Others referred to it as the "expensively poor" or "deluxe poor" look (Ashley 1972, 119). The Great Depression that followed seems to have contributed a perverse luster to its chic allure. As Hollander (1980, 385) notes in her perceptive discussion of the symbolic values attaching to color in dress:

> In America the Depression made elegant the "poor look," of which the little black dress was the herald. Black, used as a serious, modest color in conservatively cut daytime dresses suggesting a shop assistant, could, by the 1930s, seem as revolutionary and new as the slapdash, pale, bright, and shapeless dresses of the 1920s had been.
> . . . The emergence of the shop girl's simple black dress as a new and somewhat daring mode for leisured women was a striking sign of the spirit of the 1930s. Social consciousness was expressed, as before and since, in clothes of the utmost elegance.

The symbolic convolutions of the color black, particularly in regard to status claims, acquires added significance when we realize that only in the latter half of the 19th century did black come to be closely associated with domestic service and, to an extent, with the "lower orders" generally. Forty (1986, 82) points out that until well into the nineteenth century female servants in English households did not have a distinctive dress. But by about 1860 good prints had become so inexpensive that servants came to look very much like their mistresses, a circumstance that became the butt of cartoonists' jokes and humorous stories.

> Faced with this prospect and with servants who were seeking greater independence, mistresses began to insist upon uniforms for their maids, particularly parlor maids, who would be seen by visitors. From the 1860s it became normal for maids to wear black dresses, with white caps and white aprons, the distinctive garb of the domestic servant well into the twentieth century.

Again, Chanel's little black dress and her injunction to women to dress as plainly as their maids attest to fashion's facility at appropriating and inverting status symbols.

A more recent, though hardly as singular, example of the rich-poor inversion in dress and the penchant for suggesting elevated status by abjuring (in this case, abusing) traditional insignia of wealth is provided by the well-known designer Karl Lagerfeld.

> Beyond his work with fur, what Lagerfeld does is rearrange our ideas of basic bourgeois dress. Without ever having been a "fashion revolutionary," he has had an enormous impact on the way women wear clothes. At Fendi [a leading Italian furrier], he uses, for instance, crushed Persian lamb so that it looks like flannel, shaves mink, mixes fake with real fur, and makes sweaters out of sable. This lack of reverence toward one of wealth's great symbols has been seen elsewhere now, but Lagerfeld pioneered the trend. (Dyansky 1985)

Overdressing versus Underdressing

Another status attitude conveyed by clothing concerns "overdressing" for the occasion as against, what is somewhat more common in democratic society, intentionally "underdressing" for it. Depending on the worldliness of one's company, each is subject to the numerous hazards of status misreading and misinterpretation, which is perhaps why most persons try to comply with whatever the reigning dress code decrees as appropriate for the occasion. Still, calculated underdressing, especially among men and— ironically, though understandably—mainly in cosmopolitan upper-middle-class circles, is much more common in contemporary America than is its opposite. Thus, wearing jeans, sweats, or jogging suits to all but the most formal of affairs, while perhaps not quite the norm, seems to attract a good deal less attention than does a too fastidious attachment to such traditional dress proprieties as the man's three-piece suit or the women's cocktail dress. It is this conventionalization of the indifferent posture, this anti-conformist conformity, that sets the stage for further inversions and convolutions in status signaling, some of which come to serve in short order as tokens of the *new* fashion. The American writer Nathaniel West is said to have caused a considerable stir in Ameri-

can expatriate circles in Paris in the 1920s and started something of a minifashion when he appeared among his coarsely clad bohemian writer friends in tuxedo and bowler hat and carrying a rolled black umbrella.

The tuxedo itself makes for an interesting case history of how a calculated affront to reigning status conventions can acquire with time the same symbolic value it sets out to derogate. Introduced in the late 1880s at gatherings held at the palatial Tuxedo Park, New York, estate of tobacco tycoon Pierre Lorillard, it was regarded initially as something of a populist slap at the reigning men's formal attire of the time, the tail cutaway worn over a stiff white shirtfront with white bow tie (De Gennaro 1986). But by the time of the First World War, the tuxedo's anticonformist origins had largely been forgotten and wearing it had become de rigueur for formal occasions; so much so that men appearing in tails were thought gauche, or at best terribly old-fashioned.

Disingenuous Mistakes

A symbolic nuance closely akin to the one-upmanship of subtly claiming elevated status by underdressing for the part is that of disingenuously "doing something wrong" with one's dress or resorting to some other form of vestmental imperfection for the purpose of enhancing status. A missing button on the sleeve of a man's jacket, a foppish handkerchief dangling from the breast pocket, a tie worn slightly askew, the mismatched socks of teenagers, an article of clothing whose color or pattern clashes with the dominant tones of a women's outfit—all are examples of the trope, provided, of course, the error is calculated and not inadvertent. At the textual level this is, perhaps, an instance of a code violation serving to reinvigorate the hierarchical principle structuring the code's symbolic legitimacy, i.e., an exception that proves the rule. The Italian designer Nino Cerruti gives pointed expression to this stratagem:

> "For a man to be elegant, he must dress simply with some mistakes," says Cerruti, whose clothes are carried at Madonna Man in Beverly Hills. "There is nothing less elegant than to be too elegant."
> (Hawkins 1978)

Beard stubble, a popular disingenuous mistake of the late 1980s. *Courtesy of Perry Ellis International*

Of course, what may at first seem a person's strategic mistake in dress may very soon come to be absorbed into the reigning fashion per se, a circumstance that in the long run neutralizes the status claim sought via the device.[4] Still, as Kennedy Fraser (1981, 210) had occasion to observe in her review of British fashions of the late 1970s, "one of the first principles of style today [is]: that however much the wearer cares or spends, the clothes should never look entirely *serious*" [emphasis in original]. One must not, however, infer from Fraser's observation that a status-sensitive unseriousness is new to fashion. It has manifested itself many times during the course of the West's seven centuries of involvement with fashion.[5] The renown of designers like Chanel, Schiaparelli, and, more recently, Lacroix derives in no small part from their imaginative use of it.

BLUE JEANS

The new clothes [jeans] express profoundly democratic values. There are no distinctions of wealth or status, no elitism; people confront one another shorn of these distinctions.
Charles A. Reich, *The Greening of America*

Throughout the world, the young and their allies are drawn hypnotically to denim's code of hope and solidarity—to an undefined vision of the energetic and fraternal Americanness inherent in them all.
Kennedy Fraser, "That Missing Button"

Karl Lagerfeld for Chanel shapes a classic suit from blue and white denim, $960, with denim bustier, $360, . . . and denim hat, $400. All at Chanel Boutique, Beverly Hills.
Photograph caption in *Los Angeles Times Magazine* for article "Dressed-Up Denims," April 19, 1987

4. Mistakes in dress can be of two sorts, those intended, as here, and those unintended. For some observations on the latter and on the special vulnerabilities of women to them, see the discussion of ambivalences of gender (chapter 3).

5. Many contemporary punk-influenced stylings are of this ilk, as were certainly those of the outrageously garbed young men and women (*les incroyables* and

Since the dawn of fashion in the West some seven hundred years ago, probably no other article of clothing has in the course of its evolution more fully served as a vehicle for the expression of status ambivalences and ambiguities than blue jeans. Some of the social history supporting this statement is by now generally well known.[6] First fashioned in the mid-nineteenth-century American west by Morris Levi Strauss, a Bavarian Jewish peddler newly arrived in San Francisco, the trousers then as now were made from a sturdy, indigo-dyed cotton cloth said to have originated in Nimes, France. (Hence the anglicized contraction to *denim* from the French *de Nimes*. A garment similar to that manufactured by Levi Strauss for goldminers and outdoor laborers is said to have been worn earlier in France by sailors and dockworkers from Genoa, Italy, who were referred to as "genes"; hence the term *jeans*. The distinctive copper riveting at the pants pockets and other stress points were the invention of Jacob Davis, a tailor from Carson City, Nevada, who joined the Levi Strauss firm in 1873, some twenty years after the garment's introduction.

More than a century went by, however, before this working-man's garment attained the prominence and near-universal recognition it possesses today. For it was not until the late 1960s that blue jeans, after several failed moves in previous decades into a broader mass market, strikingly crossed over nearly all class, gender, age, regional, national, and ideological lines to become the universally worn and widely accepted item of apparel they are today. And since the crossover, enthusiasm for them has by no means been confined to North America and Western Europe. In former Soviet bloc countries and much of the Third World, too, where they have generally been in short supply, they remain highly sought after and hotly bargained over.

A critical feature of this cultural breakthrough is, of course, blue jeans' identity change from a garment associated exclusively

les merveilleuses) of postrevolutionary France, ca. 1795–1800 (Batterberry and Batterberry 1977, 199).

6. Excellent, sociologically informed accounts of the origins and social history of blue jeans are to be found in Belasco (n.d.) and Friedmann (1987).

with work (and hard work, at that) to one invested with many of the symbolic attributes of leisure: ease, comfort, casualness, sociability, and the outdoors. Or, as the costume historians Jasper and Roach-Higgins (1987) might put it, the garment underwent a process of cultural authentication that led to its acquiring meanings quite different from that with which it began. In bridging the work/leisure divide when it did, it tapped into the new, consumer-goods-oriented, postindustrial affluence of the West on a massive scale. Soon thereafter it penetrated those many other parts of the world that emulate the West.

But this still fails to answer the questions of why so rough-hewn, drably hued, and crudely tailored a piece of clothing should come to exercise the fascination it has for so many diverse societies and peoples, or why within a relatively short time of breaking out of its narrow occupational locus it spread so quickly throughout the world. Even if wholly satisfactory answers elude us, these questions touch intimately on the twists and turns of status symbolism I have spoken of.

To begin with, considering its origins and longtime association with workingmen, hard physical labor, the outdoors, and the American West, much of the blue jeans' fundamental mystique seems to emanate from populist sentiments of democracy, independence, equality, freedom, and fraternity. This makes for a sartorial symbolic complex at war, even if rather indifferently for nearly a century following its introduction, with class distinctions, elitism, and snobbism, dispositions extant nearly as much in jeans-originating America as in the Old World. It is not surprising, therefore, that the first non–"working stiffs" to become attached to blue jeans and associated denim wear were painters and other artists, mainly in the southwest United States, in the late 1930s and 1940s (Friedmann 1987). These were soon followed by "hoodlum" motorcycle gangs ("bikers") in the 1950s and by New Left activists and hippies in the 1960s (Belasco n.d.). All these groups (each in its own way, of course) stood strongly in opposition to the dominant conservative, middle-class, consumer-oriented culture of American society. Blue jeans, given their origins and historic associations, offered a visible means for announcing such antiestablishment sentiments. Besides, jeans were cheap, and, at least at first, good fit hardly mattered.

Whereas by the late 1950s one could in some places see jeans worn in outdoor play by middle-class boys, until well into the 1960s a truly ecumenical acceptance of them was inhibited precisely because of their association with (more, perhaps, through media attention than from firsthand experience) such disreputable and deviant groups as bikers and hippies. Major sales and public relations campaigns would be undertaken by jeans manufacturers to break the symbolic linkage with disreputability and to convince consumers that jeans and denim were suitable for one and all and for a wide range of occasions (Belasco n.d.). Apparently such efforts helped; by the late 1960s blue jeans had achieved worldwide popularity and, of greater relevance here, had fully crossed over the occupation, class, gender, and age boundaries that had circumscribed them for over a century.

What was it—and, perhaps, what is it still—about blue jeans? Notwithstanding the symbolic elaborations and revisions (some would say perversions) to which fashion and the mass market have in the intervening years subjected the garment, there can be little doubt that at its crossover phase its underlying symbolic appeal derived from its antifashion significations: its visually persuasive historic allusions to rural democracy, the common man, simplicity, unpretentiousness, and, for many, especially Europeans long captivated by it, the romance of the American west with its figure of the free-spirited, self-reliant cowboy.[7]

But as the history of fashion has demonstrated time and again, no vestmental symbol is inviolable. All can, and usually will be, subjected to the whims of those who wish to convey more or different things about their person than the "pure" symbol in its initial state of signification communicates. Democratic, egalitarian sentiments notwithstanding, social status still counts for too much in Western society to permanently suffer the proletarianization that an unmodified blue-jean declaration of equality and fraternity projected. No sooner, then, had jeans made their way into the

7. This is not to put forward some absurd claim to the effect that everyone who donned a pair of jeans was swept up by this imagery. Rather, it is to suggest that it was such imagery that came culturally to be encoded in the wearing of blue jeans (Berger 1984, 80–82), so that whether one wore them indifferently or with calculated symbolic intent, imitatively or in a highly individual manner, they would "on average" be viewed in this light.

mass marketplace than myriad devices were employed for muting and mixing messages, readmitting evicted symbolic allusions, and, in general, promoting invidious distinctions among classes and coteries of jean wearers. Indeed, to the extent that their very acceptance was propelled by fashion as such, it can be said an element of invidiousness was already at play. For, other things being equal and regardless of the "message" a new fashion sends, merely to be "in fashion" is to be one up on those who are not as yet.[8]

Elite vs. Populist Status Markers

Beyond this metacommunicative function, however, the twists, inversions, contradictions, and paradoxes of status symbolism to which blue jeans subsequently lent themselves underscore the subtle identity ambivalences plaguing many of their wearers. In a 1973 piece titled "Denim and the New Conservatives," Kennedy Fraser (1981, 92) noted several such, perhaps the most ironic being this:

> Some of the most expensive versions of the All-American denim theme have come bouncing into our stores from European manufacturers. The irresistible pull of both European fashion and denim means that American customers will pay large sums for, say, French blue jeans despite the galling knowledge that fashionable young people in Saint-Tropez are only imitating young people in America, a country that can and does produce better and cheaper blue jeans than France.

By 1990 a nearly parallel inversion seemed about to occur in regard to the garment's post-1950s image as leisure wear, al-

8. From this perspective, assumed by such important French critics as Barthes (1983) and Baudrillard (1984), all fashion, irrespective of the symbolic content that animates one or another manifestation of it, gravitates toward "designification" or the destruction of meaning. That is to say, because it feeds on itself (on its ability to induce others to follow the fashion "regardless") it soon neutralizes or sterilizes whatever significance its signifiers had before becoming objects of fashion. Sheer display displaces signification; to take the example of blue jeans, even people hostile to their underlying egalitarian message can via fashion's mandate wear them with ease and impunity and, contrary to the garment's symbolic anti-invidious origins, score "status points" by doing so. This argument is powerful but in my view posits, in a manner similar to the claim that fashion is nothing more than change for the sake of change, too complete a break between the symbolic content of culture and the communication processes that embody and reshape it.

though for destinations other than fields and factories. With the introduction of men's fall fashions for the year featuring "urban denim," a spokesman for the Men's Fashion Association said (Hofmann 1990): "It's not just about cowboys and country and western anymore. It used to be that denim meant play clothes; now men want to wear it to the office the next day."

Framing the garment's status dialectic was the contest of polarities, one pole continuing to emphasize and extend blue jeans' "base-line" symbolism of democracy, utility, and classlessness, the other seeking to reintroduce traditional claims to taste, distinction, and hierarchical division. (Any individual wearer, and often the garment itself, might try to meld motifs from both sides in the hope of registering a balanced, yet appropriately ambivalent, statement.)

Conspicuous Poverty: Fading and Fringing

From the "left" symbolic (and not altogether apolitical) pole came the practice of jean fading and fringing. Evocative of a kind of conspicuous poverty, faded blue jeans and those worn to the point of exposing some of the garment's warp and woof were soon more highly prized, particularly by the young, than new, well-blued jeans. Indeed, in some circles worn jeans commanded a higher price than new ones. As with Chanel's little black dress, it cost more to look "truly poor" than just ordinarily so, which new jeans by themselves could easily accomplish. But given the vogue that fading and fringing attained, what ensued in the marketplace was predictable: Jeans manufacturers started producing prefaded, worn-looking, stone- or acid-washed jeans.[9] These obviated, for the average consumer if not for the means connoisseur disdainful of such subterfuge, the need for a long break-in period.

Labeling, Ornamentation, and Eroticization

From the "right" symbolic pole emerged a host of stratagems and devices, all of which sought in effect to de-democratize jeans while

9. A yet later variation on the same theme was "shotgun washed" jeans manufactured by a Tennessee company that blasted its garments with a twelve-gauge shotgun (Hochswender 1991b).

Eroticizing the once "honest workingman's garment": blue jeans, shortened and rolled up. *Courtesy of Tweeds, Inc.*

capitalizing on the ecumenical appeal they had attained: designer jeans, which prominently displayed the label of the designer; jeans bearing factory sewn-in embroidering, nailheads, rhinestones, and other decorative additions; specially cut and sized jeans for women, children, and older persons; in general, jeans combined (with fashion's sanction) with items of clothing standing in sharp symbolic contradiction of them, e.g., sports jackets, furs, dress shoes, spiked heels, ruffled shirts, or silk blouses.

Paralleling the de-democratization of the jean, by the 1970s strong currents toward its eroticization were also evident. These, of course, contravened the unisex, de-gendered associations the garment initially held for many: the relative unconcern for fit and emphasis on comfort; the fly front for both male and female; the coarse denim material, which, through it chafed some, particularly women, was still suffered willingly. Numerous means were found to invest the jean and its associated wear with gender-specific, eroticized meaning. In the instance of women—and this is more salient sociologically since it was they who had been de-femininized by donning the blatantly masculine blue jeans in the first place—these included the fashioning of denim material into skirts, the "jeans for gals" sales pitches of manufacturers, the use of softer materials, cutting jeans so short as to expose the buttocks, and, in general, the transmogrification of jeans from loose-fitting, baggy trousers into pants so snugly pulled over the posterior as to require some women to lie down to get into them. So much for comfort, so much for unisexuality! Interestingly, in the never-ending vestmental dialectic on these matters baggy jeans for women again became fashionable in the mid-1980s.

Designer Jeans

Of all of the modifications wrought upon it, the phenomenon of designer jeans speaks most directly to the garment's encoding of status ambivalences. The very act of affixing a well-known designer's label—and some of the world's leading hautes couturiers in time did so—to the back side of a pair of jeans has to be interpreted, however else it may be seen, along Veblenian lines, as an instance of conspicuous consumption; in effect, a muting of the underlying rough-hewn proletarian connotation of the garment

through the introduction of a prominent status marker.[10] True, sewing an exterior designer label onto jeans—a practice designers never resort to with other garments—was facilitated psychologically by the prominent Levi Strauss & Co. label, which had from the beginning been sewn above the right hip pocket of that firm's denim jeans and had over the years become an inseparable part of the garment's image. It could then be argued, as it sometimes was, that the outside sewing of a designer label was consistent with the traditional image of blue jeans. Still, Yves Saint Laurent, Oscar de la Renta, or Gloria Vanderbilt, for that matter, are not names to assimilate easily with Levi Strauss, Lee, or Wrangler, a distinction hardly lost on most consumers.

But as is so characteristic of fashion, every action elicits its reaction. No sooner had the snoblike, status-conscious symbolism of designer jeans made its impact on the market than dress coteries emerged whose sartorial stock-in-trade was a display of disdain for the invidious distinctions registered by so obvious a status ploy. This was accomplished mainly through a demonstration of hyperloyalty to the original, underlying egalitarian message of denim blue jeans. As Kennedy Fraser (1981, 93) was to observe of these countercyclicists in 1973:

> The denim style of the more sensitive enclaves of the Village, the West Side, and SoHo is the style of the purist and neo-ascetic. Unlike the "chic" devotee of blue jeans, this loyalist often wears positively baggy denims, and scorns such travesties as embroideries and nailheads. To underline their association with honesty and toil, the denims of choice are often overalls.

10. Everyone, without exception, whom I interviewed and spoke with in the course of my research on fashion (designers, apparel manufacturers, buyers, persons from the fashion press, fashion-conscious laypersons) interpreted designer jeans in this light. Most felt that status distinctions were the *only* reason for designer jeans because, except for the display of the designer label, they could detect no significant difference between designer and nondesigner jeans. Not all commentators, however, are of the opinion that the prominent display of an outside label can be attributed solely to invidious status distinctions. Some (Back 1985) find in the phenomenon overtones of a modernist aesthetic akin, for example, to Bauhaus design, exoskeletal building construction, action painting, and certain directions in pop art wherein the identity of the creator and the processual markings of his/her creation are visibly fused with the art work itself.

Not long after, the "positively baggy denims" of which Fraser speaks—this antifashion riposte to fashion's prior corruption of denim's 1960s-inspired rejection of status distinctions—were themselves, with that double reflexive irony at which fashion is so adept, assimilated into the fashion cycle. Then those "into" denim styles could by "dressing down" stay ahead of—as had their older, first-time-around denim-clad siblings of the sixties—their more conformist, "properly dressed" alters.

CONCLUSION

And so, with Hegelian interminability, do the dialectics of status and antistatus, democracy and distinction, inclusiveness and exclusiveness pervade fashion's twists and turns; as much, or even more, with the workingman's humble blue jeans as with formal dinner wear and the evening gown.

But such is fashion's way. If it is to thrive it can only feed off the ambiguities and ambivalences we endure in our daily lives and concourse, not only over those marks of social status considered here but equally over such other key identity pegs as age, gender, and sexuality, to mention but the most obvious. Were it the case, as some scholars have maintained, that fashion's sole symbolic end was registering and re-registering invidious distinctions of higher and lower, or better and lesser—that is, distinctions of class and social status—it would hardly have enough "to talk about"; certainly not enough to account for its having thrived in Western society for as long as it has. But, as we have already seen and will see again in chapters to follow, it does have more to say: about our masculinity and femininity, our youth and age, our sexual scruples or lack thereof, our work and play, our politics, national identity, and religion. This said, one need not take leave of what has engaged us here, that rich symbolic domain that treats of the deference and respect we accord and receive from others (what Max Weber meant by *status*), in order to appreciate that fashion is capable of much greater subtlety, more surprises, more anxious backward glances and searching forward gazes than we credit it with.

5 Ambivalences of Sexuality, The Dialectic of the Erotic and the Chaste

Of the numerous identity ambivalences in dress discussed and alluded to thus far, probably none can compare in prominence or historic persistence to clothing's preoccupation with matters of sexual availability and erotic taste. Indeed, many scholars (Bergler 1953; Flugel 1930; Konig 1973; Steele 1985)—and, of course, countless laypersons as well—are of the opinion that this is essentially what fashion in clothing is all about, namely, the never-ending search, the burden of which has in Western culture been so lopsidedly assigned to women, for ways to make oneself sexually alluring. That sex appeal, however muted or amplified, is not *solely* what clothing and fashion are about is fundamental to my analysis. But that it has over the centuries counted for a very great deal cannot for a moment be gainsaid, even if, as with so much else pertaining to dress, it has since the eighteenth century fallen more to women's clothing than men's to cater to erotic interest.

Indeed, so inseparably intertwined are woman's sexuality and woman's dress in the West that Anne Hollander (1980), in her seminal book *Seeing through Clothes,* is able to argue persuasively that in Western art over the centuries the ever-changing visual conception of the female nude has been molded primarily by the prior image of her clothed in the reigning fashion of the time. In other words, artists from Titian and Rubens to Modigliani and Mueller have rendered female nudity to conform with the aesthetic of favored dress styles of the period rather than with some historically transcendent conception of "the nude." From this it is but a thought away to the recognition that the way the nude is seen in imagination and on the page is also likely to replicate the ideal form bestowed on woman's body by the dress styles of the day.

THE THEORY OF THE
SHIFTING EROGENOUS ZONE

Among those explanations of fashion which locate its source in a desire to heighten sexual allure, the best known is the Theory of the Shifting Erogenous Zone. The most fully developed statement of it, notwithstanding its author's failure to designate his explanation as such, is to be found in the enduringly learned and insightful book *The Psychology of Clothes* by the psychoanalytic psychologist J. C. Flugel (1930). As do I, Flugel regarded ambivalence, specifically that generated through the psychic clash of modesty and display, as the main mover in fashion change. He saw this ambivalence manifesting itself in dress in the areas of social status rivalry and sexuality. It is, however, in regard to the latter that the thesis most often associated with his name was enunciated.

> But perhaps the most obvious and important of all the variations of fashion is that which concerns the part of the body that is most accentuated. Fashion, in its more exuberant moments is seldom content with the silhouette that Nature has provided, but usually seeks to lay particular stress upon some single part or feature, which is then treated as a special centre of erotic charm. But when modesty predominates [the tension of modesty versus display was for Flugel *the* key force in fashion] these same centres of potential greater attractiveness become the objects of particular concealment and suppression. (160)

Flugel goes on to show how woman's dress since the middle ages has periodically abandoned, usually in conjunction with some historically generated instability in the balance of modesty and display tendencies of persons, one "most accentuated" body part for another. No period-fixated historian averse to treating developments less than a century old, Flugel included in his purview the very times in which he wrote, the late 1920s, when the short-skirted flapper styles that earlier in the decade had virtually revolutionized women's dress were about to give way.

> The fashions of the last few years have thus been based upon a certain upward displacement of modesty, an accentuation of the body rather than of clothes, an idealisation of youth rather than of maturity, and a displacement of erotic value from the trunk to the limbs. We shall do

well to contemplate this picture while it lasts, for we are perhaps at a turning of the ways which will soon hide it from our gaze. A reaction appears imminent, and has indeed already begun. (162)

Flugel was, of course, not far wrong. In the wake of the 1929 stock market crash and ensuing worldwide depression a reaction did indeed set in: hemlines dropped, though not nearly to pre-World War I ground level; erotic attention was redirected to the upper torso through the devices of décolletage.

Given the phrase's apt, suitably medicalized, capturing of Flugel's ideas, it is easy to understand why the Theory of the Shifting Erogenous Zone would have been attributed to him. Indeed, scholarly writers on fashion have in the intervening sixty-some years almost universally attributed the theory and its naming to him. Yet, interestingly, the phrase "shifting erogenous zone" appears nowhere in *The Psychology of Clothes* and, as far as I have been able to determine, was neither originated nor later appropriated by Flugel.[1] Still, it clearly would not be amiss to assign the ideas associated with the theory to him.

The phrase "shifting erogenous zone" in reference to fashion occurs most prominently, although perhaps not initially, in the writings of the noted British costume historian Sir James Laver. While the words may be Laver's—he takes no credit for them, attributing them rather to unnamed "psychologists"—he renders the underlying theory with a good deal less subtlety than did Flugel. Consider a characteristic reference of Laver's (1969, 241):

> If the psychologists' theory of the Shifting Erogenous Zone can be accepted, once a focus of interest loses its appeal another one has to be found. In the early 1930s the emphasis shifted from the legs to the back. Backs were bared to the waist and, indeed, many of the dresses of the period look as if they had been designed to be seen from the rear. Even day dresses had a slit up the back, and the skirt was drawn tightly over the hips so as to reveal, perhaps for the first time in history, the shape of the buttocks.

1. A similar monumental misattribution in the social sciences involves the increasingly popular, by now part of the lexicon of everyday speech, "significant other." The term is widely attributed to George Herbert Mead, specifically to his book *Mind, Self, and Society*. In fact it appears nowhere therein or, according to those who have investigated the matter, in any of Mead's works.

Before considering some specific shortcomings of the Theory of the Shifting Erogenous Zone, it is worth noting how it, or at least Flugel's more sophisticated version, differs from my own approach to the problem of fashion's sources. First and foremost, whereas Flugel sees ambivalence in dress emanating solely from the psychic clash of modesty and display, I see it as a more general condition obtaining *wherever* and *whenever* meanings bearing on social identity are at cross-purposes. This implies that to the extent dress is capable of embodying meaning (although its capacities in this regard are far from limitless—see chapter 1), it can be assailed by ambivalence over many different kinds of identity issues (e.g., political, religious, ethnic, cultural, regional), not just those resulting from the subjective tension of modesty and display.[2] To limit the derivation of fashion's orbit to the latter does indeed constrict its applicability to issues of status rivalry and sexual attractiveness, which is probably why *The Psychology of Clothes* deals so exclusively with them, especially the latter.

Second, as a psychologist and, moreover, a psychoanalytically oriented one, Flugel's distinct tendency is to locate the fulcrum for ambivalence in the individual psyche, where it is seen to function as an almost autonomous psychogenic entity. This is not to say Flugel is unaware of or indifferent to clothing's sociocultural contexts. No reader of *The Psychology of Clothes* could possibly come away with such an impression. In many places he points to how the class rivalries, material riches, courtship practices, marital institutions, sexual mores, etc., of European society have engaged, enlivened, and often exacerbated the ambivalence of modesty versus display he finds at the very heart of fashion. Still, his theoretical commitments, insofar as represented by what has come to be know as the Theory of the Shifting Erogenous Zone, are clearly toward conceiving of an ambivalence-driven fashion in terms of psychically occasioned instabilities rather than culturally derived and symbolically negotiated identity disjunctions. My own preference, needless to say, is to place considerably greater emphasis on the latter. The notion of symbolically inscribed *social*

2. A number of these other issues bearing on social identities are discussed in chapter 8.

identity serves, as I see it, as a necessary conceptual bridge between the person's subjective vestmental tendencies and the culture that defines and frames them. Put more crudely, there would be no ambivalence for fashion to fasten onto were it not for the crosscurrents of meaning that swirl about in, and actually constitute, modern culture.

Plausibly as the shifting erogenous zone theory may strike one, then, it suffers some serious deficiencies. Besides unnecessarily confining fashion theory to the realm of sexuality, within that realm it treats as biologically foreordained and nonproblematic Western culture's conventional rendering of the structure of sexual interest and motivation, i.e., men in women's erogenous zones with no equivalent allowance for women in men's (that is, assuming erogenous zones are universally the libido-arresting objects Flugel and Laver make them out to be). Moreover, while it is true(different fashions do sometimes highlight a distinctive portion of the sexual anatomy, the presumption that they do so to the relative exclusion of other erogenous zones—or that wearers and viewers of clothes react to them in this way—is on the face of it farfetched (see Lowe and Lowe 1985)) And while it is also true that periodic shifts in collective attention from one erogenous zone to another may be brought about by clothing fashions, why the specific move from one localized zone to another? From bosom to buttocks, let us say, and not to abdomen? Is this purely a matter of some designer's whim, or are there deeper psychic or, more likely, psychocultural forces at play that influence the direction of the shift? The Theory of the Shifting Erogenous Zone provides little, if any, enlightenment on these questions.

Finally, what are the erogenous zones? Are they, as the theory's implicit biological determinism would lead one to believe, the same everywhere? For all time? Why, then, do some African peoples find sexual excitement in distended lips whereas those in the West find them grotesque? Or, what accounts for the Chinese fascination with women's feet and the Japanese with the back of a woman's neck, "zones" Occidentals remain indifferent to or may actually find repugnant? Further, if persons are destined to tire of a vestmentally featured erogenous zone, why did not the Chinese and Japanese tire of theirs over the centuries, as the West has with its in rapid

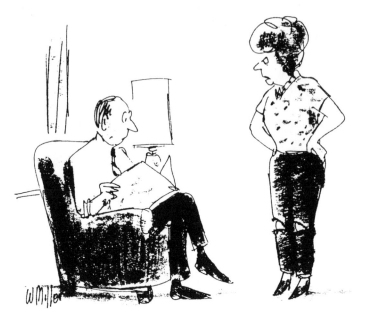

"Knees peeking out of jeans are sexy, but what would you know?"

Drawing by W. Miller; © 1987 The New Yorker Magazine, Inc.

succession from one period to the next? Questions of cultural relativism and gender stereotyping are almost impossible to accommodate in the shifting erogenous zone theory of fashion change.

THE EROTIC-CHASTE DIALECTIC, NOTES ON SYMBOLIC FORM

It is, however, to the credit and clear vision of the proponents of one or another erotically based theory of fashion, including certainly Flugel and Laver, that they are extremely loath to claim it is wholly some raw concupiscent impulse that women's clothing means to address. Obviously, elements of concealment, disguise, denial, and calculated ambiguity also enter the equation and form an integral part of the erotic dialectic emanating from much clothing. More than ample evidence of this abounds in daily life,

history, and the arts. I cite the following, less by way of substantiating a too obvious condition than to convey some idea of the sorts of erotically tinged subtleties and ambiguities I have in mind:

> In explaining his sliver-of-bare-midriff evening gown designs for Spring 1990 the American designer Calvin Klein is reported as saying "It's sexy but it's not too revealing. A woman could wear these dresses in a public place like a restaurant without attracting too much attention. [It's] the next step in body-conscious dressing— showing some skin but not too much." (Morris 1989b)
>
> Costumer Lisa Jensen, the person responsible for Michelle Pfeiffer's provocative wardrobe for the motion picture *The Fabulous Baker Boys* in which Pfeiffer plays a sexy torch singer, relates how she achieved this effect for Pfeiffer by "following the golden rule of sex appeal: Don't show it all. . . . Although she [Pfeiffer's character] has an ideal body, she avoids wearing anything obviously sexy, like the predictable, slit-to-the-thigh [skirt]. . . . You don't always have to go for massive amounts of flesh pushed together. You should play hide-and-seek with the body." (Goodwin 1989)[3]

These examples, though, pale to insipidity compared to what remains perhaps the most striking example in Western art of erotic-chaste tension, the famous fifteenth-century painting *Virgin and Child* by Jean Fouquet. There an amply cloaked, chaste-visaged Mary, the model for whom was Agnes Sorel, mistress to Fouquet's patron Charles VII of France, is shown haughtily baring from within a tightly laced bodice a breast of extraordinary voluptuousness to the infant Jesus seated upright on her knee.

As with gender and social status, the dialectic of eroticism and modesty in dress strikes many different chords. Although falling within the same broad spectrum, they are sufficiently distinct in expressive connotation to merit delineating several here. One might cite, for example, the oppositions of chaste-promiscuous (sometimes alluded to as the "madonna-whore" syndrome), straight-kinky, unadorned-glamorous, reticent-forward, innocent-experienced, refined-brash, open-guarded, spiritual-corporeal, etc. Again, there is almost no end to the more or less minor, though finally meaningful, symbolic oppositions of erotic import with which clothing has

3. I thank Jacqueline Wiseman for calling my attention to the newspaper article from which this example is drawn.

toyed over the centuries. But that an erotic value can, however imprecisely and variably from one period to another, be communicated to clothing viewers is evident from experience alone. How this is done, however, poses the more difficult analytical problem. It is to this I now wish to turn.

Without attempting a full analysis of the issue here (see chapter 1) I would, in line with Murray Wax's (1957, 588–93) early seminal writing on the topic and, more recently, that of Marshall Sahlins (1976), suggest that such *apparel-receptive* values as "chaste" or "open" or "refined" (along with their antinomies) come through some complex cognitive process of symbolic linkage to be associated with certain visual design features.[4] To a lesser degree, they connect with tactile and olfactory qualities as well.[5] In his discussion of cosmetics and grooming, Wax points to such features as casualness and control, exposure and concealment, and plasticity and fixity. The modern brassiere, for example, can be seen as an instance of the erotic-chaste dialectic utilizing the formal design feature of concealment versus exposure:

> [It] conceal[s] the bosom from view. On the other hand, the brassiere makes the bosom more conspicuous, so that, even beneath several layers of clothing, the onlooker can appreciate the feminine form. (589)

Analogous effects are, of course, obtained by the thigh-high slit in the otherwise severely tailored skirt and the slightly misaligned blouse button whose fastening tugs revealingly at the bosom. Earlier in this century, before women's hemlines began their ascent from ground level, "a glimpse of stocking" was, as Cole Porter put it in the thirties musical *Anything Goes,* "looked on as something shocking." A more recent example of the erotic-modest dialectic is

4. In his discussion of the "American Clothing System" Sahlins (1976, 179–204) from an avowedly structuralist perspective proposes that such formal features as color (e.g., light vs. dark), hue (bright vs. dull), texture (rough vs. smooth), direction (horizontal vs. vertical), and line (straight vs. curved) all serve to encode in systematic ways (of which we are rarely conscious, however) fundamental cultural distinctions of gender, status, age, occupation, life-style, ethnicity, etc. To these there must be added, especially for women's dress, the matter of sexuality.

5. For example, conventional wisdom regarding perfume has it that sweet floral scents connote modesty whereas oily, musk-tinged ones signify sexiness.

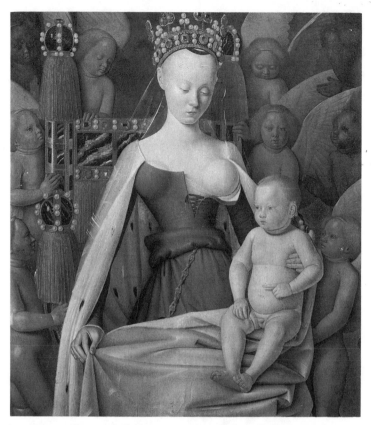

Jean Fouquet, *Virgin and Child. Courtesy of Royal Museum of Fine Arts, Antwerp*

found, as it nearly always can in just about any fashion publication, in the fashion pages of the *Los Angeles Times* (McColl 1982):

> At Saint Laurent, Dior, Ungaro and Givenchy, the new erogenous zones are the bare back and the derriere. All four collections had covered-up evening dresses in velvet or satin. Once the mannequin turns around, the back is completely bared with hips emphasized by an oversized bow or bustle.

The resort to veiling and translucent fabrics is often made to serve a similar purpose, as was recently noted by *The New Yorker*'s fashion writer (Brubach 1989a).

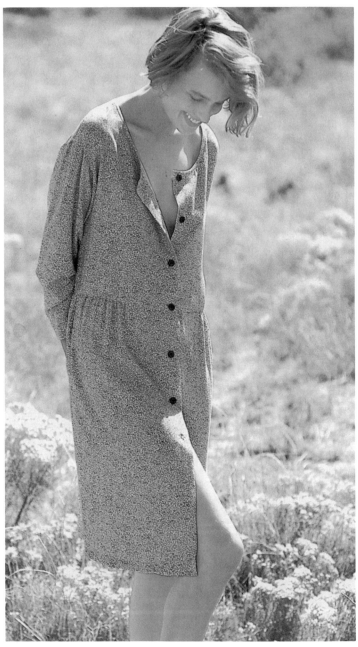

Familiar turns in the Erotic-Chaste Dialectic: The unbuttoned button. *Courtesy of Tweeds, Inc.*

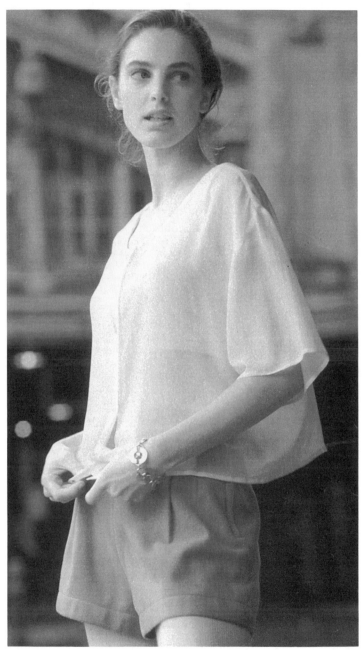

Familiar turns in the Erotic-Chaste Dialectic: Translucent fabric. *Courtesy of Tweeds, Inc.*

Like Lagerfeld and Chanel before him, Adolfo has done a group of
revealing cocktail dresses veiled with matching chiffon overdresses—
an ingenious and elegant way for older women to look discreet and
sexy at the same time.

In all such instances what is encoded is neither eroticism nor
modesty per se but the existential tension of their opposition. Of
course, at different times in different places the tension will be dif-
ferently weighted toward one pole as against the other. In any case,
the balance or imbalance registered communicates something real
about the wearer's identity in regard to sexuality.

Another important visual design feature of the erotic-chaste
dialectic—which, incidentally, operates across the whole spec-
trum of clothing's ability to communicate social identities—is that
of symbolically compressing "large" meanings into the design of
some single piece of apparel. Women's shoes are an exemplar; for
example, sling-backs are said to signify décolletage; oxfords, non-
sexual seriousness; low-cut uppers, breast cleavage; stiletto heels,
kinky sexuality; open toes, a desire for lingerie display (Pond
1985).[6]

Surely, meaning are not *so* specific for all observers of women's
shoe stylings, and, clearly, connotations will vary according to oc-
casion and locale. (Whether the styling is seen as complementing
or contrasting with the rest of a woman's outfit also may affect the
identity message transmitted.) Still, that so relatively small,
and arguably minor, an item in the visual ensemble can, for
some lights, harbor so much sexual information—whether true or
not—is fascinating from an analytic standpoint. Mimi Pond, the
author of the book from which the above examples are taken, also
finds in them reason for much amusement.

SOURCES OF THE EROTIC-
CHASTE AMBIVALENCE

It is probably unnecessary here to ponder at length on the histor-
ical and cultural sources of the erotic-chaste tension in the lives of

6. For many decades prior to their going so thoroughly out of fashion in the
1960s, women's hats were said to serve a similar function. Alison Lurie (1981,
242–43) playfully makes a case along these same lines for handbags and purses.

persons and in the clothing worn to represent those lives. Court-
ship institutions in the West, which simultaneously enjoin women
to sexually entice while abjuring premarital—not to mention
extramarital—sex, have over the centuries provided a more than
ample dramaturgic resource for enacting via clothing the erotic-
chaste dialectic. More generally, as with the tensions that have
over the centuries built up around issues of status display, much of
the ambivalence obviously derives, on one side, from the perdur-
ing impress of the Judeo-Christian ethic with its denigration of
sexuality and praise for the modest and chaste. The ethic's relega-
tion of sexual intercourse solely to conjugal reproductive ends fur-
ther underscores the chaste component of the dialectic.

On the other side, there are in the West admixtures, varying
from era to era, of pagan hedonism and romanticism that accord a
central place to erotic pleasure in the relations of the sexes. In the
modern world this disposition is furthered in no small part by the
easy availability of contraceptive devices and other birth control
methods. Overall, the post-eighteenth century, and more de-
cidedly post-Victorian, courtship ethos conjoining marriage to ro-
mantic love and that, in turn, to erotic fulfillment has greatly
intensified the erotic pole of the ambivalence.

That these contraries may in terms of some general dress code
be combined in different proportions and that fashion often dic-
tates the balance of their combination is clearly the case. Consider,
for example, the barely-above-the-ankle hem lengths of Dior's late
1940s New Look and, by contrast, the miniskirts of the late
1960s, each of which came in time to be widely accepted despite
the aesthetic and moral distress it gave rise to initially.[7]

At the same time there are, to be sure, certain widely accepted
apparel modes that all but obliterate, yet, interestingly, finally re-
tain, some minimum obeisance to a contrary tendency. From op-
posite poles one can cite, for example, the nun's habit and the

7. In France ca. 1947–49 the House of Dior was picketed by women protesting
the New Look (O'Hara 1986). In the United States public parades and demonstra-
tions were actually mounted against the style, and resolutions condemning it were
introduced into the legislatures of several midwestern states. The "sexual freedom"
connotations of the 1960s miniskirt fashion gave rise to considerable censure in
quite a few quarters as did the largely failed attempt to revive the miniskirt in the
late 1980s.

bikini (especially the latter's increasingly common "topless" version). The former permits the face to be exposed, surely a focus of some erotic attention, and the latter still manages to artfully conceal the pudendum. Even these dress extremes, therefore, do not negate the general point of the erotic-chaste tension encoded for centuries into much Western clothing, particularly that worn by women since the late eighteenth century.

NUDISM AND THE EROTIC-CHASTE DIALECTIC

None of this, of course, is to deny there are cultures, past and present, in which no such tension manifests itself in clothing and persons are free to run about naked to the world. There is in fact no reason to believe that the use of clothing for sexual modesty or display is dictated by human nature anymore than is men wearing pants and women dresses. The attitudes and practices of modern-day nudists, however, should not be confused with such primeval innocence. The very proclamation by nudists of the superiority of an unclothed way attests in itself to the identity-defining power *in Western culture* of the erotic-chase encodings (enclothings!) nudists mean to overturn.[8] By contrast, clothing-free or near-clothing-free societies manage to make do without apparent reference to the terms of the erotic-chaste dialectic.

Nudism as a way of life constitutes, perhaps, the ultimate irony as far as the dialectic of the erotic and chaste in Western dress is concerned. So deep is the cultural linkage of nakedness and the erotic that despite nudists' repeated protestations in behalf of "health," the "natural," and the "honest and straightforward," society persists in viewing public nudity as indecent, obscene, and illegal, when not actually criminal.[9] At the same time, one of the more commonplace observations of those who have spent time

8. For an amusing rendition of the unsettling reflexivities even the most emancipated of moderns is likely to experience on encountering pubic nudity, see the delightful piece by Italo Calvino (1985) "The Naked Bosom," in his novel *Mr. Palomar*.

9. Jane and Michael Stern (1990) present a vivid account of the trials and tribulations of a middle-class group of ideologically committed Rochester, New York, nudists who sought to defy local statutes banning public nudity.

among nudists is of how strangely de-eroticizing casual nudity turns out to be (Davis 1983). At a prosaic level, this merely confirms the native wisdom of Michelle Pfeiffer's wardrobe mistress (quoted earlier in this chapter), whose golden rule for sexual arousal is: Don't show it all! On a more eschatological plane, it points to the pathos of a too thorough undoing of an adversary. In so robbing modesty of its protective claim to clothing, nudism extinguishes eroticism.

FURTHER THEMES
AND VARIATIONS

Of course, the subtleties and complexities to which the dialectic of eroticism versus modesty in clothing can aspire are, if not infinite, then certainly more than sufficient to shade meanings, moods, and attitudes along any number of conceivable lines. Though not concerned with women's clothing per se, Simmel (1984, 146) writing on flirtation nicely captures, with characteristic aperçu and smart conceptual turns, the possibilities at hand.

> The flirt places all objective polarities of every sort at her disposal: an inviting as well as discouraging glance, piety as well as atheism, naivete as well as sophistication, knowledge as well as ignorance—indeed, a woman can flirt with her flirtatious conduct itself just as well as she can flirt with her non-flirtatious conduct. In the same way that all things must be at the disposal of the artist because he wants nothing from them except their form, so they must also be at the disposal of the flirt because she wants only to incorporate them into the game of holding and releasing, compliance and aversion.

Historically, and aesthetically the clothing code resources of the West are by this late date rich and variegated enough to achieve the subtleties of which Simmel speaks. As in the arts generally, however, much depends on the "sophistication of the audience"; on whether wearers and viewers can appreciate the qualifications, contradictions, calculated ambiguities, and paradoxes designers, however intuitively and gropingly, seek to communicate by their stylings. Of doubtless relevance in this connection is that "the audience" in modern society is, as Gans (1974) and many others have noted about the consumption of cultural goods generally,

segmented along numerous age, class, gender, ethnic, and life-style lines, each of which brings somewhat different interpretative capacities to the cultural product at hand.

This said, it is still the case that many a subtle erotic attitude, drawing cleverly on visual conventions and cultural trends, does manage somehow to get communicated, at least to those segments of the audience predisposed by a fashion sensibility to attend to such nuances.[10] Kennedy Fraser in her late fashion writing for *The New Yorker* found frequent occasion to comment on one or another convolution in the erotic-chaste dialectic, especially as it tried to cope with the ideological influences emanating from the women's movement. Writing on the hesitant reappearance of the miniskirt in the fall 1977 collections, she noted (1981, 186):[11]

> Virtually all the New York designers showed at least a token example of the miniskirt. . . . But when miniskirts were shown they were generally accompanied by a whole panoply of leg disguising tricks—high boots; socks rolled over boots; socks rolled over other socks; kneewarmers; legwarmers; and tights and shoes whose color merged with that of the dress. . . . The effect of short skirts over real legs is thus considerably watered down. The fashion industry and the fashion press approach the prospect of drastically shortened skirts with a circumspection bordering on fear.

And writing of the 1978 New York collections, Fraser (1981, 219) pointed to how changing life-styles transmute what on the surface appears a blatantly erotic message into something quite different:

> All this, like many other evening styles on Seventh Avenue this year, shrieks out the official message of "sexiness." Sexy such clothes may or may not be, for one night stands. . . . They are clothes to make assertive passes in, perhaps. But they are certainly not fit for starting or

10. For example, the young, up-and-coming New York designer Christian Francis Roth, wishing to take advantage of the greatly heightened environmental consciousness of these times, works numerous ecological motifs into his designs.

11. A bolder reappearance of the miniskirt in 1987–88 met with considerably greater protest by American women. The fashion industry, sensing an economic debacle in the offing akin to that suffered in the mid-1970s with the mididress flop, hastily retreated to longer hemlines, knee-length shorts, and pants in the hope of recouping some of the loss from the thousands upon thousands of unsold mini-skirts on retailers' racks.

sustaining those "lasting relationships" that people, in spite of themselves, persist in craving. In the end, most of the sexy new clothes look like costumes to caricature sexuality. For beneath the clothing that symbolizes the new woman lies the new body. This is jogged, jacuzzi-bathed, exercised, and dieted to the point of looking androgynous. It needs sex the way it needs kelp or B15 vitamins, but is fundamentally self-sufficient.

Even more paradoxical, perhaps, is how through elusive processes of symbolic fusion the same sartorial device comes over time to serve both Venus and Diana simultaneously. A striking case in point is provided by the art historian David Kunzle (1977, 579).[12] In rebutting a familiar feminist thesis to the effect that corseting and other forms of feminine tight-lacing during the Victorian era signified women's social confinement and erotic disenfranchisement, he argues:

> It is not an historical accident that waist confinement was first manifested as fashion, with its concomitant décolletage, in the mid-fourteenth century and that it survived, with decreasing validation, down to World War I. For waist confinement and décolletage are the primary sexualizing devices of Western costume, which arose when people first became sexually conscious, and conscious of sexual guilt in a public and social way. They did so both as cause and result of the particularly Christian sexual repression which reached a point of maximum intensity in the Victorian age. Having few means of sexual sublimation in war, work, etc. woman made a dialectical response: she satisfied the Christian ascetic, body and self-denying ideal in the principle of binding and the sexual, self-expressive instinct in the principle of exposure. By confining the waist in order to throw out the bust, she made the moral principle serve the sexual instinct and vice versa. The embodiment of fading religious practices and sentiments, woman adopted "monastic" macerations of dress; as the embodiment, conversely, but equally of nature, she also denied—satirized—the original spiritual purpose. . . . The corset died not because of the [women's dress] reformers' campaign but because other means were found for the sexual and self-expression of women and men.

12. See Kunzle 1980 for a historical and psychocultural analysis of the role of corseting, lacing, binding, and other bodily constraints in fashion.

What these other means were Kunzle does not state. Clearly, though, post-Victorian women's clothing proved more than adequate to the task.

Kunzle's analysis, it should be noted, forms part of a broader historical reappraisal underway of the moral climate of the Victorian era and, in particular, of Victorian women's dress in relationship to it. This reappraisal questions the widespread conventional belief, among scholars nearly as much as with the educated public, that this was an era of extreme sexual repression of women, a repression that was both enforced and symbolically figured by the clothing women wore. In line with my own thesis of the persistent impress of ambivalence on dress, other students, like Kunzle, are discovering eroticized "details" in the seemingly somber dress of Victorian women. Commentators are also displaying a keener, culturally relativistic awareness of the possibility that what strikes late twentieth-century eyes as prudish, patently desexualized dress may have appeared quite different to contemporaries. Steele (1985, 100–101), a leading proponent of the reappraisal, concludes her investigation of Victorian sexuality and dress this way:

> If we can speak at all of an "official" "middle class" [Victorian] ideal of femininity, then an analysis of nineteenth-century fashion indicates that that ideal was, in part, an erotic one. The Victorian woman played many often contradictory and ambiguous roles, but she cannot be characterized as a prude, a masochist, or a slave. Her clothing proclaimed that she was a sexually attractive woman, but this had a particular meaning within the context of her culture.

CONCLUSION

Thus it is fair to infer that ambivalent orientations toward the erotic and the chaste even then played, as they most certainly do now, a profound role in Western dress and the symbolic buffeting to which fashion is forever subjecting it. Although the balance of opposing sartorial forces in Victorian times was clearly different from what it is now, that both were present and locked in some tension-generating exchange seems indisputable. Of course, one would like to have some inkling of what the balance of forces is likely to be in the decades ahead and of whether the tilt toward the erotic pole, initiated at about the time of the First World War, is to

continue, except perhaps for occasional minor retreats, unchecked into the new century. By then, will near-nudity or nudity finally dispel the very eroticism that the countervailing attraction of modesty frames? Indeed, by the late 1960s some saw exactly this prognosticated in the radically minimalist, near-nude and topless designs of the late Rudi Gernreich.

Only the most foolhardy would claim such prescience, however. For, as centuries of fashion have demonstrated, reversals in trends can be both sudden and profound. Already there are seers who claim to detect intimations of one such reversal in heightened public apprehensions over AIDS and other sexually transmitted epidemic diseases. But they, too, may as easily be proven wrong as not.

6

Fashion as Cycle, Fashion as Process

The present fashion is always handsome.

Thomas Fuller, 1732

No matter how much we may come to under-
stand it, it will probably always be a cause for wonderment that
what begins as a "new idea" in a designer's head, an idea at odds
often with the reigning visual conventions of the time, can so
swiftly not only disseminate to the public at large but be thought
beautiful by it as well. For it is exactly this type of visual "conver-
sion process," often intellectual and emotional as well, that is of
the essence of fashion. What was "in" is now "out"; what was at-
tractive yesterday is dowdy today; last year's model never looks
right, and try as you may, there's nothing you can do to it to make
it look right; etc., etc. Countless other, equally clichéd statements
could be summoned that reach for the same point. And despite our
gnawing awareness at another level of the ephemerality, capri- ?
ciousness, and duplicity of fashion's blandishments, we more of-
ten than not, even as we resist them, succumb to them.

Why does this happen? *How* does it happen? I have so far given
a good deal of attention to the first question, chiefly by highlight-
ing the role of identity ambivalences in Western society for
clothing communication and fashion innovation. It is now time to
turn to the how.

THE FASHION CYCLE AND
THE FASHION PROCESS

Both terms are widely and interchangeably used in scholarly, and
even popular, writing on fashion. There is reason to distinguish
them. The *cycle* can best be defined as the phased elapsed time from
the introduction of a fashion (a new "look", a new visual gestalt, a
pronounced shift in vestmental emphasis, etc.) to its supplantation
by a successive fashion. The *process* refers to the complex of influ-
ences, interactions, exchanges, adjustments, and accommodations

among persons, organizations and institutions that animates the cycle from its inception to its demise.

Both terms, of course require delineation, specification, and qualification if we are to understand what happens, and how it happens, during the course of a fashion cycle. While I shall not attempt to be exhaustive on the matter, some prominent features of the cycle and its attendant processes merit general discussion in this chapter. I shall also take up several of the more important social science theories that have been invoked to explain them. This, I trust, may serve as useful background to the detailed treatment in the next chapter of influences at play at successive stages of the fashion process, from inception to extinction.

The Cycle, Then and Now

A metaphor often employed for the fashion cycle compares it to waves in the sea (Brenninkmeyer 1963, 52–53). As one wave crests and begins to dissipate, new waves form; these, too, will crest and possibly overtake a prior wave. But what of the waves themselves? Do they all follow the same pattern, or do they vary in amplitude, speed, and force? Indeed, there are students (Grindering 1981; Konig 1973, 46) who maintain that, as on a roily sea, several different kinds of waves (long/short, large/small, major/minor, etc.) overlap at the same moment. Depending on what feature of the fashion repertory one is observing (e.g., silhouette, hem length, fabric, color, decolletage), a different wave pattern is likely to form. Thus in the area of the women's dress, for example, hem length and color emphasis will as a rule change more frequently than the basic silhouette, although even with this the magnitude of change from one season to the next can be quite erratic, at times pronounced and at other times minuscule.

So, while all may agree that fashion in dress is cyclical, there are many different points of view regarding the nature and content of its cycles.[1] This, it will be noted, is a problem that besets all cycli-

1. Whether fashion in other realms (e.g., the fine arts, literature, architecture, automobile styling, furniture, domestic pets, cuisine) is as cyclical or, for that matter, cyclical at all is somewhat problematic. Part, though not all, of the answer would depend on whether the institutional apparatus for structuring and sustaining a fashion cycle exists in these other realms. Clearly, the apparel industry is

cal theorizing, from Spengler to the stock market. The search for some inherent or "natural" law above and beyond the vagaries of human agency that can explain every move and deviation in the cyclical pattern almost invariably runs afoul of history.[2] But, when the "law" attempts to accommodate history's eccentricities, it tends to lose its cogency; the litany of exceptions and adjustments overwhelms whatever generalizing potential the cyclical theory possessed initially.

Such absence of lawlike properties notwithstanding, some cautious generalizations do seem warranted in regard to the fashion cycle and the manner in which it has developed in Western society over some eight centuries. Students (Bell 1947; Lowe and Lowe 1985) generally concur, for example, there has been no break in the flow of fashion change since the thirteenth century despite variability in the duration of fashion cycles. Such a finding is by itself less interesting than what it suggests about the presence of certain structural and cultural continuities in Western society, which, despite profound social transformations over the centuries, continue to excite the changes in popular taste and sensibility that mark fashion. Some of these continuities, for example those deriving from an invidious status system and from the moral impress of an ascetically inclined Judeo-Christian ethic, have, as far as fashion is concerned, been dealt with in earlier chapters.

Further, there is (except for Lowe and Lowe [1985], who argue to the contrary) widespread agreement (Anspach 1967; Bell 1947; Brenninkmeyer 1963; Fraser 1981; Konig 1973) that the pace of the fashion cycle has greatly accelerated since the nineteenth century, most especially since the Second World War. The decisive development in the nineteenth century was the emergence of the independent couturier who designed clothes primarily for a market consisting mainly of upper-middle-class women, rather than, as had been the case previously, individual clients, typically women of the aristocracy or prominent haute bourgeoise society

much further along in this regard than are the others, although there are students who suggest (Moulin 1984) the visual arts are rapidly approaching a similar condition.

2. In the study of fashion, Kroeber's (1919) quantitative analysis of several centuries of women's gown proportions survives as the *locus classicus* for this approach.

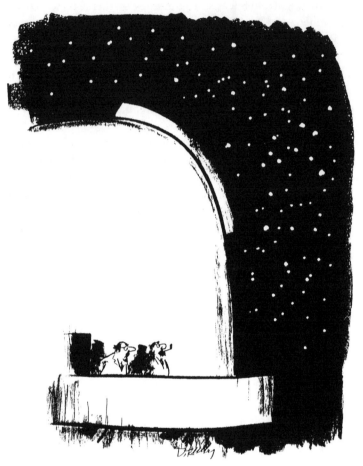

*"I've never been able to figure out the cycle of the quiet
disappearance and after an indeterminate interval the
mysterious reappearance of men's trouser cuffs."*

Drawing by D. Reilly; © 1989 The New Yorker Magazine, Inc.

figures.[3] The English-born and -reared Charles Frederick Worth,
who established his own design house in Paris in 1858, is credited
as being the first of this breed (O'Hara 1986, 265). The fashion

3. Analogous shifts from aristocratic patronage to independent production for
a broader, albeit class-restricted, market occurred, of course, in all of the arts dur-
ing the nineteenth century.

cycle has not been the same since. Before Worth, the names of de-signers of gowns and other wear for aristocratic and bourgeois ladies were hardly known to the public at large.

Prior to the mid-nineteenth century it would often take decades for one dress style to succeed another. Following Worth a new dress fashion for women, with perhaps the most minor of altera-tions from season to season, would last typically for only the bet-ter part of a decade and on occasion somewhat longer. Today it is not uncommon for a new style to survive for no more than a sea-son or two. Intensive capitalization and rationalization of the ap-parel industry, consumer affluence along with democratization and a loosening of class boundaries, and the greatly quickened flow of information via the electronic media are cited typically as factors accounting for the progressively shortened span of the fashion cycle. The idea has even been put forward (Davis 1979; Klapp 1969) that these forces, especially the mass media, have served to so quicken the cycle that it stands in danger of expiring altogether. Apropos, one fashion writer (Hochswender 1991a) was led recently to observe:

> The cycles in fashion get shorter and shorter. How many times have the 60's been revived since the 60's? They're never out long enough to be completely out. Soon all the decades will overlap dangerously. Soon everything in will simultaneously be out.

The last observation touches on yet another alteration in the fashion cycle, particularly in that period since the Second World War, namely, the emergence of what is referred to as "fashion plu-ralism." The term crops up in several different contexts, making it difficult to attach a single referent to it. The underlying assertion, however, is that, in sharp contrast to what obtained until well into the present century, contemporary dress fashions are neither as universal nor as symbolically focal as they once were. Neither in women's nor men's dress today can a single fashion come to rule the roost as was the case with, for example, the crinoline, the bustle, the flapper dress, Dior's New Look, or the three-piece single-breasted man's suit. Nor do fashions today seem capable of enforcing uniformlike compliance throughout society and across all class and status groupings. Bell (1947) anticipated the point

glancingly when he claimed that since the last decades of the nineteenth century clothing, and its attendant styles, have become ever more specific with respect to occasion and activity: day and evening wear, business and leisure, town and country, home and office, seasonal wear, etc. Styles and fashions that dominate in one domain do not automatically carry over, or even necessarily influence, what dominates in another.

But much more has come to be implicated in the notion of fashion pluralism than the phenomenon of dress specificity. In conjunction with the wide-ranging critique of "trickle-down theory" (of which, more later) what is also implied is the passing—assuming it ever existed in quite the manner Veblen (1899) and Simmel (1904) wrote of it—of a hierarchically organized, symbolically consensual prestige structure in society, one in which all groups, classes, and coteries looked, however soon or belatedly, in the same direction for cues for what was to be thought beautiful, acceptable, and fashionable. This accounts for the unrelieved stylistic uniformity of many nineteenth- and early twentieth-century fashions as they descended through the class and status structures of society.

By contrast, students of fashion diffusion in today's world (Field 1970; King 1981) claim that a condition of fashion polycentrism prevails. Different socioeconomic, age, subcultural, ethnic, and regional groupings, no matter what their relationship to the "means of production" or the occupational structure of a society, adopt and frequently create their own rather distinctive fashions, some of which (e.g., blue jeans, punk-influenced hair stylings, oversized men's shirts worn by women, the man's earring, tie-dyed T-shirts, hippie beads, running shoes) soon spread, via lateral and even upward movement, to other subcultures and more inclusive social groupings.[4] Nonetheless, in contemporary America, and particularly among younger age groups, fashions can become so localized that what is "in" at one high school or junior high is strikingly different from what is "in" at nearby schools in the same city (Louie 1987; Penn 1982; Rimer 1985).

4. See the extended discussion of denim blue jeans in chapter 4.

SOME THEORIES OF THE
FASHION CYCLE

Implicated in the concept of cycle is, of course, some notion of phases, which as a rule are thought of as divided into, at minimum, a beginning, a middle, and an end. Such a delineation is most often accompanied by some causal scheme meant to explain how the phenomenon in question moves (or develops, or unfolds) from one phase to the next. And, so it is with fashion. A perusal of the extensive literature on the topic (see Kaiser 1985; Sproles 1985) reveals any number of alternative schemes by which the phases of the fashion cycle are conceived as well as a goodly number of theories to explain why the phases develop as they do. But to even contemplate the latter immerses us in questions of process; for hardly any of the theories is so naive as to conceive of the cycle as a *ding an sich,* unfolding inexorably by itself, wholly free of outside agency. On the contrary, nearly all of the theories propose some force or condition by which the cycle is animated and made to follow its phased course.

This said, it must also be noted that it is much easier to secure essential agreement among scholars on the phases of the cycle than on theories to explain them. Perhaps out of sheer logical necessity, all concur explicitly or by implication in one or another variant of the beginning-middle-end phase formulation.[5] Substantive theories of the fashion process, however, range all over the map. As noted earlier in one and another connection, some see boredom as the well-spring of fashion change. Others emphasize sexual allure, sometimes specifying the conditions even further by referring to shifting erogenous zones. Still others take their cue from market interests, at times extending the theory to embrace notions of, at minimum, tacit economic conspiracies. A much-quoted aphorism of G. B. Shaw (Auden and Kronenberger 1962, 126), for example, has it that "a fashion is nothing but an induced epidemic, proving that epidemics can be induced by tradesmen."

5. In the subsequent extended discussion of the fashion process, I too employ such a scheme.

And, of course, there are the familiar, if characteristically vague, a posteriori, *Zeitgeist* theories.[6]

By far the most prominent *sociological* theory of fashion since the turn of the century, however, has been, as stated above, the trickle-down or, as Blumer (1969a) has termed it, "class differentiation" theory. Because of the great sway these interrelated ideas of trickle-down and class differentiation have exercised on scholarly and popular writing in the field, it is useful to consider the theory's limitations before proceeding to the next chapter's examination of the stages of the fashion process. For without this, there is a danger the theory's lingering—though, I would hold, distorting—appeal may skew the understanding of how the fashion process actually works in today's world.

Trickle-Down Theory, A Critique

As developed by followers of Veblen (1899) and to a lesser extent those of Simmel (1904), the trickle-down conception of the fashion process, as the name implies, holds essentially that fashion is launched at the top of the social structure and eventually works its way down to bottom stopping short perhaps of what Marx termed the *lumpenproleteriat* but nowadays we usually think of as the "underclass." In the course of its descent what may have been aesthetically innovative about the new fashion is lost as stylings, in order to meet the economic exigencies of the mass market, become progressively vulgarized, or "tacky" in common parlance. As the fashion passes into the lower-middle and upper-working classes it is, of course, no longer fashionable. By then the upper class, especially its more fashion-conscious segment, has fixed on some new fashion. This, in turn, starts the cycle all over again.[7]

Thus, trickle-down theory (in league often with intimations of a "clothiers' conspiracy") places preponderant emphasis on the

6. Or as Schucking (1944, 5) puts the matter so pithily in his critique of zeitgeist theories of literary production, "It is very easy to adduce as part of a demonstration the very thing that has to be proved. The spirit of the Gothic period, for instance, is first deduced from its art and then rediscovered in its art."

class differentiation functions of fashion.[7] And certainly, there is and was much about civic life in Western society to lend plausibility to the emphasis. To paraphrase the theory's underlying reasoning (see Goffman 1951):

> The class structure of society requires appropriation of symbolic devices by which social classes can distinguish themselves from each other. Clothing, generally, and fashion, in particular, lend themselves admirably to this purpose in that they afford a highly visible, yet economically strategic, means whereby those "above" can by the quality and "fashionableness" of their clothing signify their class superiority over those "below." Moreover, that those below come in time to emulate, however crudely, the fashions of the upper classes attests symbolically to the legitimacy of the patterns of deference inherent in a class system. I.e., those below demonstrate thereby a "proper respect" for their "betters."

Although neither Veblen nor Simmel referred explicitly to this process as "trickle-down"—a politically contentious term that found its way into economic discussions later in the twentieth century—there is ample evidence in their classic works of 1899 (Veblen) and 1904 (Simmel) they conceived of fashion essentially along these lines. In Simmel's essay on fashion (1904, 136), only the term itself is lacking:[8]

7. In almost a classic Parsonian sense, the theory is heavily structural-functional in its emphasis, discovering in "function" if not quite the sole, then certainly a sufficient, explanation for the phenomenon in question (see Parsons 1951).

8. Still, on balance, Simmel's rendition of "trickle-down" is more subtle and insightful than Veblen's. Veblen grinds away relentlessly on "conspicuous waste" and "conspicuous consumption" as the symbolic sine qua non of fashion whereby the leisure class differentiates itself from less advantaged classes. For Simmel, fashion, in addition to this societal function, at the interpersonal level affords a near-ideal mechanism for balancing several of the "contrary human tendencies" that figure so prominently in the corpus of his sociological writing (Simmel 1950), i.e., individualization vs. equalization, union vs. segregation, dependence vs. freedom, etc. What he had in mind was that fashion at one and the same time, allowed persons to express their individuality and afforded them the security of conformity with numerous similarly disposed peers. Or, as Sapir (1931) put the matter somewhat later, "Fashion is custom in the guise of departure from custom." Simmel (1904) was also unusually prescient in his analysis of the special position of the demimonde in the fashion process: While "its peculiarly uprooted form of life" permitted it to pioneer in matters of fashion, it could not on its own establish or legitimate a new fashion. That power was reserved for the upper classes.

Social forms, apparel, aesthetic judgment, the whole style of human expression, are constantly transformed by fashion, in such a way, however, that fashion—i.e., the latest fashion—in all these things affects only the upper classes. Just as soon as the lower classes begin to copy their style, thereby crossing the line of demarcation the upper classes have drawn and destroying the uniformity of their coherence, the upper classes turn away from this style and adopt a new one, which in its turn differentiates them from the masses; and thus the game goes merrily on.

More recent statements espousing trickle-down theory are to be found in Barber (1957) and Robinson (1961), although the latter modifies the claim by noting that within social strata diffusion of the new fashion is likely to be horizontal rather than vertical (King 1981).

Incident to the earlier discussion of the fashion cycle, one criticism of trickle-down theory has already been set forth, namely, its inability to account for the fashion pluralism and polycentrism that more and more characterize contemporary dress. The theory, however, is wanting on any number of additional grounds. (But in fairness, so are nearly all reasoned explanations of the fashion process, whether we call them theories or not.)

A most obvious shortcoming of trickle-down theory was touched on in the discussion of ambivalences of status (chapter 4). This is the reductionistic assumption that irrespective of the intentions of designers or clothes-wearers, fashion in the end is concerned solely with symbolizing social class. However, were we to follow the phenomenological (and commonsense) injunction of "turning to the thing itself," it is at once evident that clothes generally, and fashion in particular, communicate much more about the person than the social status he or she occupies or aspires to. As I have tried to show throughout this work, gender, sexuality, age ascriptions, leisure inclinations, ethnic and religious identifications, political and ideological dispositions, and still other attributes of the person can be in play in the clothes we wear. To isolate from this rich design a single, though admittedly important, element is to do violence to the phenomenon itself. It is not surprising, therefore, that even those who still seriously entertain the theory (McCracken 1985b) introduce numerous qualifications and additions that aim to expand its tunnel-vision view of fashion.

The theory's narrow symbolic focus is but part of a larger deficiency that plagues sociological theories of fashion generally, including that of trickle-down theory's most forceful sociological critic, Herbert Blumer (1969a). As I have discussed elsewhere (Davis 1982), whereas sociology may tell us a great deal about how fashion diffuses through a population (i.e., the structural outlines of the fashion process), it has thus far offered little by way of telling us what specific fashions *mean*, (i.e., the images, thoughts, and feelings communicated by a new or old fashion and the symbolic devices with which this is done). What does the shortened hemline or double-breasted suit mean to those who, cautiously, are among the first in their social circles to adopt them? How do these meanings, elusive or inchoate as they may be, relate to meanings that preceded and will follow them in the fashion cycle? Why do some new meanings (read, new fashions) "click" while others "fizzle"? Trickle-down theory, along with other sociological theories of fashion (Tarde's and Sumner's imitation theory, Konig's displaced sex urge emphasis, Blumer's collective selection formulation), reveals itself as peculiarly incapable of informing us substantively of how clothing meanings are engendered, communicated, and eventually dissipated. Yet it is this, after all, that lies at the core of the fashion process.

Doubtless there are those who in defense of the sociological enterprise would argue that trickle-down theory need not concern itself with questions of content; that, in accordance with the fundamental telos of the discipline, it is sufficient to delineate the structure within which the fashion process is contained and the abstract forms by which its manifestations can be comprehended. Indeed, some such distinction between form and content distinguishes Simmel's and later Wiese's (1927) formal school of sociology.[9] This may account for Simmel's partiality to a trickle-down

9. In the sense that, for example, the social "form" superordination-subordination comprehends the "content" of such relationships as employer-employee, officer–enlisted soldier, master-slave, teacher-student, parent-child, etc. As for fashion, such dialectical processual forms as competition-cooperation, individuation-affiliation, and union-segregation should have been, in accordance with the dictates of "formal sociology," at the center of Simmel's analytical scheme. While these are alluded to in the landmark 1904 essay, there, as in much of Simmel's sociological writing, he (wisely, in my opinion) avoided applying them with rigor or consistency.

version of the fashion process, although in recognition of his genius it must be noted he was never one to be held intellectually captive to any circumscribed disciplinary doctrine, another's or his own. This metatheoretical stance of sociology may well be altogether tenable logically. Each science purports to do some things and not others, and it is pointless to expect it to delve into areas lying outside its established boundaries. Still, whether it be via sociology, another discipline, or some mix of disciplines, the problem of meaning in clothing and fashion is so critical for an understanding of the fashion process that it needs somehow to be addressed. From the vantage point of humanistic learning, it is equally foolish to abandon it solely because it does not axiomatically fall within the recognized boundaries of some established discipline.

Finally, it is worth noting that for a theory conceptually so in tune with structural-functional approaches in sociology—fashion is said to "function" in behalf of sustaining the social stratificational system of society—trickle-down, remarkably, barely attends to the complex of institutional, organizational, and market structures that channel and, at very least, mediate the fashion process. None would deny, for example, that the social construction of "seasons," competition among designers and fashion centers (Paris, Milan, London, New York), the fashion choices of buyers for big American department stores at the fall and spring showings, the fashion press, merchandising strategies, etc., have a great deal to do with how fashion "happens." Yet these palpable structural influences are hardly ever reflected in the formulations of trickle-down theory or, for that matter, in sociological writing on fashion generally. If considered at all, they are treated as something of a black box whose invisible operation serves solely to sustain and reproduce the social class system of society.[10] Although, with Blumer (1969a), I hold strongly to the view that changing subjective aspirations and discontents of a people have much to do

10. In a well-known piece Bourdieu and Delsaut (1975) do examine the structure of rivalry and cooperation among Paris's top designers. Their aim, however, is not to illuminate the fashion process per se but rather to indicate how such rivalry and cooperation ultimately feed into the distinctive taste preferences of France's upper and middle bourgeoisie.

with the turns fashion takes—a view, incidentally, favored neither by trickle-down nor "economic conspiracy" theorists—this need not entail neglect of the role played by the institutional apparatus of the fashion industry in the fashion process. For it is certainly also the case that the fashion industry in its totality is necessarily deeply implicated in the apprehension, definition, diffusion, and dissipation of the collective moods and tensions that feed fashion. Whichever sociological theory of fashion one leans to, it would seem a better understanding of that industry than we now have is called for before a still broader understanding of fashion's place in the lives of modern peoples can be attained. Otherwise, the breathless clichés of the fashion press on the one hand, and on the other the easy, often snobbish or, at best, patronizing generalizations of social critics given to devalue fashion as trivial and culturally corrupting, are likely to continue to dominate discourse in the field as they have for too long now.[11]

Blumer's Collective Selection Theory

In light of trickle-down theory's shortcomings, what sociological alternative is there? Perhaps the only other well-articulated, reasonably comprehensive attempt to conceptualize the fashion process is that of the late Herbert Blumer (1969a), who terms his approach "collective selection." Designed in large part specifically to rebut trickle-down or class differentiation theory and incorporating many key ideas from the somewhat amorphous subdiscipline of sociology known as "collective behavior," Blumer's formulation denies that hierarchical class relations animate the fashion process and that, in turn, fashion serves primarily to symbolically ratify those relations. Not that fashion cannot or does not ever serve the purpose of class differentiation, but this is at best

11. It is striking that, although one can locate hundreds of scholarly articles and books on fashion at any time, one almost never comes upon, for example, an ethnographic or other sort of close-in study of a fashion house, a fashion publication, store buyers, or a retail establishment where new fashions are sold. Some noteworthy exceptions are provided by Kovats (1987), who has published some material from her field research in a Paris fashion house, and Peretz (1989), who has reported on the selling of fashionable wear in Paris retail establishments.

only one purpose among many and, at that, of distinctly second-ary significance in the context of fashion's overall sweep. As Blumer (1969a, 281) states the case:

> The efforts of an elite class to set itself apart in appearance takes place inside of the movement of fashion instead of being its cause. The prestige of elite groups, in place of setting the direction of the fashion movement, is effective only to the extent to which they are recognized as representing and portraying the movement. The people in other classes who consciously follow the movement do so because it is the fashion and not because of the separate prestige of the elite group. The fashion dies not because it has been discarded by the elite group but because it gives way to a new model more consonant with developing taste. *The fashion mechanism appears not in response to a need of class differentiation and class emulation but in response to a wish to be in fashion, to be abreast of what has good standing, to express new tastes which are emerging in a changing world* [Blumer's emphasis].

In place, then, of a functional explanation finding fashion's source in some societal predicate of class differentiation, Blumer shifts the analytical ground to where more elusive states of *collective* mood, tastes, and choice are seen as critical. Perhaps the clearest statement to this effect occurs in the entry he wrote on the topic for the *International Encyclopedia of the Social Sciences* (Blumer 1968):

> Tastes are themselves a product of experience; they usually develop from an initial state of vagueness to a state of refinement and stability, but once formed they may decay and disintegrate. They are formed in the context of social interaction, responding to the definitions and af-firmations given by others. People thrown into areas of common interaction and having similar runs of experience develop common tastes. The fashion process involves both a formation and an expression of collective taste in the given area of fashion. Initially, the taste is a loose fusion of vague inclinations and dissatisfactions that are aroused by new experiences in the field of fashion and in the larger surrounding world. In this initial state, collective taste is amorphous, inarticulate, vaguely poised, and awaiting specific direction. Through models and proposals, fashion innovators sketch out possible lines along which the incipient taste may gain objective expression and take definite form. Collective taste is an active force in the ensuing process of selection, setting limits and providing guidance; yet, at the

same time it undergoes refinement and organization through its attachment to, and embodiment in, specific social forms. The origin, formation, and careers of collective taste constitute the huge problematic area in fashion.

Some additional key points are put forth by Blumer (1969a) in his analysis of the fashion process:

1. He conceives of fashion as a *generic process* permeating many more areas of social life than that to which scholarly work and popular interest customarily confine it, i.e., clothing (women's clothing in particular). The susceptibility of an area to fashion's sway is inversely related to the degree to which its "competing models" can be subjected to open, objective, and decisive test. "It is for this reason that fashion does not take root in those areas of utility, technology, or science where asserted claims can be brought before the bar of demonstrable proof" (1969a, 286). Blumer himself, though, I am sure, would have agreed that even in science and technology what constitutes "demonstrable proof" is not always as clear-cut and unproblematic as one wishes; this, perhaps, helps account for the fact that it is by no means uncommon to hear scientists, engineers, and, certainly, social scientists speak of "fashions" in their respective fields. Indeed, his somewhat earlier "Fashion" entry for the *Encyclopedia of the Social Sciences* Blumer [1968] all but says as much.

2. Fashion is closely allied to modernity and intertwined with the "modern temper," with restlessness, an openness to new experience, and fascination with the new, viz., a rather generalized cultural predisposition to "keep abreast of the times." Thus, regardless of what happens to social class relations in contemporary society, whether they become more egalitarian or more steeply hierarchical, the domain of fashion is an ever-expanding one. "As areas of life come to be caught in the vortex of movement and as proposed innovations multiply in them, a process of collective choice in the nature of fashion is naturally and inevitably brought into play" (1969a, 289).

3. Although as one highly critical of "structural-functionalism" Blumer never attributes causality to fashion's "function" as such, he does see the fashion process as fulfilling a number of useful social purposes, which he refers to as its "societal role."

First, it "introduces order in a potentially anarchic and moving present," through collectively narrowing choice and selecting among competing models so as to reduce the likelihood of Tower of Babel effects (1969a, 290).[12] Second, it "serves to detach the grip of the past in a moving world" (1969a, 290), a world that requires people to be free to move in new directions. "Third, fashion operates as an orderly preparation for the immediate future. By allowing the presentation of new models but by forcing them through the gauntlet of competition and collective selection the fashion mechanism offers a continuous means of adjusting to what is on the horizon" (1969a, 291).[13]

I think it safe to say that students of fashion, much as they may differ with many of its details, would find in Blumer's scheme a more balanced, comprehensive, and felicitous analysis of the fashion process than that offered by trickle-down theory or, for that matter, most extant theories. As with so much Blumer wrote (see Blumer 1969b), one senses his rendition of "collective selection" to be much closer to what actually happens in the real world of fashion creation and diffusion. It rings truer to the complexities, ambiguities, and uncertainties that mark the emergent, and at least initially indeterminate, character of the larger social processes that simultaneously wear down and reconstitute the familiar fabric of the social order. Still, as with trickle-down theory, problems remain, though this time more through omission than commission. I will briefly allude to them here before attempting a stage-by-stage analysis of some of the many influences that activate, shape, and direct the fashion process in today's world.[14]

To begin, I would again note that, as are nearly all sociological theorists of fashion, Blumer is largely indifferent to what is com-

12. But, as noted, there are those who argue that with the spread of fashion pluralism and polycentrism a "Tower of Babble" is exactly what has come into being (Wolf 1980).

13. Some sense of what Blumer had in mind when making this last point (he, incidentally, spent time in Paris in the early 1930s studying fashion at firsthand) can be gleaned from the passing observation of an expert fashion reporter on viewing the latest Paris collections. "Paris is a kaleidoscope of styles and attitudes as designers search for a new look for the new decade. There is much talk of fashion's girding itself for the 90's, but there is hardly any agreement about what the main direction should be" (Morris 1990c).

14. For a fuller critique of Blumer's views on fashion, see Davis 1991.

municated by fashion. And in deference to his well-taken counsel to view fashion as a generic process, this indifference, by extrapolation, would extend to fashion in all things: in dress, architecture, music, household pets, or whatever (Davis 1982). That something of symbolic significance is being communicated to individuals and that its communication is realized through an interactive process that both apprehends and alters meanings as the process unfolds is a conceptual stance strongly held and deeply felt by Blumer. One would expect nothing less from the founder of the school of sociological thought known as "symbolic interactionism." Yet nowhere does Blumer offer a methodology for assaying what clothing's meanings are.[15] (A corrective is found to an extent in the work of semioticians (Barthes 1983; Eco 1979; Enninger 1985) and clinical and social psychologists who have utilized projective tests of one sort and another to study clothing meanings.)[16] As with trickle-down theory, with Blumer the analyst is left with a processual skeleton.

Beyond this there is the more general problem of vagueness in collective selection theory. Stages in the fashion process, whether real or meant to serve as analytical devices, are not differentiated and identified. Who the key actors are never emerges clearly. Although their presence can be felt, their appearance is like that of figures hovering in a conceptual darkness. They are not well-etched silhouettes capable of being targeted by the researcher. The guiding imagery is of some massive gaseous disturbance in which volatile elements of collective mood, taste, and selectivity ignite and implode each other so as to move the transformative process on to some largely unforeseen end. There is nothing particularly infelicitous about this metaphor when applied to fashion. (Antipositivist and antiempiricist that he was, Blumer [1969b, 153–82] was, we know, quite partial to the notion of "sensitizing concepts," and doubtlessly much of what he wrote on fashion was intended in this vein.) Still, as one who has tried to build upon such imagery in my own studies of fashion, I can testify to how, in the absence of

15. Some important first steps toward filling this lacuna in the symbolic interactionist analysis of clothing were, however, taken by Gregory Stone (1962), a student of Herbert Blumer's. There has unfortunately been little followup on Stone's pioneering efforts in the area.

16. Kaiser 1985 discusses many such studies.

greater specificity, it is virtually impossible to account for the turns fashion takes.

Displaying the lingering impress of its origins in turn-of-the-century (Le Bon 1896; Tarde 1903) and slightly later (Park and Burgess 1921) collective behavior–"mass society" paradigms of social change, collective selection theory is, finally, quite ahistorical in its grasp of the fashion process. Searching for fashion's sources in the concatenation of current collective moods, discontents, and yearnings, it offers few if any clues on why dress and fashion in Western society have taken the directions they have over the centuries. The threads of what the student senses must ultimately be fashion's links to the relatively fixed and continuing class, gender, and institutional arrangements of society get lost somehow. Any ensuing analysis of a particular fashion cycle or cluster of cycles is, therefore, made to appear ad hoc, or worse yet bootless. Not that the missing links need be thought of as determining, as they usually are in trickle-down and Marxist theories (Fox-Genovese 1978). But given what we already know of the historical direction of, for example, class and gender dress in the West, it would seem the linkages, however attenuated or obscured at times, deserve more of a place in fashion's analytic equation than collective selection theory accords it.

Last, I would simply reiterate the point raised several pages back, namely, the failure of collective selection theory (along with trickle-down) to adequately consider the palpable influence of the elaborate institutional apparatus surrounding the propagation of fashion in the domain of dress. Blumer (1969a) is, of course, quite correct about the flow of fashion (generically conceived) in other areas of social life not being nearly as institutionalized as it is in clothing. This recognition by itself challenges those who would totally reduce fashion to the economic apparatus of its manufacture and promotion; for if such were the case, fashion would flourish as unabashedly in cookware, gardening, and building design as it does in apparel, which of course it does not. Granted this, it seems equally shortsighted to treat as unproblematic its intensive institutionalization in the realm of dress. That fashion has found its mansion there may be as much of a clue to its generic properties as is its diminished presence in other spheres of social life.

7 Stages of the Fashion Process

Fashion enthrones itself as something lasting and thus sacrifices the dignity of fashion, its transience.

T. W. Adorno, 1981

The discussion of theories of fashion should make it evident that what we conceive of—most reasonably, I might add—as the fashion *process* cannot be explained in terms of any single psychological motive, human propensity, or societal exigency. As process it is sustained through some complex amalgamation of inspiration, imitation, and institutionalization, all of which seem necessary, even though the nature and degree of their fusion is, as we can infer from fashion history, quite variable. Roughly speaking, major fashion "revolutions" such as the lifting of hemlines following the First World War, Dior's post–World War II New Look, and women's donning of slacks in the 1960s would suggest a process that draws relatively more on inspiration than on imitation or institutionalization. By contrast, the "average" fashion cycle, as a rule, seems much more institutionally constrained by numerous aesthetic conventions, publicity practices, and merchandising requirements.

In the pages that follow, therefore, while I shall not attempt a singular, transcendent, or monolithic theory of the fashion process, I will point to some more than incidental influences and constraints upon the process along the way. This could lay the basis for a more integrated, if as yet far from parsimonious, account of what transpires over the course of the process from creation through consummation to extinction.[1] To facilitate such an account I shall borrow essentially the six-stage scheme proposed by Sproles (1985): invention and introduction; fashion leadership;

1. As discussed in greater length in the book's concluding chapter, the analysis that follows derives essentially from what has been the dominant paradigm in the study of fashion diffusion, namely, that from a creative center to ever more remote, less innovative, problematically receptive strata of the fashion-consuming public. As is also suggested there, it is quite possible to conceive of fashion diffusion in terms of an alternate paradigm I term "populist."

increasing social visibility; conformity within and across social groups; social saturation; and decline and obsolescence. Inasmuch as I regard the two phases of Sproles's first stage, invention and introduction, as quite distinct, I shall treat them separately. Also, because they are intrinsically of less interest, I shall for purposes of discussion combine Sproles's three last stages—conformity, saturation, and decline—into one, waning. It is perhaps unnecessary to add that in reality neither Sproles's stages nor my adaptation of them are nearly as cleanly demarcated, one from the other, as their designation here as successive stages might suggest. Particularly over the extended period leading up to waning, one is likely to find a good deal more overlapping and backing and filling than clear beginnings and endings.

1. INVENTION

Of all that goes into the fashion process it is doubtlessly the act of invention (or, as it is more commonly referred to, creation) that most intrigues laypersons and scholars alike. The fascination usually takes the form of puzzlement over where couturiers and their creative allies in fashion (e.g., milliners, furriers, hair stylists, jewelers, perfumers) "get their ideas from" and, once gotten, which ideas succeed, which don't, and why. With some important qualifications deriving mainly from the inherent limitations imposed on clothes design by the human form (Brenninkmeyer 1963, 100–101), the sources and circumstances of creativity in couture are basically no different from those obtaining in the arts generally.[2]

2. At that, there is and probably always has been a significant formalistic element in couture that, beholden to principles of "pure design," unabashedly, and often defiantly, pays scant attention to questions of comfort, fit, and convenience, much less to those of price and social suitability. For designers of this tendency, clothing values (i.e., fabric texture, weave, volume, light reflection, color, pattern, etc.) are thought to constitute an aesthetic of their own, one to which the human form must submit rather than the reverse. Strains of this can be found in the clothing designs of the early 1920s Russian constructivists, in the 1960s "space suits" of Courrèges and Cardin, and not long ago at a Massachusetts Institute of Technology (1980) exhibition titled *Intimate Architecture, Contemporary Clothing Design*, which displayed a variety of "almost inconceivable to wear" garments by eight world-renowned contemporary designers from Italy, France, Japan, and the United States.

The following brief observations, some by no means unfamiliar, seem worth registering.

As do Western artists generally, designers, especially those aspiring to international reputation, take great pride in being thought of as "original," "innovative," "possessed of great creative talent," etc. In short, they court fame and wish to leave their distinctive mark on fashion history. Hence, from the outset—and presuming the existence of an international fashion arena in which reputations are to be made and rewards are to be garnered—a strongly institutionalized motive, the constant pursuit of "originality," is in place for initiating any particular cycle of the fashion process.[3] To a degree, the apparel market and key segments of the fashion world, notably the fashion press, sustain and reinforce the designer's quest for originality. For interlocking reasons of their own (profit, career repute, pride in one's critical acumen, etc.) they, too, befitting the modern temper, are constantly on the lookout for the original, the different, the innovative, in the person of an as yet unheralded genius designer whose break with the past will set the fashion world aflame. The failure of this, or intimations of it, to appear always provides some cause for disappointment, as witness the fashion page jottings of a *New York Times* writer (Gross 1987b):

> An hour later [on the flight from London to Paris], the plane shook violently; a flight attendant said it had been struck by lightning as it descended through flashing, stormy skies into Charles de Gaulle Airport. Unfortunately, that moment was more explosive than most of the collections that have been shown here.
>
> Paris fashion for next spring is feminine and quietly romantic. But there has been little new on view. . . . The absence of innovation carried over into the utterly charming line of cocktail and evening clothes shown by Christian Lacroix [the then newly arisen star of the Paris couture], as the designer himself was the first to admit. "It was

3. One important circumstance that does, however, inhibit couture creativity is the frequency with which designers are expected to present their wares to the public. As Morris (1989a) and designers themselves have observed, "With new collections to show every six months (couture houses show every three months) designers have little time to develop fresh ideas. Instead of searching for a new fashion idiom for the 1990's, they are reworking the past."

not for new ideas, but for charm and sales," he said of his entry into the ready-to-wear arena.

As between the apparel market and the fashion press, the former, as one would expect, is more constraining of designers' innovative impulses. For much as reporters, critics, and even fashion leaders (see below) may herald and applaud the new and the daring, a constant danger—in itself, a critical element in the articulation of the fashion process—is that too sharp and radical a break with what is already in vogue may end up as a massive flop in the marketplace. As noted in other connections, this has occurred often enough, its most recent dramatic manifestation being the "mididress" debacle of the mid-1970s.[4] Kidwell's (1989, 141) conclusions on the general point are altogether apt:

> The precedent set by the current fashions also influences the kinds of choices that are made. Rarely is a new season's popular fashion a dramatic departure from the past. The average consumer has seldom accepted new styles that were radically different from what they were already wearing. They prefer to get used to a new feature gradually. *Designers, manufacturers, and merchandisers are aware of this tendency. Their choices are influenced by their perception of how adventuresome or how conservative their targeted customers might be* [emphasis mine].

In this there are to be found some additional influences that contextually distinguish (but hardly vitiate) creativity in the world of couture from that in the other arts. It would be naive to doubt for an instant that the market (i.e., what interested publics wish to buy and what they're willing to pay) has very much to do with what gets produced in such diverse artistic endeavors as painting (see Moulin 1987) and poetry, rock music and ballet—indeed, *all*

4. I was told by several Los Angeles designers and fashion writers I interviewed that John Fairchild, publisher of *Women's Wear Daily*, America's most influential fashion medium, had dedicated himself so totally to the midi, he sought to deny the pages of his publications to any publicity whatsoever for rival styles, thereby coercing much of the industry (designers, manufacturers, and merchandisers) to follow his lead. Withal, the style rather quickly proved a dismal failure. For further documentation on this episode see Luther 1990.

of the arts—but the sheer massiveness and demand constancy of the apparel market, along with, of course, heavy fixed capital investments in clothing manufacture and distribution, combine to restrain unbridled artistic license in couture more than in the other arts. (We all, after all, wear clothes nearly all of the time, but few of us regularly read poetry or install contemporary art in our homes.)

Massiveness and economic necessity also act to greatly diminish, nearly to the point of extinction, the role of the critic in dress fashions. Whereas a prestigious theater critic or art critic can make or break a play or gallery exhibition, a writer on clothes fashions exercises no such power. To the extent that some of the fashion press aspire to such influence, the expectations of publishers, advertisers, and readers (and nowadays cable TV viewers as well) usually conspire to dilute their "criticism" to little more than reportage or, worse yet, promotional copy for some designer, line of apparel, or department store chain.

Southern California fashion writers and editors I interviewed stated as much. As one of them put it, "Mostly what we do is report on what's in the stores, and what's in the stores is pretty much at the end of the cycle." Some said their own tastes would often diverge sharply from the fashions they were asked to report on, but the market-accommodative norms of fashion journalism prevented them from venting criticisms. From what I could generally ascertain of the careers of persons in the fashion press, few have the sort of training and background one associates with the role of critic. For example, of the four I interviewed, none had any formal education in design, art, or art history. All had drifted into fashion writing from other reportorial assignments. In sum, the very notions of "critics" and "criticism" as we know them in the other arts seem strangely misplaced when applied to clothing fashions.

The point to all this is not the scarcity of fashion critics as such, but the recognition that the presence of critics and critical audiences in the other arts acts as both a check and prod to creative activity. At very least, it is usually they who provide the language terms and cognitive frames by which "new work" is apprehended and appraised. This means that, apart from confusing responses from a poorly differentiated mass marketplace, the designer qua

artist has fewer signposts to guide his or her creative endeavors;[5] aesthetic standards are less sure, and a kind of anomic condition can easily come to prevail in the craft. Put differently, whether one approves or disapproves of the influence critics exert on creative activity in the arts, it is at once obvious their presence makes for a very different creative milieu for the artist than their absence.

To return to the ever-nagging prior question of where designers "get their ideas from," the platitudinous though probably true answer (and one I would invariably hear whenever I asked) is "anywhere and everywhere." The answer is, I would hazard, shorthand for suggesting that talented designers, like artists everywhere, think constantly of what they next want to do, and "just about anything" can prove a source of inspiration or touchstone for a fruitful idea. Some indication of the free and fluid impulses at play in the mind of the designer can be had in the following excerpt from a profile on the renowned Japanese couturier Issey Miyake (Cocks 1985):

> Working with his close associate Makiko Minagawa, Miyake creates his own fabric from what he calls a "broad image, not necessarily too specific. Something from daily life: leaves, trees, bark, sky, air. Anything. A noodle." "To know what kind of fabric he is going to want," Minagawa says, is not merely a matter of "what color the sky was that day, but what kind of dance or architecture he is interested in."

Likewise, the leading Italian designer, Giorgio Armani, is reported (Morris 1990b) as tracing the inspiration for his 1990 fall and winter collection to "such diverse sources as the mountains of Mongolia and China. (His slouchy daytime look, he said, was suggested by photographs of Cuban intellectuals in the early 1930's.)"

True, couturiers have been known to consult books of costume history for ideas, as well as to shamelessly "borrow" from their

5. In this connection, Rosenblum (1978, 346) has proposed the interesting thesis that in creative fields where "proximate organizational influences dominate," i.e., those where markets have a more direct and immediate impact on what gets produced and distributed (as is certainly the case with fashion), one is less likely to witness the development of "complex and diverse [aesthetic] imagery" than in those where "remote institutional influences dominate," as, for example, in art photography or serious music composition.

own earlier work and that of others. But the easy cynicism that holds that purloining the past is essentially *all* that is involved is, judging from innumerable biographical and autobiographical accounts (Batterberry and Batterberry 1977; Dior 1957; Lynam 1972), far off the mark. Rather, what is frequently cited in the biographical literature and in the fashion writings of journalists and scholars (see Blumer 1969a; Boodro 1990) is the heightened awareness and receptivity of the great couturiers to emerging developments in the arts, especially the visually oriented ones of painting, sculpture, architecture, and dance.[6] Perhaps subscribing, if only unwittingly, to that questionable theory often called upon to explain fashion, they lean to the view that trends in the fine arts presage a nascent *Zeitgeist*. They believe that insofar as couture is capable of echoing such trends, their designs will put them a step ahead of others in finding favor with fashion cognoscenti and, eventually, with the public at large. The remarks of the Italian designer Gianni Versace (Morris 1990d) are typical:

> "I am not interested in the past, except as the road to the future. . . . I am never nostalgic. I want to understand my time; I want to be a designer for my time. I love the music, the art, the movies of today. I want my clothes to express all of this."

"Fashion forecasters" (of which, more later) are, it seems, of much the same opinion with respect to fashion's muse. A director of Promostyl, a French firm of fashion forecasters and stylists, describes the condition thus (Green 1985):

> "You have to be plugged in to the underground of cities that are in fashion—everything that's culture, everything that's fashion. You see an art exhibition well received in New York, Paris, elsewhere, you must say to yourself, 'Hey, why is this exhibit important?' "

Versace's and Promostyl's fixing on the present and near future aside, it is also true, as fashion commentators are forever noting, that a fair measure of fashion innovation finds its inspiration in

6. Artists themselves have been known to make major detours into the field of clothing design. Some important figures who did so are the Russian-French painter Sonia Delaunay (1884–1979), the Russian constructivists Nathalie Gontcharova (1881–1962) and Lyubov Popova (1889–1924), and the Bauhaus sculptor Oskar Schlemmer (1888–1943).

nostalgia. Periods whose events leave them well marked in the flow of time and are yet capable of evoking collective memories of a pleasant sort seem peculiarly subject to nostalgic recall and revival (see Davis 1979). This accounts, I would hold, for the frequency with which fashions from the 1920s and 1960s have been resurrected for recycling and reinterpretation. Revivals, however, if only by virtue of one's recognition of them as such, can never experientially replicate the original regardless of how exact designers strive to be in their reproduction of details from the period.[7] Ultimately, perhaps, it is in the subjective discordance of the original with its resurrection, that is, the sense of time warp thereby induced, that the distinctive *fashion* element in a remembered style is to be found.

But no matter what the sources from which designers derive their ideas may be, it is important to recognize that the presentation of those ideas in designer sketches, in the garments themselves, in mannequins parading down runways, in first reports and photographs in the fashion press—all of this occurs against the visual and psychological backdrop of the most recent fashion, which, in the nature of the case, is still the dominant mode even as it is on its way to being eased out. Inevitably, therefore, the new fashion finds itself in a kind of dialectical relationship with the extant one. Indeed, it derives much of its direction and distinctiveness from the manner in which it engages the values and moods expressed in the still current fashion; for example, whether it chooses merely to contrast with them, overthrow them, or radically extend them. Or, as this same thought has, with slightly different emphasis, been expressed by a thoughtful fashion columnist (Brubach 1986):

> Fashion exists in that tension between the past and the future, the familiar and the undiscovered.

7. More often, however, designers, sensing that "then" cannot be made into "now," take liberties with the stylistic features of the original. Reporting on the London fashion season's revival of the 1960s, Morris (1990e) writes: "In their current incarnation of the 60's spirit, the most successful designers have softened the sharp edges and blunted the aggressive thrust of clothes of that time. If you listen carefully, you can catch an echo of the protest, but many of the clothes shown in the spring collections here last week are simply gentle and relaxed. Only the very short hemlines remain."

It can then be said that, as with the arts generally, the reigning mode acts also as constraint on the fashion-to-be. Not "just about anything" is possible. Whatever is proposed must in some meaningful way address itself to what already exists. The point may seem obvious, but it must be emphasized in order to put to rest a familiar thesis, both critical and popular, which holds that fashion is change merely for the sake of change; that any change will do as well as any other provided the public is ready for change (Wolf 1980). The perennially labile issue of hemline length provides a recent example illustrative of the point (Morris 1991):

> Hemlines are in a similarly precarious state. For after several years of mid-thigh hems (which postfeminist women did not necessarily embrace), designers have that faint sense of unease indicating an imminent change. . . .
> The reason couture designers picked up on these irregular hemlines [short in front, long in back] is simple: they offer a bridge between short and long hemlines. They also help accustom the eye to what's coming along the fashion track.

I shall have more to say on the matter of likely and unlikely changes in fashion direction later in the discussion of haute couture. For now it may suffice simply to point out that some changes one can easily think of (e.g., Rudi Gernreich's futuristic topless day wear; Poiret's pre–World War I "lampshade" dress; nineteenth-century street gowns that swept the ground) clearly fall so far outside current practice and sentiment that they stand no chance of fashion acceptance.

A frequently raised related question bearing on the creativity of the successful designer is whether he or she is specially adept at sensing "what women want" and, if so, what this ability consists of. Do talented designers possess some "sixth sense" for tapping into women's "collective unconscious" or, perhaps, "collective semiconscious"? Can they somehow divine women's inchoate yearnings so as to then fashion into cloth new symbolic arrangements that assuage or possibly even resolve the psychic tension?[8]

8. Interestingly, the phrasing of this intriguing and important question in fashion writing is almost always in terms of women and hardly ever in terms of men. In part, of course, this reflects the post-eighteenth century historic precedence of

The following, from a biographical sketch of Chanel (Ashley 1972, 117), is characteristic of what is written about many famous couturiers, past and present:

> She [Chanel] now [during the first World War] produced her first stroke of unmistakable genius [the famous Chanel jacket]: the genius for sensing just what women wanted a split second before they knew it themselves. The ability to sense and provide for a corporate need.

Hollander (1980, 351) offers a fuller and more reasoned argument along the same lines:

> It has been thought that designers dictate to a gullible public. But many expensive and pretentious designers fail where one succeeds, and successful designers also perpetually risk failure in their attempts to seize and direct even a small portion of the public taste in personal looks. The truly successful designer has an instinct for visualizing sharply what is perhaps nebulously and unconsciously desired.

Short of accrediting the questionable "change for the sake of change" theory of fashion, it seems altogether plausible to assume, albeit difficult to prove, the existence of subtle, nonverbal exchanges between couturiers (and, of course, artists generally) and their publics. The more difficult task is to specify what such communication consists of. In this work I have placed great stress on the centrality of culturally encoded identity ambivalences for fueling fashion's ever-shifting symbolic forays. Doubtless, however, other symbolic configurations come into play as well, as witness the oft-noted reverberations of economic and political conditions on clothing fashions (Lowe and Lowe 1985), e.g., the dropping of hemlines in the wake of the post-1929 world depression as if to mark an end to 1920s jazz age frivolity; the movement to mannish, military style jackets for women during the Second World War; the "space age" stylings of Cardin, Courrèges, and Gernreich following Sputnik and the other space explorations of the early 1960s; the "antifashion" fashions of the late 1960s

women in matters of clothing fashions. At a deeper level, however, it also echoes the conventional cultural stereotype of women as "the mysterious sex," persons whose moods and desires defy rational formulation and thus require an artist's arcane talents in order to be properly understood.

(jeans, ethnic wear, decorative costuming, etc.) that seemed to celebrate the protest postures of the era. However different their social circles, designers and their publics do, after all, live in the same world over approximately the same historic span. It should not be surprising, therefore, that common concerns and prevalent conditions are likely, however indirectly, to find their way into the silent exchange of symbolic gestures between them.

This said, though, it would be wrong to assume, as do *Zeitgeist* theorists of fashion, that the totality of fashion boils down to just this, i.e., a mirrorlike "reflection of the times." As I point out earlier in this chapter, not only do most *Zeitgeist* theories suffer from the *post hoc, ergo propter hoc* fallacy, but one is hard put often to find any symbolic connection at all between the great political and economic developments of an age and its fashions. How have the Holocaust, the decline of nineteenth-century imperialism or, today, AIDS and the democratic upheavals in Eastern Europe been reflected in fashion? This is not to say that events of this or even lesser magnitude have no bearing whatsoever on what designers come to create—AIDS, as I suggest in chapter 5, certainly does— only that the symbolic influences are considerably more complex and circuitous than any simple, mirror-style invocation of the *Zeitgeist* thesis would lead one to believe.[9]

2. INTRODUCTION

Thus far I have spoken mainly of conditions, endogamous and ex- ogamous, to the situation of the couturier cum designer known to affect the *creation* of new fashions, what Sproles (1985) terms "in- vention." Any serious analysis of the fashion process, however, re- quires the student to be as concerned with the conditions and circumstances affecting what Sproles views as an integral, co- equal portion of the first stage, namely, the *introduction* of new fashions. While there is not too much point in pursuing the some- what academic issue of whether invention and introduction should be conflated in this manner, it is patently the case that not all "creations" make it to the fall and spring openings where, typ-

9. Schapiro (1978, 185–232) makes many telling points against the "art mir- rors the times" thesis in his survey of twentieth-century abstract art.

ically, new fashions are "introduced." Even fewer, for that matter, survive the mannequin's strut down the salon runway.

The distinction is, to be sure, a bit arbitrary in that what a designer decides to create is, as Becker (1982) argues in regard to artistic production generally, bound to be greatly influenced by his or her prior knowledge of the conditions affecting the public introduction of an art work: whether venues are available for its display; how it relates to other new art work currently being shown; the price it can reasonably be expected to command; etc. Still, the mental processes involved—the generation and distillation of ideas versus an intelligent appreciation, and perhaps manipulation, of factors bearing on their public presentation seem sufficiently different to justify treating invention and introduction as distinct stages of the fashion process.[10]

Of the variety of conditions, at nearly every level, that impinge upon the public introduction of new fashions, there is, first and foremost—something Blumer (1969a) emphasized and is daily brought home in press accounts from Paris, Milan, and other fashion centers—the fact that the occasion is marked by intense competition among designers. In lesser degree, the competition extends to major corporate buyers who vie among themselves to "pick a winner," i.e., a fashion that will set trends and be highly profitable for their stores.[11]

This proposition may seem misplaced in light of what often is felt to be a remarkable sameness in the new dress fashions shown by different designers at the fall and spring openings in Paris and

10. Indeed, over the centuries famous artists have characteristically displayed vastly different aptitudes for one as against the other. Consider, for example, the familiar comparison of the nineteenth-century pianistic contemporaries Chopin and Liszt. The former, a creative genius of the highest order, was much less adept at impressing audiences than was Liszt, whose own compositions are much inferior musically.

11. Earlier, and even now, though to a greatly reduced extent, the competition to be among the first to adopt a fashion-to-be was in the main limited to prominent society figures and personages from theater, dance, the popular music hall, etc. In major European capitals until well into the present century the latter often merged with a bohemian demimonde who, as Simmel (1904) noted, could because of their marginal location in the class structure play a strategic role in the introduction of new fashions. That is, they were neither important enough to prove threatening to the upper classes nor so unimportant as to be unseen or altogether discounted by them.

elsewhere. Some attribute the apparent sameness to the preseason sample presentations of major Swiss and Italian fabric manufacturers who, for reasons of their own, choose from one season to the next to promote some fabric designs rather than others (Hochswender 1988a). This, it is said, channels the fabric choices of couturiers toward certain themes, which in turn results in striking similarities in the collections displayed. But one manufacturer of women's fashions I spoke with said, to the contrary, it was the leading Parisian and Milanese couturiers who "suggested" to the fabric houses the textiles and fabric designs that would be of interest to them in forthcoming seasons. In either case, it would be quite mistaken to think that similarity of fabric makes for similarity of design. Different designers, of course, fashion the same fabric differently.

Even among designs that appear to be quite similar, however, there remain often subtle, yet meaningful differences in aesthetic and commercial appeal. That the similarities are to an extent as actual as they are apparent—and there certainly are seasons in which such is the case—can probably be traced to the fact that by the time the new fashions are paraded at the annual collections they have already gone through an extensive filtering process, the effect of which typically is to produce greater rather than less consensus among designers. Industry gossip on what "the others" are doing, hints in last year's collections of "new directions" that at the time seemed premature or failed for other reasons to "take off," the frequently off-the-cuff observations and merchandising opinions of important buyers, and, increasingly, a shared nervous attentiveness to spontaneous street fashions (especially those of big-city youth) all contribute, in indeterminate combination with still other influences, toward setting the vector of a new fashion well before it reaches the stage of becoming established as such. Add to this the increasing utilization by certain design houses, apparel manufacturers, and major merchandisers of so-called fashion forecasters—just a few firms in Paris and New York monopolize the business (Bogart 1989; Cone and Scheer 1990)— and one can appreciate the many forces making for considerable, if still far from total, design consensus at the point fashions make their seasonal introductions. Thus, while a suspect consensus seems to infuse the new creations of ostensibly independent and

rival designers, that very consensus is attained through competitive processes. In that process more gestures are arrested than completed, and more ideas are abandoned than kept.

But even so early in the fashion cycle, consensus can prove a fragile thing. Not only must the new creation survive later stages of the cycle before it can be truly established as a fashion, but at the very moment of its public introduction there nearly always are a few dissenting and oppositional postures to contend with. Like the proverbial dark horse, one of these may in the end win the race of public acceptance. Or the race may fall into such disarray as to produce no clear winner, making it possible for the "old fashion" to survive for yet another season. A vivid picture of the contending forces and contrary tendencies emerges from a *New York Times* report (Morris 1986) of the fall 1986 Paris openings.

> In the end, what stayed in the mind after the Paris shows was a haze of short ruffled and poufed dresses in blazing colors, tightly belted and with bare shoulders. There were other clothes, of course, notably Valentino's wearable, day-through-evening styles and the chic, elegant clothes Karl Lagerfeld made for his own company.
>
> But the dominant impression was of madcap frivolity, typified by frilly short dresses for the very young.
>
> At the same time, a countertrend was developing in the hands of such avant-garde designers as Jean-Paul Gaultier and Patrick Kelly. They were making skin-tight clothes out of stretchy swimsuit fabrics that left absolutely nothing to the imagination. It will be interesting to see whether the cancan or the clingy look will prevail among fashion's most ardent followers.

Much of this early-stage design confusion in the fashion world results from the overlay of what Bourdieu and Delsaut (1975) term "strategies of conservation" with "strategies of subversion." As may easily be inferred, the former is favored typically by older, more established designers anxious to extend and build upon the signature designs that marked their first successes. The latter is characteristically the tack of younger "upstart" designers who, trading on the latent desire of fashion cognoscenti to be stunned by the brash and unexpected—expanding on Veblen, Quentin Bell (1947) terms this "conspicuous outrage"—try to muscle their way into a field dominated by "star" designers from well-

established houses. It is not uncommon, of course, for talented "subversives" to get bankrolled by business interests and, within a few years, to find themselves among the well-established.

In general, the countercyclical impulse is almost as assiduously cultivated in fashion (see chapter 8) as it is throughout the modern arts. Many historically celebrated couturiers, Chanel, Vionnet, and McCardell among them, made their reputations through flaunting the established clothing conventions of their time (Morris 1987a). Still, precisely because it is just that, *countercyclical*, the gesture is, at least commercially, more often quashed than realized. This helps explain why, despite repeated assertions of originality and indifference to the dominant trend, most designers in the end tend to move with the pack rather than break off in uncharted directions of their own.

What at one time belonged exclusively to the domain of haute couture, namely, the design studio and its numerous associated arts, crafts, and technologies, also has, of course, a profound bearing on the many linked and overlapping phenomena of fashion invention and introduction I have been writing of. For much as new and fresh ideas may underlie fashion's inception, it is the joining of a highly complex set of crafts and skills—from fabric selection to buttonhole sewing, to the work of models, to, in effect, theater management (to mention a mere few)—that is responsible for bringing those ideas before an interested public. How the crafts, skills, and talents are coordinated and integrated will naturally have a great bearing on the introduction of a new fashion and on the reception it receives. These tasks devolve upon the management of the fashion house rather than on the designer per se, notwithstanding that the latter may, as is often the case, choose to be closely involved in the process. As with cuisine, where the culinary talent of the chef hardly guarantees the success of the restaurant, so with fashion: More than design brilliance or originality is called for to succeed or, for that matter, to even get one's name before the public. On visits to Los Angeles and New York fashion houses I would regularly be told of talented designers who came a cropper because of the poor workmanship of their finished apparel, late deliveries, sloppy billing practices, etc. Similar reports are a staple of the fashion press (e..g, Hochswender 1988d) and acquire over time the mythical patina of a tribal cautionary tale.

Haute Couture

Regarding the institution of haute couture itself—its nineteenth-century origins and organizational evolution; its changing relationship to its clientele, the mass market, and the social order sustaining it; its shifting stature in the world of taste and among the arts generally; its role in the spread of Western dress to peoples and societies everywhere—several volumes of historical and sociological analysis would be in order, if only to better understand how a phenomenon that on its face seems so ephemeral and capricious came to command the immense artistic, financial, marketing, and organizational resources it did and, though now sociologically much altered, still does.[12] Without meaning in the least to slight the importance of such an inquiry (see Brenninkmeyer 1963; Steele 1988), I can here only comment on haute couture's present-day role in the launching of new fashions or, specifically, on the question of whether a new fashion "takes off" or fails to.

The pronounced consensus among students (Anspach 1967; Batterberry and Batterberry 1977; Brenninkmeyer 1963; Fraser 1981; Hollander 1980; Konig 1973; Wilson 1985) is that, much as the haute couture may still serve as the principal locus of fashion inspiration (and there is reason to believe that this, too, is no longer what it was), its influence over what happens once a new fashion is launched is nowhere near as great as it was through the last half of the nineteenth century up to as late, perhaps, as the years immediately following the Second World War. A variety of factors accounts for this; many of them can be subsumed under the generalization that over the past century the propagation and

12. Whereas a near literal translation of the term would render it as "high quality tailoring," it is, of course, its metonymic usage we have in mind, namely, those prominent dress houses, mostly Parisian, though increasingly in recent decades in Milan, London, and New York as well, that dominate the official, as it were, introduction of new fashions. These are the houses that stage the semiannual shows, widely reported in the world press, to which the clothing trade and fashion-conscious persons generally look for indications of the directions fashion may take. The leading Parisian houses are organized into a powerful trade federation, the Chambre Syndicale de la Haute Couture, which receives considerable economic support from the French government. It acts as official host for the semiannual Paris fashion shows and sets criteria for the designation "haute couture" by French fashion houses (Brubach 1988). No similar organization exists in the Italian, American, or English fashion industry.

diffusion of fashion have become subject to strong democratizing trends. What had been a rather privileged relationship between the couturier and his exclusive, wealthy bourgeois women clients had by the time of the First World War become universalized into an abstract market relationship between him and a much broader, though still predominantly bourgeois, fashion-oriented public. The client-linked acclaim accorded the English-born Parisian tailor Charles Frederick Worth (1825–1895), generally regarded as the father of modern haute couture, stands in vivid contrast to the celebrity, media-star status of today's more successful designers.[13]

At the court [of the Second Empire in the early 1860s] Worth maintained a studious politeness and distance from his clientele. The one phenomenon which never came to Worth in his lifetime, by his own choice, was social acceptance in the high society of France. Unlike his descendants—Dior, for example—he never mixed on equal footing with the *beau monde* of his day. He considered himself always as a "tradesman," rather than a socially accepted artist, although he came to live in regal splendor at a country house he had built outside Paris. . . . This [social acceptance by the beau monde] was a development in the status of the couturier which emerged with the social changes of World War I. (Settle 1972, 54–55)

The democratization of fashion was furthered, of course, by major technological advances in the late nineteenth and early twentieth centuries in clothing manufacture. It became possible to produce en masse credible copies of what previously, because of the sewing and tailoring skills entailed and the cost of materials, could only be produced in the couturier's workshop or, by some talented seamstress working from patterns for long hours at her sewing machine. The fashion press, which with the spread of literacy also grew phenomenally over this same period, functioned in tandem with mass manufacture to further diminish haute couture's dominance in the fashion marketplace. Certainly, by the mid-twentieth century ready-to-wear (*prêt à porter*) had become the terrain on which the viability of new fashions would be tested.

13. As far as name recognition and notoriety go, in America clothing designers did not, with some few exceptions, come into their own until the 1960s. As Morris (1988b) observes in her obituary on a prominent apparel manufacturer, "Until the 60's designers tended to be anonymous workers in the back rooms of fashion houses, and it was the manufacturer's name that was on the label."

By then, more and more classes of fashion-conscious consumers, including some of quite modest means, had been brought into fashion's orbit.[14] Indeed, by the 1920s a shopgirl could, to the casual eye at least, dress as stylishly as a *grande dame*. Moreover, knock-offs and the speed with which clothing designs could be put into mass manufacture made it impossible to confine a new fashion for more than a few weeks to the small elite groups who in earlier times had been its parade ground for whole seasons and even years.[15]

Once fashion consciousness spread beyond its mainly elitist preserves, two important developments ensued. The market for fashionable clothing, and for fashionably styled consumer goods generally, expanded enormously. At the same time, designers became much more dependent for their success on a diffuse public rather than on the small circles of upper-class women whose stamp of approval they had sought formerly. This meant that while haute couture designers might still be looked to for fashion originality, the vagaries of public taste and the economic uncertainties of a mass consumption economy prevented them from dictating what fashions would be to nearly the same extent as they had when they were able to bring their personal influence to bear on exclusive clienteles and when, in general, fashion's orbit was a good deal more circumscribed and homogeneous. As I have noted in other connections, a number of notorious fashion flops over the course of the twentieth century testify to the diminished authority of haute couture. Most recently (1987–89) the short-skirted haute couture "pouf" and "bubble" designs of Christian Lacroix, which received extravagant praise from the fashion press and fashion cognoscenti following their 1987 Paris introduction, fared abysmally in their ready-to-wear versions. Prestige department stores and exclusive boutiques that rushed to carry Lacroix's line of ready-to-wear were soon offering drastic markdowns on his

14. Even Chanel, known for her arrogant posturing in matters of dress, is reported to have stated in 1953: "I am no longer interested in dressing a few hundred women, private clients; I shall dress thousands of women" (quoted in Wilson 1985, 89).

15. Knock-offs are products of the unauthorized plagiarizing and copying of Parisian and other haute couture designs of manufacturers wishing to get a jump on the fashion market. The practice is quite widespread, and, unlike copyrighting in other fields, there appears to be little the design originator can do about it.

gowns and other apparel. Within the year many stores dropped Lacroix altogether.

Still, rather than destroying the haute couture, the democratization of fashion has served to greatly transform its cultural scope and character. Today the chain of fashion influence is no longer that between the designer, an exclusive clientele, and progressively removed circles of fashion followers. Rather, since World War II, and in certain respects well before that, a more complex linkage has, via *prêt à porter*, been forged between the designer and a faceless, abstractly defined fashion public, major segments of which are likely to respond differentially, less submissively, and in accordance with different temporal rhythms (some slower, some faster) to new fashions offered them. Haute couture designs, therefore, now hardly function at all as the exclusive emblems for aspiring social classes; rather, they are more like competitive, aesthetically framed market "statements." Their aim is to point a direction or set a trend (Blumer 1969a; Brubach 1988) that, by succeeding in the massive, worldwide ready-to-wear market, redounds to the repute and wealth of the haute couture house and the corporate allies and affiliates tied to it by a variety of licensing, franchise, and other contractual arrangements. The designer Pierre Cardin, for example, has licensed his logo to more than eight hundred products (Milbank 1990, 64).

A number of interesting developments for the presentation and diffusion of fashion have resulted from the great influence the vast ready-to-wear market has had upon haute couture design. First, through its association with prestigious name designers (e.g., St. Laurent's Rive Gauche, Armani's Emporio, Kawakubo's Comme des Garçons, Donna Karan's DKNY) ready-to-wear has acquired much of the snob appeal and cachet once reserved for haute couture itself. Many designer ready-to-wear items nowadays command four-figure dollar prices reminiscent of what until recently was charged for custom crafted haute couture. (Haute couture creations, if marketed at all, can cost in the tens of thousands.) Short of their being drastically marked down later in the season, which they often are, it is only the very wealthy who can afford them.

Second, because the semiannual fashion shows in Paris, New York, and elsewhere hardly serve any longer as occasions for linking a designer to his or her small, exclusive clientele, but instead

aim ultimately to capture a vastly expanded ready-to-wear market, they have come increasingly to resemble theatrical productions and prearranged media events (Cunningham 1988). Elaborate stage lighting, specially arranged taped musical scores—one I heard was a pastiche of Mahler, Mozart, Rilke poetry, the rock group U2, and Paul Simon—amplified on the most advanced theatre audio equipment, statuesque mannequins coached in miming the most affecting expressions of daily life: All these and still more are now de rigueur for even a modest fashion show in one of the world's fashion capitals. This has, of course, driven up the costs of fashion shows inordinately—$200,000 for a front-rank designer like Bill Blass, $120,000 for a middle-rank one like Charlotte Neuville (Hochswender 1988e)—to where younger aspirants simply cannot raise the capital to stage them. It has also acted to further falsify and make meretricious the relationship between what is displayed on the runway and what is sold in the marketplace. As Hochswender (1988e) reports:

> In reality, most of what comes down the runway loses money, according to industry sources. Major designers, with few exceptions, make their fortunes through product licenses—for example, perfume or lower-priced sportswear—once they've established their names. The designer collections, with their fantasy styles, function as "loss leaders," shown for prestige value and fashion direction. The shows are essentially dream sequences, based on designer-name illusion.
> . . . Mr. Blass considers the [fashion] show a "giant come-on," but he does it anyway. "It impresses the hell out of the licensees," he said, referring to the companies that contract to manufacture Bill Blass–designed products. "As obsolete as the fashion show may be, there's no other way we can generate the same excitement."

In general, the growing disjunction between the fashion show's presentational effects and what is actually put up for sale would seem to fully warrant Blass's cynicism. Another of Hochswender's (1989c) Paris bulletins chronicles a somewhat bizarre instance.

> PARIS, Oct. 23—At one point during the Thierry Mugler show last week, the model Linda Evangelista cruised down the runway in a chrome and plastic bodice that resembled a speedboat dashboard. She pushed a button in her midriff, casually extracted an electric cigarette lighter and had herself a smoke.

Such fashion theatrics . . . are just that, theatrics.
Buyers who came to his Faubourg Saint-Honore show room today
saw a somewhat different collection. At a working "mini-show," held
in the same blue rococo room as the runway presentation, about 50
merchants sat at tables with order forms in front of them.
"Here they send out all the suits and salable dresses," said Bar-
bara Lemperly, the buyer for advanced designer clothing at Saks Fifth
Avenue. "You can wear some of them to business meetings."
. . . Jackets trimmed with chrome [in the runway show] could be
bought without it. The models were smaller, less glamorous.
"For a long time we didn't invite clients to the runway shows,"
said Didier Grumbach, the chairman of Thierry Mugler. "We were
losing too many who didn't understand. Thierry makes themes. The
shows create a concept."
A white leather diver's jacket from the runway show, with port-
holes, gauges and chrome tubes, had been stripped down and
simplified (the original weighed more than 35 pounds). . . .
The speedboat bodice with cigarette lighter? It wasn't on the or-
der form.

Last, though of distinctly lesser import, is this ironic circum-
stance: To the extent that genuine haute couture apparel is actually
stocked by "upscale" department stores like Nieman-Marcus or
Saks Fifth Avenue, this, too, is done primarily to lend prestige to
the store and not from any serious expectation of actually selling
such extraordinarily expensive ware for a profit. A fashion-
knowledgeable New York woman I spoke with told of visiting the
designer clothing departments of several leading New York de-
partment stores to inquire about Parisian haute couture apparel
the stores had recently advertised. The salespersons who waited
on her did not know where to lay hand on the advertised items.
They also had difficulty remembering and pronouncing the de-
signers' French names.

Having over the course of the twentieth century restructured the
audience for fashion, haute couture qua design, if it was to survive
at all, had to adapt in a number of ways. It was to become more
polycentric in its locus; Paris, though still dominant, is no longer
the sole cynosure. It would become more open and responsive to
"outside influences"; witness the "fashions from the streets"

eruptions of the 1960s that, as a recent report makes evident (Bru-
bach 1991, 94), has not altogether abated since:[16]

> This season, Lagerfeld has found his inspiration in the street: in the
> B-boy style worn by the guys who sell fake-Chanel sweatshirts on the
> sidewalks in New York; in bikers; in club kids dressed in early-
> seventies, late-hippie clothes that they bought at the flea market.

The haute couture would become more polymorphous, too, in
the range of clothing motifs and styles offered the fashion-buying
public; the 1960s seemed to mark the end of that extended era
when a single fashion, be it a skirt length, a garment, a color, or a
silhouette, would come to so dominate the field that it would to-
tally exclude all other lengths, colors, silhouettes, etc. Remarking
on the near unanimity with which the Paris haute couture seemed
to climb aboard the changed fashion signaled by Lacroix's 1987
"pouf" styling, the fashion columnist Bernadine Morris (1987c),
sounding a slightly nostalgic note, wrote, "This is the way it used
to be, when the couture was considered the world's laboratory of
fashion and when a hemline set by a couture leader was estab-
lished around the world." The ascent or descent of a hemline in
Paris or some other fashion capital may still signal a fashion
change, but its occurrence no longer carries all other hemline
lengths with it as it once did.

In summary, then, it is probably fair to say that, although Pari-
sian haute couture still serves as the prime arena for introducing
new women's fashions to the world, the conditions and character

16. So powerful had seemingly capricious fashion influences "from the
streets" become by the late 1960s that there were many "in the trade" (e.g., gar-
ment manufacturers, department store buyers, retailers, and designers themselves)
who feared that fashion, as some more or less ordered diffusion of taste choices,
was finished. The anxiety sprang much less from any sentimental attachment to the
institution of haute couture as such than from the sheer confusion and unpredic-
tability fashions from the streets introduced into the marketplace. One could not
sense from one month to the next where fashions were coming from and going, or
what quirkish fad (e.g., kaftans, torn jeans, spandex bodysuits) was about to dis-
place the current rage. The course of fashion had never been particularly predict-
able, but what came into being during that turbulent decade seemed little short of
anarchic. The current consensus is that in the intervening years a fair degree of sta-
bility has been restored to the fashion marketplace, although there are many who
fear that the temblors of the 60s portend some final fashion cataclysm one year
soon.

of the introduction have changed so markedly over the years that the ensuing fashion process is now far different from what it once was.

Constraints of Cultural Continuity and Economic Feasibility

Irrespective, however, of the role haute couture once played and may yet play for introducing new fashions, important questions remain regarding the constraints that almost invariably impinge upon the process and under some circumstances can inhibit it altogether. Quite apart from such elusive matters as taste appeal, two in particular, usually lost sight of by students, are worth mentioning. The first is what the Lowes (1985, 202) have termed "inherent brakes in the form of cultural continuity and aesthetic rules" on the fashion process. By this they mean to suggest that visually, with respect to such basic physical features as a garment's dimensions and proportions, a new fashion will not be assimilated if it departs too far from what preceded it. Of course, it is not always easy at any particular historic moment to say what exactly will be perceived by the fashion public as "too far." Still, certain possibilities one can conceive of clearly fall beyond the pale. For example, the Victorian crinoline, or any style nearly approximating its exceptionally wide skirt width, could not conceivably be accepted as fashion in today's world. Much the same probably holds for the very protuberant bustle or wasp-waist corseting of the late nineteenth century.[17] However far, then, it presumes to depart from the prevailing mode, fashion must in the end sustain some vital cultural connection to its near past.

Second, even if at the point of its introduction a fashion does possess sufficient aesthetic appeal and is not culturally discordant with what came before, the question remains whether its design features and/or price structure are such as will enable it to pass through what one writer (Fraser 1981) has termed the "industrial web" of the fashion industry, i.e., the technology of mass garment production, established merchandising channels, cost economies, etc. (cf. Rosenblum 1978). If an appealing fashion is judged want-

17. As noted earlier, such examples argue against the view that fashion is nothing more than change for the sake of change regardless of the change proposed.

ing on these counts, it is almost certain to die soon after being introduced—that is, assuming it did not fall by the wayside well before it was trotted onto the modeling ramp. And even after a success there, many questions remain, as was explained to me by a New York fitting model.[18] For instance, can the "one of a kind" garment created for runway presentation, given the technical requirements of large-scale production, be adapted for multiple manufacture?

3. FASHION LEADERSHIP

Once a fashion is presented to its premiere audiences—nowadays, chiefly buyers from large department store chains along with members of the international fashion press—and is seen by them as potentially viable, there follows a period of uncertainty, increasingly short in today's world, in which interested parties attend closely to whether "key persons" adopt the fashion. This stage of the fashion process is usually referred to as that of "fashion leadership" and, like so much else about fashion, is now very different from what it once was (Blumberg 1974). Through most of Western history, up to the time of Worth and the founding of haute couture establishments in mid-nineteenth-century Paris, fashion leadership was to be found mainly in court society among the wives, daughters, and mistresses of male aristocracy and, in the earlier periods, within the male aristocracy as well. From the mid-nineteenth century until well into this one it was mainly the *grandes dames* of upper-class business society who would grant or deny their stamp of approval to a new fashion.[19] Following acceptance by them it would, in line with Veblen's and Simmel's *fin de*

18. Fitting models, as distinguished from the runway models who appear in fashion shows, are employed in the workshops of designers and manufacturers. It is upon them that the designer's new creation or the to-be-manufactured version thereof is actually fitted. Although they earn less than runway models, they are much closer to the processes of design and manufacture. The fitting model I interviewed was spoken of in the trade as "a perfect size 8."

19. However, before the stamp of approval was granted a new fashion by the *grandes dames* of the bourgeoisie it was not unusual for it to first be "tested" by fashionable actresses, courtesans, kept women, and others of the demimonde. Proust's monumental *Remembrance of Things Past* alludes to this in many places (Steele 1988), and Simmel (1904) essays a fascinating sociological analysis of it.

siècle trickle-down theory, radiate out in slow waves to persons farther and farther down the social ladder. As we have seen, a very different condition obtains today.

If anything approximating pre–World War I fashion leadership can be said to exist today, it has, at minimum, splintered into several segments, each constituting something of a taste elite in its own right with a rather amorphous and fluid band of followers trailing in its wake. The fashion writer Carrie Donovan, for example, distinguishes three kinds of fashion leaders in today's world: avant-garde (i.e., stylistically adventuresome), luxury (i.e., expensively dressed) and real-life (i.e., "everyday" middle- and upper-middle-class fashion-conscious women), the last comprising by far the largest segment (Donovan 1983). Moreover, neither the avant-garde nor real-life leaders can be thought of as remotely the equivalent (in terms of social position, money, round of life, and personal influence) of the aristocratic and haute bourgeois fashion elites of yore. And while the luxury segment probably does include women every bit as wealthy as, if not wealthier than, their turn-of-the-century forebears, the sheer growth in size, heterogeneity, and democratized manners of monied social circles has acted to greatly diminish the force and breadth of the fashion leadership they can exert within this stratum.

At that, one should not make too much of Donovan's tripartite division of fashion leadership. As she herself recognizes, in the aggregate it is hardly the case that the lines separating them are so clear or the divisions as such so homogeneous in themselves. Though at their source these emphases are, one can assume, fairly distinct and aesthetically referable to different fashion genres, as their influences radiate out there is a good deal of mixing, overlapping, and confounding of tendencies.

Indeed, some students would challenge whether it is correct to conceive of fashion leadership in these terms at all. It is not that they dispute the existence of avant-gardistes or the luxury-predisposed in the ranks of fashion-conscious clothes-wearers; rather, they question whether hierarchies of taste transmission are formed around such distinctions. Horowitz (1975), for one, sees the critical distinction as that between elite fashions and mass fashions, each being relatively self-contained and undifferentiated in its own domain. The continuing, large-scale success of certain

popular apparel lines, like that of Liz Claiborne, that pay little if any attention to haute couture fashions (Hochswender 1991e) lends support to this viewpoint.

On the other hand, following from what they see as fairly direct, mass media depictions of new fashions to a large fashion-receptive public, Grindering (1981), King (1981), and Schrank and Gilmore (1973) posit the existence of leadership pockets at all status levels and within all taste subcultures. Accordingly, fashions in their view radiate horizontally from such pockets rather than vertically, from higher to lower, as classic trickle-down theory would have it. Other commentators (Fraser 1981) maintain that in today's world even those regarded as fashion leaders are given to much improvisation in what they choose to wear. Almost as a matter of principle, such persons make it a point not to embrace the latest fashion too closely.[20] The visual impact of such improvisation can often inspire subfashions, which in their own right contribute to and sometimes redirect the trend of a dominant fashion.[21]

As with so much else in contemporary life, the fluidity and openness of fashion leadership today makes it possible for the mass media, particularly the visual media of movies and television, to influence the direction of taste more than had been the case when print media dominated. Without the example of looked-to aristocratic and upper-class models (e.g., the Duchess of Windsor, Madame Martinez de Hoz, Mrs. William Paley) to legitimate the viability of a new fashion, the media, willy nilly (though by no means indifferently), take this task upon themselves. Showing little hesitancy to proclaim the new colors, silhouettes, dress

20. With what is perhaps more than a touch of disingenuousness, designers themselves often counsel their public not to slavishly follow their fashion prescriptions. Patrons are urged to "exercise their own imagination," to add their own "personal stamp," not to be afraid to "break away from the pack," etc. Most such exhortations fall under the (by now clichéd) maxim that to be too much in fashion is unfashionable. They allow a degree of moral scope to the antifashion impulse, which nearly always runs in tandem with fashion itself, thus calming its destabilizing potential.

21. The collective effect of such improvisatory effects is akin to that of the fashion-from-the-streets phenomenon, which many believe has greatly shaken both the haute couture and ready-to-wear fields since the 1960s (Field 1970).

lengths, apparel combinations, etc., they manage in short order to generate a fictional consensus among themselves. (The fear of being out of step with their media colleagues facilitates a kind of tacit agreement on details and tendencies.) This is then represented to interested publics as "fashion reality." This "reality" presumes to lay to rest all further questions of the viability and acceptance of the new fashion. At the same time, because of the public's justifiably defensive habit of discounting so much of what it sees, hears, and reads in the media, the media reality tends in the long run to be less persuasive with the fashion public than were the "real live" aristocratic and upper-class fashion leaders of yore (Cunningham 1988).

The attenuation of "old style" fashion leadership helps account, perhaps, for the greater improvisatory freedom with diverse fashion motifs found at all levels of society nowadays (see Fraser 1981, 200). This is of a piece with the previously noted improbability of a single fashion motif today (e.g., short skirts, padded shoulders, a particular color) preempting and monopolizing the apparel marketplace.

In any event, it would seem on balance that contemporary fashion leadership is profoundly polycentric with respect to its social locations and decidedly polymorphous as regards its thematic materials. Sociological analysis can, perhaps, discern in the abstract its general form (Blumer 1969a; Meyersohn and Katz 1957) but to locate its exact nuclei or trace its precise pathways over the course of a fashion cycle has become a singularly daunting task.

4. INCREASING SOCIAL VISIBILITY

For the marketplace, this is perhaps the critical stage. Much as a new fashion may be praised (as it nearly always is) by fashion writers and publicists, and much as some fashion-conscious persons may, out of a desire to be first in their circle, take to wearing it, will it attain a sufficient visibility to persuade vast numbers that it is about to become, or is already, that fashion which, if shunned, will cause one to soon feel "old-fashioned"? Designer clothing, which up to this point is likely to be the main vehicle for the new

fashion, accounts, it should be noted, for less than 1 percent of the $30 billion annual women's apparel business in the United States (Hochswender 1989b).

It is, then, just short of this point—though well after the Milan, Paris, and New York showings—that manufacturers and merchandisers must assume the risks of major capital, material, and inventory investments in styles that, strictly speaking, have not proven themselves. Not to do so is to incur the (probably considerable) costs of being left out in the cold with last year's stylings or, at best, arriving on the scene too late to profit from the infectious buying enthusiasms that usually accompany a fashion success.

Fashion history is, of course, littered with examples of those who at this stage bet and lost or, contrariwise, failed to bet and also lost. Most recently a near disaster occurred in the fashion industry when it sought to revive the miniskirt and minidress of the 1960s. Although by 1990 the style had received something approximating widespread acceptance, mostly among younger women, great losses were incurred by manufacturers and retailers who on the heels of its 1987 introduction climbed aboard too soon. Even greater losses were experienced in the early 1970s when, notwithstanding strenuous promotional efforts by the fashion press and genuine enthusiasm aroused in some circles, the attempt to get women to adopt the mid-calf, or midi, hem length proved a resounding flop (Luther 1990). Moreover, it should not be thought that because of the acceleration of the fashion cycle and the enormous advertising resources available to fashion promoters nowadays flops of this magnitude are strictly a recent phenomenon. In 1909, Paris's, followed by New York's, dedicated attempts to get women to forsake their straight tight skirts for the pannier skirt, which utilized a great deal more cloth, failed as miserably as any number of more recent fashion debacles (Brenninkmeyer 1963, 74–75).

Failures aside, the process by which the eye—or, more truly, the mind and the self—engages and assimilates the new fashion constitutes a fascinating psychological transformation. It is one wherein the strange is soon rendered familiar and the familiar strange. This transformation of percept and attitude, experienced by millions of persons at more or less the same time, is what, more than anything else, psychologically undergirds the period of in-

creasing social visibility, which of course, is necessary if the fashion is to reach a level of massive assimilation. An acute personal account of the process is provided by the Langs (1961, 470) in an extract from the journal of an American woman returning from abroad in 1947 encountering Dior's New Look:

At every airport where we stopped on the way back from China I started watching the women coming the other way. At Calcutta the first long skirt and unpadded shoulders looked like something out of a masquerade party. At the American installations in Frankfurt (also in Vienna) a lot of the newer arrivals were converted and were catching everyone's attention. At the airport in Shannon I had a long wait; I got into a conversation with a lady en route to Europe. She was from San Francisco, and told me that there they hadn't been completely won over; just as many were wearing the long skirts as not. But as she flew East, she found that just about everybody in New York had gone in for the new styles and she was happy she wasn't staying or her wardrobe would have been dated. By the time I took the train from New York for home, my short skirts felt conspicuous and my shoulders seemed awfully wide! Two weeks now and I am letting down hems, trying to figure out which of all my China-made clothes can be salvaged, and going on a buying spree!

It is rare for the garment or styling or apparel combination, or whatever it is that has become the object of fashion, to make it through the period of increasing social visibility in an unmodified state. Almost inevitably, as the fashion becomes more popular some of its more "extreme" features are toned down. At the same time the anxieties of potential buyers are allayed by assurances in the fashion press and from the mouths of store salespersons that the new fashion is "for everyone," that one needn't be too thin, too tall, too young, too sexy, etc. (depending on which attributes the fashion plays to), in order to wear it to good effect. The blatant marketeering behind such blandishments aside, it needs to be recognized that both the minor stylistic modifications and self-image reassurances proffered the public at this stage make for somewhat more cultural continuity in fashion succession than there would otherwise be.

The "cooking" of a new fashion as it begins to attain widespread visibility is evident at all levels of the trade, from the sales practices of design houses to point-of-sale exchanges between cus-

tomers and salespersons. As a rule, some cooking has, as we have seen, already taken place at the points of introduction and fashion leadership. Not mentioned in those connections is the practice of designers to stage their fashion shows in ways to steer potential department store buyers and other retailers to certain of their offerings rather than others. Aware as designers and, especially, their financial backers are of the inherent conservatism of the apparels market, the privileged offerings tend to be those which, it is felt, stand some reasonable chance of attracting a following while not posing particularly difficult problems of manufacture (e.g., fabric is in sufficient supply; the production tolerances in the cutting and joining of parts are not so narrow as to threaten the integrity of finished garments). Thus, of the several dozen items of apparel typically paraded on the runway, only a few are "genuine entries." Others are either sheer "throwaways" meant to lend an aura of "depth" to the show or, more strategically, purposefully exaggerated renditions of the more marketable items the design house hopes to cash in on. All available theatrical resources of the fashion show are brought to bear in behalf of the favored items: lighting, musical accompaniment, placement in the sequence of presentations (usually somewhere near midpoint), mannequin choice (the most stunning wearing the genuine entries).

As earlier noted in another connection, modifications are also effected in the days and weeks following the semiannual fashion shows as buyers place their orders with the design houses. Again, Hochswender (1989d) provides telling evidence.

> [In t]he Perry Ellis collection . . . skirts, which were shown super-short—anywhere from 12 to 17 inches long—are available for shipment at 21 to 23 inches. . . . [S]aid Susan Sokol, the president of the Calvin Klein Collection division, "Calvin shows above the knee, and we ship them longer, anywhere from 23 to 25 inches, to the top of the knee or covering it. . . ." Even Gordon Henderson, whose clothes are geared to the young designer customer, makes modifications to his line. "On the runway, the skirts and shorts were very short," said Perrie Kane, Mr. Henderson's national sales manager. "We ship them longer, 19 to 20 inches."

Several merchandising levels below this, as the fashion penetrates the world of medium- to medium-low-priced department

stores, specialty shops, neighborhood boutiques, etc., still further modifications are likely to occur. To this day, a great deal of the apparel carried in neighborhood stores and shopping centers is manufactured and sold by the thousand-and-one garment manufactories that crowd the streets and highrises of the New York and, on a lesser scale, Los Angeles garment centers. (Many of these businesses, however, now subcontract varying proportions of their work to factories in the south and south central United States and, in some cases, to plants overseas in such places as Korea, Thailand, India, Malaysia, and the Caribbean countries.) Buyers and buyers' representatives for local stores flock to New York's garment center in the spring and fall of every year to look over merchandise in the showrooms of the apparel manufacturers and to place orders for the oncoming fall/winter and spring/ summer seasons.[22]

It is here, at the New York and Los Angeles garment manufacturers' showrooms, in the interaction of the visiting buyer and the showroom salesperson, that, above and beyond the inevitable haggling over prices, the next-to-last acts of the still unfolding drama of fashion innovation versus fashion marketability are played out.

Buyers, often themselves salespersons in their own stores, believe themselves possessors of special local knowledge on what their customers will like or, at very least, are prepared to accept in the name of fashion. For example, in observations I made of such showroom transactions, it was not uncommon for a buyer being shown a jacket, a skirt, or some other item of apparel by the salesperson to make some remark like "Helen would sure go for that" or "Duchess is too big back there to ever think of trying that on." For their part, salespersons are of course acutely aware of their firms' stake in a certain line of apparel for the upcoming season.

22. Retail establishments too small to afford to send their own buyers to New York or Los Angeles will often employ the services of firms known as resident buying offices that place orders in their behalf. Because resident buying offices can combine the orders of several dozen of these smaller stores with one or a few apparel manufacturers at one time, they come to exert a good deal of price leverage and style influence with manufacturers. And because they represent small- to medium-sized stores whose clientele is more truly reflective of America's mainstream taste their influence tends typically toward moderating those features of a fashion felt to be extreme or impractical.

Besides, then, stressing such factors as good workmanship, fair prices, and prompt delivery dates, the showroom salespersons are likely to wax over the fashionability of their wares: "This lavender is going to be very big next spring"; "We haven't been able to keep up with orders on this jacket with the raglan sleeve"; etc. At the same time it is clearly understood that within the technical limits imposed by a particular design, the manufacturer is prepared to cut a bit longer or a bit shorter, to combine Jacket A with Skirt C rather than with Skirt B or Pants D, etc.

Repeat such encounters thousands upon thousands of times, frequently (though not always) structured from one to the next by remarkably similar taste coordinates and market contingencies, and the trajectory assumed by a new fashion as it moves into the mass marketplace is sure to become more fixed than it had been hitherto. The dialectic of innovation versus conservation has almost resolved itself, until from the present's shore the next wave is seen forming.

Once into the mass marketplace, at the level of sales interaction between customers and retail salespersons, very little by way of further modification of the essential fashion can occur. Indeed, the very opportunity for this to happen, assuming it were somehow possible, has all but vanished, what with the virtual disappearance of personal service on the retail sales floor—customers now select their apparel directly from the store's pipe racks—and the phenomenal growth in recent years of catalogue sales. In any case, by now the signature elements of the new fashion are so well set that even in those rare instances when personal attention by a salesperson is extended to the customer little by way of further modification, (except for minor alterations that barely affect the essential fashion) is possible. And the growing scarcity of skilled tailors and the high cost of alterations have acted to discourage even this.

5. WANING

Sproles (1985) designates the last stages of the fashion cycle, when the process that has carried a new fashion forward begins to play itself out, as conformity within and across social groups, social saturation, and decline and obsolescence. The first of these signifies broad popular acceptance of the new fashion such that it is

"seen everywhere." With its novelty value now greatly diminished, it no longer startles or jars one's sensibility.

Classically, before fashion became as polymorphous and pluralistic as it has in recent decades, it was at this stage that those not displaying the fashion would become conspicuous in their failure to do so. Referred to in the literature (Kaiser 1985; Sproles 1985) as laggards and indifferents, this heterogeneous aggregate sometimes includes persons, fewer in number, who almost as a matter of ideological conviction proclaim their hostility to the new fashion or, for that matter, to fashion in general by a fervent refusal "to go along."[23] (I shall discuss this group further in the next chapter.)

Predictably, and by this late date for reasons mainly demographic, the stage of massive conformity gives way to that of social saturation, even if phenomenologically it is probably impossible to draw any clear line between them. Still, a host of interrelated phenomena attest (again, more clearly in the past than presently) to the formation of a saturated condition: Inventories build up as manufacturers and retailers are unable to register sales in nearly the same volume as in previous seasons; boredom and restlessness begin to afflict fashion-conscious persons, with some actually abandoning the current mode in favor of those from earlier seasons while others scoff, more by word than by deed of dress, at the ubiquity of the reigning fashion.[24] Finally, and perhaps most telling, the first semblances of new fashion motifs and tendencies begin to appear, usually (though less so in recent years) in the haute

23. These must be distinguished from persons whose social situation places them at the margins of the great civic mass encompassed by fashion's orbit, e.g., the very young and very old, institutionalized populations such as prisoners and the severely mentally retarded, unassimilated ethnics wearing traditional "old country" dress, vagrants, skid-rowers and other isolates.

24. At the conceptual level, however, there is a danger of attributing all fashion change solely to such feelings. Parallel exhaustion-reaction theories in the arts (which see every style change as a reaction to the putative aesthetic exhaustion of the previous style) are refuted masterfully by Meyer Schapiro (1978). As applied to fashion, theories of this ilk usually fail to take into account such matters as these: Boredom and restlessness sometimes extend over many seasons and other times over a very short span before the new fashion appears; not all new and/or reactive fashions succeed (indeed, most don't!); successive fashions will as a rule reveal more thematic continuities than discontinuities. At very most, it is perhaps possible to hold that while boredom and restlessness constitute a necessary condition for fashion change, by themselves they are by no means a sufficient one.

couture, thereby affording fashion enthusiasts fresh fascinations to fasten on.

Obsolescence, the waning stage's final phase, cannot be said to have truly occurred until the fashion in question has been so engulfed by its successor as to cause those still beholden to it to be seen as "old-fashioned" (*démodé*). Almost by definition, this cannot happen until the succeeding fashion has progressed to a relatively advanced stage, no earlier than that of increasing social visibility. As should be obvious, therefore, prior and successive fashion cycles invariably overlap chronologically, there being nothing like a sharp, discontinuous break between them. What is of interest is the amount of overlap, the social-psychological processes brought into play during the overlap that constrain the old to give way to the new, and the historical trends in aesthetic preferences, gender representations, and life-style leanings revealed in the patterning of overlaps.

Generally, and following from much of what has already been said about the emerging polycentric and polymorphous structure of contemporary fashion innovation, it would appear that overlaps now occur more frequently and more rapidly than in the past. It has become increasingly difficult for even an attentive fashion consumer to know which fashion is "in" and which "out," so fast and various has the onrush of new fashions become. The problem is compounded to varying degrees depending on which reference groups (occupational, regional, political, subcultural, age, and class configurations) the fashion consumer identifies with. In some the pace and diversity of fashion movement, as well as the salience of a fashion sensibility as such for one's identity, are much greater than in others. For example, with certain contemporary youth groups (e.g., punkers, surfers, junior high and high school students) an extreme is reached of fadlike styles succeeding each other on almost a weekly basis, there being hardly any consensus from one group and locale to the next on what is "in" (Penn 1982; Rimer 1985).

CONCLUSION

These last remarks bring us full circle to the chapter's initial observations on the changing character of the fashion cycle since the

nineteenth century, in particular in the period after the Second World War. Clearly, the cycle as we knew it for the better part of a century, as a reasonably ordered succession of unitary fashions, albeit unpredictable from one to the next, with fairly well demarcated beginnings, midpoints, and terminations, seems fated to pass, if it has not already. Brubach (1990c) reflects insightfully on the phenomenon:

> Fashion as it's presented on the runways is nowhere near as unanimous as it used to be, but coverage of it in the press still focuses on hemlines and colors and items—on what the collections have in common. . . . The truth is that these days you can find practically anything in somebody's collection somewhere. It's the randomness that makes fashion now so unwieldy, so hard for journalists and stores (and women) to deal with. Still, you can't blame the fashion writers for seeking a theme that would make some sense out of what they've seen: their job is to find a story.

Fashion still lives, however, as it probably shall continue to in the West for a very long time to come. What appears to be emerging in place of the classic, three- to five-year, bell-shaped cycle is a plethora of microcycles, each oriented toward a different identity segment of the apparel market. And even within the same segment, however it is delineated by market researchers (e.g., married working women, fitness enthusiasts, alienated middle-class youth, affluent seniors), there is not likely to be a single reigning fashion at any moment in time; thus there are cyclical irregularities within identity segments as well as between them.

Doubtlessly there are those who by way of rebutting suggestions of an emerging era of fashion polycentrism and polymorphism will claim to discern (of course, in hindsight) underlying common themes and preoccupations in this welter of fashion microcycles. (Some of this is already being done in the name of postmodernism.) The proposition almost invariably will follow that the seeming diversity is more apparent than real. But even if such were the case, the mere "appearance" of this sort of fashion pluralism—and, after all, what does fashion deal in if not "appearances"—makes for a very different visual, and hence social, representation of the human form from what we knew in the past.

The larger theoretical question of why the unitary macrocycle has been displaced by numerous disparate microcycles is as difficult to answer for clothing fashion as it is for other areas of modern culture where similar phenomena have been noted, e.g., painting, music (both popular and serious), architecture, leisure pursuits, culinary practices, and even health care modalities. One can only speculate. As Bell (1976) argues, it would seem that at the level of the economy, as the institutions that support Western society's media-borne, mass-based culture of consumption become more uniform, rationalized, and global in scope, strong structural imperatives for a homogenization of cultural products ensue. Profound reactions, often of a romantic, antitechnological bent, then begin to set in against cultural uniformity and homogenization. It is the hallmark of such reactivity, as Klapp (1969) so ably documents, to search for and structure group identities that impart a semblance of individuality along with a sense of belonging, but yet resist being submerged into the mass.

In lieu of a better explanation, one can for now only infer that the classic "long wave" fashion cycle, which formerly would in time dragoon all into the same stylistic camp, fell victim somehow, most certainly by the late 1960s, to the identity-defining reactivity elicited by late capitalist consumer culture (see Davis 1967). True, the pluralistically based micro fashions that have increasingly taken its place become, after the usual co-opting (though not necessarily at their points of origin), as much a part of that culture as was the long wave fashion cycle itself. I leave to others to judge whether this makes of them genuine or spurious cultural products. But certainly it has made for a very different fashion milieu.

8 Anti-Fashion, The Vicissitudes of Negation

The man who consciously pays no heed to fashion accepts its form just as much as the dude does, only he embodies it in another category, the former in that of exaggeration, the latter in that of negation. Indeed, it occasionally happens that it becomes fashionable in whole bodies of a large class to depart altogether from the standards set by fashion.

Georg Simmel

People who look like they're too interested in

fashion are not in tune with the times.

Calvin Klein

In things that are considered "in bad taste" you

can always find a certain beauty.

Jean-Paul Gaultier

A ntifashion is as much a creature of fashion as fashion itself is the means of its own undoing.[1] This would seem to be obvious in that whatever form antifashion takes it must via some symbolic device of opposition, rejection, studied neglect, parody, satirization, etc., address itself to the ascendant or "in" fashion of the time. The well-groomed dowager in her haughty disdain for the new and trendy stands with antifashion as much as does the leather-garbed, mohawked punker in his scathing rejection of conventional wear.

At the subjective level, the oppositional stance of antifashion, however timid or tentative its gesture, distinguishes it at once from fashion *indifference*. There one is either oblivious to or, for one reason or another, thoroughly unconcerned with what the reigning or ascendant fashion is.[2] Many persons in society are fashion

1. An oft-quoted remark of Chanel bearing on the latter half of this sentence holds that "fashion is made to become unfashionable."
2. For another definition of antifashion see Polhemus and Procter (1978, 16): "Anti-fashion refers to all styles of adornment which fall outside the organized system or systems of fashion change." Under this definition they subsume not only oppositional dress of one kind and another, but all forms of traditional and folk dress including even that of primitives and other peoples far removed from Western culture. My own sense is that it is more felicitous to restrict the term *antifashion* to oppositional dress, i.e., that which takes place in response to the currents of fashion change and does not just lie outside them. The term *nonfashion* would seem more appropriate for the remaining dress forms mentioned by these authors (e.g., folk, peasant, tribal, the boudoir costumes of rubber and leather fetishists) that lie outside the realm of fashion. See Brubach 1989b for a similar distinction between antifashion and nonfashion.

indifferents; far fewer are antifashionists. The indifferents remain outside the dialogue of fashion symbolism and countersymbolism; the antifashionists, of whatever stripe, sustain and nurture it.

The clothing rebellions ushered in by the 1960s have led many to assume that antifashion as a kind of self-conscious, even organized, oppositional stance toward prevailing fashions is of relatively recent origin. Actually, antifashion themes and motifs in dress (and doubtlessly in other decorative and artistic realms as well) stretch far back in European history and appear to have served the same function then as they do now: to dissent, protest, ridicule, and outrage. The milkmaid-attired court ladies in Marie Antoinette's *bergerie,* the absurdly bedecked Incroyables and Mervielleuses of postrevolutionary France, the London dandies of Brummel's time and latterly their nineteenth-century French imitators, the demimonde of Lautrec's Paris and Malcolm Cowley's Greenwich Village, all reveled in and sought notoriety through their antifashion gestures. And as Flugel (1945) and others have observed, persons on the political left were—and still are, for that matter—as given to modish forms of unorthodox dress as are bohemians.[3]

So constant an accompaniment to fashion has antifashion been that by this late date in Western dress it can fairly be said the antifashion posture has become firmly, and perhaps irrevocably, incorporated into fashion's very own institutional apparatus. This chapter's epigraph by Calvin Klein castigating those "too interested in fashion" bears witness to this, as does the even more often earlier cited remark of Chanel, "Fashion is made to become unfashionable." A prestigious shoe stylist, Manolo Blalnick, is quoted as saying, "My shoes are unfortunately sometimes in fash-

3. From about the time of the First World War up to about the blue jeans mania of the 1960s, at which point the political left and cultural (bohemian) left coalesced to a marked degree, the prevailing "antibourgeois" men's style among American leftists revolved around such apparel as dark-hued, solid-color dress shirts worn open-collared or, on the rare occasion when neckwear was mandatory, with a coarse wool tie; unpressed corduroy jackets (sometimes with elbow patches) and, almost as often, corduroy trousers; bare head (in an era when in public the felt slouch hat was practically obligatory) or, on occasion, a beret; and, with somewhat less regularity, heavy workman's shoes or hiking boots. As might be expected, over time much of this garb was assimilated into mainstream men's leisure wear.

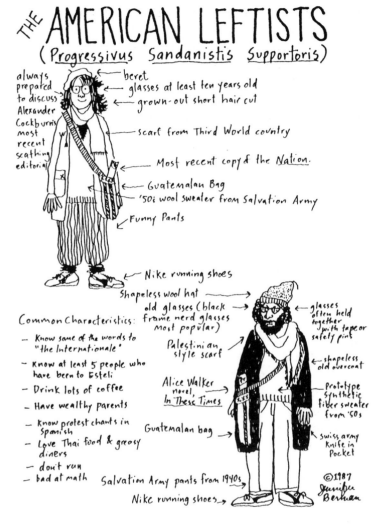

Drawing © 1987 by Jennifer Berman; from In These Times magazine

ion. But that's obscene. I want them to mean the same in 10 years"
(Gross 1987a).

Countless other statements by famous designers to the same
effect could be cited.[4] The point, only apparently paradoxical, is

4. The reputations and attendant financial success of certain present-day de-
signers rest almost wholly on their blatant antifashion proclivities. Cases in point

that those whose fame and fortune depend most on fashion seem the most ready to denigrate it. Of course, some of this is self-serving in that remarks of this ilk are meant in part to suggest that the designer's creations transcend the ephemeralities of "mere fashion." In other part, however, they speak to how much fashion looks to antifashion for inspiration. In any case, this almost institutionalized antifashion posture has in recent years been adopted by large corporate manufacturers of apparel as well. These are firms whose profits depend fully as much on a fashion sensibility in the buying public as do those of renowned designers on that of their more exclusive clienteles. For example, the fall 1987 catalogue of Esprit, a well-known maker of stylistically sanitized "funky" youth clothing, brims with denunciations of fashion and fashionableness. Esprit apparel, by contrast, is heralded as promoting a sense of "style" and as furthering "individuality."

The ambivalent relationship in which fashion stands to antifashion can, therefore, be thought of as a kind of transcendent ambivalence. It, too, is a dilalectically induced ambivalence that by virtue of the dissenting posture of antifashion—which fashion, in its turn, so often indulges—manages to again envelop many of the primary, or first order, ambivalences (of gender, status, etc.) from which fashion itself took inspiration in the first instance. Thus, to cite a recent example, fashion's assimilation of numerous motifs of punk antifashion builds not only on punk's generalized oppositional stance per se but on the more specific gender and status dissents of punk street wear ab initio.

are the Frenchman Jean-Paul Gaultier, whose worldwide sales are reported to be close to $20 million (Brantley 1984) and the Italian Franco Moschino, who claims annual sales of more than $50 million (Gross 1986a). Certain of the more notorious designs of Gaultier are corset-shaped bustiers worn as an exterior garment, sweaters worn over heavy overcoats, and "patent leather pants with cutouts at the knees and rear end" (Hochswender 1989a). Moschino's "outrages" include a skirt imprinted with tire skid marks worn with a lace bustier and "classic suits [in the style of Chanel] fastened with plastic whirligigs . . . [and] buttons laminated with Minnie Mouse cartoons" (New Yorker 1989). He titled the Milan showing of his 1990 fall collection "Stop the Fashion System" and staged an elaborate ballet in which present-day fashions were wildly lampooned (Morris 1990a).

High-fashion Antifashion: Franco
Moschino's tire skid mark skirt
worn with see-through lace bustier.
Vittoriano Rastelli/NYT Pictures

WHY ANTIFASHION?

The reasons for antifashion would seem overdetermined. In some
part it is, as already implied, a perhaps necessary device for fueling
the motor of fashion itself; that is, it helps garner the symbolic ma-
terials whence fashion can attempt its next move forward. But this
can occur only after antifashion has displayed its wares, so to
speak. The prior question remains: Why these wares at this time in
this place?

A proper answer to the question entails viewing antifashion in
its social and historical contexts. First, it should be noted that anti-
fashion presumes a certain democracy of taste and display. It is
hard to conceive of antifashion, except perhaps through some un-
derground manifestation, in strongly authoritarian or totalitarian
societies. Even if not intended as such, antifashion is usually
viewed by those in authority in these societies (as well as by a pop-

ulace perhaps in sympathy with its manifestation) as a form of political protest. It is thereby automatically rendered suspect.[5] Depending on the particular authoritarian regime in power, charges of bourgeois decadence, counterrevolutionary plotting, Communist subversion, or sacrilege are likely to be directed at those foolhardy enough to display dissenting tastes in public.

By contrast, in democracies and other less repressive societies there are numerous opportunities for marginal, minority, dissident, and other exceptional groupings and publics to form and function in the open. To the extent such aggregates develop a desire to differentiate themselves symbolically from others in the society, a by no means uncommon phenomenon of group identification in democracies, a fertile ground is sown for antifashion manifestations. These, in turn, frequently come to be absorbed, usually in diluted form, into mainstream fashions. In any case, the quest for distinctive collective identities (see Klapp 1969), be they of a racial, ethnic, occupational, or socially deviant variety, acts as a major cultural launching pad for antifashions.

Without putting too fine a Marxist point on it, it can even be said that the counterestablishment, antifashion symbolic gestures perpetrated by such groups serve ultimately to deflect what otherwise could lead to more violent and destabilizing forms of political confrontation (Blumer 1969a; Gusfield 1963). Since the 1960s designers have become increasingly aware of this relationship and, as has been noted in other connections, have themselves turned more and more to antifashion for inspiration. The observations of New York designer Ronald Kolodzie on the matter might just as well have been written by a sociologist:

> Isolated worlds have always given their styles to mainstream fashion. . . . The marginal groups—blacks, Puerto Ricans, gays—are barred from conventional culture, and so they develop their own unique look. At that point you can say it's progressive, it's authentic, it has an historical edge. Some of that progressive content remains as

5. The mainly underground, black-market rage for blue jeans, rock music, pizza, stenciled T-shirts and other Western pop culture symbols in former Soviet bloc countries and in Communist China is testimony to the difficult row antifashion must hoe, if it surfaces at all, in these societies.

the style travels up the social scale, even while it's contradicted by the people who are wearing them. (quoted in Kopkind 1979, 36)

In democracies antifashion also originates, although with less force than from the subcultures mentioned by Kolodzie, with those whose location in the social structure permits a measure of irresponsibility and some temporary suspension of major institutional commitments. Youth, especially teenagers not yet embarked on careers or family building, constitutes a prime example of this sort of structurally based exemption. This may account for the many bizarre clothing fads, strange locutions, and other distinctive mannerisms that originate among high school and junior high students in America and, increasingly, in Europe and Japan as well. Despite their antifashion thrust, however, such innovation (Louie 1987; Penn 1982, 4) tends to be so localized—it can vary markedly from one school to the next in the same part of the city—as to vitiate its potential for eventual assimilation into mainstream fashions.

Granted the habit of borrowing from antifashions, does fashion in time vanquish antifashions or do antifashions manage to endure in some vital form? Despite what Polhemus and Procter (1978, 16) see as fashion's essentially parasitic relationship to antifashion—always borrowing and giving nothing in return—they maintain that antifashions, because of their authenticity and group identity function, persist largely unaffected by the distortions and adulterations fashion characteristically subjects them to. Such may be true of the tribal, folk, and secretive fetishist groups Polhemus and Procter include in their overly broad definition of antifashion. However, as regards racial and ethnic minorities, the counterculture formations and socially deviant groupings (some "out of the closet," some still hidden) who exist side by side with mainstream elements in the modern metropolis, it would seem a less static and more complex dialectical relationship obtains between antifashion and fashion (Chambers 1986; Hebdige 1979). In surrendering their symbols to fashion, antifashion groupings are made to search for new, more subtle, and, perhaps, harder to purloin symbols of group differentiation. (The oft-noted switch among homosexual men from sensual to

"stud" apparel during the late 1960s and early 1970s is a case in point.) Thus, rather than remaining unaffected, the pace of antifashion in the modern world is more likely accelerated as a result of raiding from the fashion establishment. For its part, fashion is invigorated by the transfusion, helping the many swept up in its path to open themselves, if only at some subliminal level of sensibility, to wider cultural horizons and less parochial tastes. Such constant circulation of the symbolic material of a society also serves democracy.

VARIETIES OF ANTIFASHION

Antifashion assumes many forms and springs from diverse cultural sources.[6] Doubtlessly more forms can be delineated than I shall discuss here, but among the prevalent ones I would give names to are these: utilitarian outrage, health and fitness naturalism, feminist protest, conservative skepticism, minority group disidentification, and counterculture insult. Clearly, some of these (e.g., minority group disidentification and counterculture insult, health-fitness naturalism and feminist protest) overlap to an extent, while others are quite distinct.

Utilitarian Outrage

This is perhaps the most familiar, numerous versions of which are to be found in "famous quotations" on fashion.[7] These go far back in literature and include even biblical maxims and aphorisms decrying the vanities of egoistic dress and adornment.[8] Briefly, this attitude castigates the wastefulness, frivolity, impracticality, and vanity associated with fashion, with its changes from season to season, with the invidiousness it occasions and the fickleness it in-

6. Again, unlike Polhemus and Procter (1978), I exclude from this rubric nonfashion, which phenomenologically is of a very different order.
7. See, for example, the two dozen or so indexed under *fashion* in *The Oxford Dictionary of Quotations*.
8. The most famous of these is from Isaiah 3:16−24, the first lines of which read: "Then the Lord said: Because the women of Zion hold themselves high and walk with necks outstretched and wanton glances moving with mincing gait and jingling feet, the Lord will give the women of Zion bald heads, the Lord will strip the hair from their foreheads. In that day the Lord will take away all finery."

duces. In modern times the American economist-sociologist Thorstein Veblen stands as the foremost exemplar of this viewpoint. His *Theory of the Leisure Class* (1899) not only points to fashion as class-based capitalism's principal channel of conspicuous consumption and waste but as altogether contrary to the instinct of workmanship, which Veblen saw as one of the few redeeming traits of humans. Analogous sentiments, though in a more heavily ironic vein, are to be found in the 1836 work of Thomas Carlyle *Sartor Resartus: The Life and Opinions of Herr Teufelsdröckh*.

Of course, a near-identical form of fashion resistance is evidenced in everyday lay attitudes as well, as when persons object to the waste, expense, and inconvenience entailed in casting aside perfectly wearable old garments to make room for the new fashion. Given the greater fashion pluralism abroad today, this happens, perhaps, somewhat less often today with women's apparel than it did as recently as the 1940s and 1950s. Still, it is by no means uncommon to come upon outraged commentary and letters in newspapers and magazines denouncing some new fashion for the economic (and aesthetic) waste it would engender. A spate of these appeared most recently (1988) when designers sought to put women back into 1960s-style miniskirts.[9]

In what must at first glance seem a case of biting the hand that feeds one, it is by no means rare for designers themselves to fulminate against the profligacies and impracticalities of fashion. Championing the virtues of simplicity, functionality, and durability,

9. An op-ed column by National Public Radio's legal reporter, Nina Totenberg (Totenberg 1988), received wide notice and soon became something of a banner under which popular protest against the miniskirt rallied. The column, in part, read: "For many American women, the big news a couple of weeks ago was made not in the Middle East or the Super Tuesday primaries but in our own home towns, where the fashion industry is taking a major bath on the miniskirt. Many professional women simply refuse to buy the mini, so retail clothing sales are the worst since the 1982 recession. In short, the mini is a fashion disaster. . . . Every moment of the fashion industry's misery is richly deserved by the designers, retail clothiers and newspapers and magazine poltroons who perpetuate this absurd creation. . . . It's simple justice that miniskirt promoters are being rewarded with empty cash registers. But beware, ladies, the battle is not yet won. Many in the fashion industry haven't given up yet. They figure we'll quit first. Hold the line. Don't buy. And the mini will die."

Its death, however, turned out to be more like a coma. Within two years it experienced a remarkable recovery and was to become the preferred skirt length of younger women.

Modular dress: The same basic pieces combined in different ways to suit the occasion and season. *Courtesy of Jerell Inc.*

Chanel at one time produced clothes whose appeal derived mainly from their antifashion posture, as have such American designers as Claire McCardell, the late Rudi Gernreich, and, more recently, Liz Claiborne. Other designers have from time to time given greater scope to utilitarian outrage by coming up with what is termed "modular" or "surplice" dressing for women, and sometimes on a unisex basis for men as well. Reminiscent of Russian 1920s constructivist design or of what one can easily imagine issuing from a Bauhaus studio in its heyday, these consist typically of an array of

very simply styled, usually loose-fitting, single-color garments (e.g., separate tops, tunics, leggings, jumpsuits, skirts, scarfs, wraps, pants), which can be combined in a great variety of ways to comfortably carry their wearers through the purposes and places of the day and, within limits, from one season to the next as well.[10] Needless to say, despite comfort, practicality, and comparative low cost, modular dressing has not proved particularly successful in the marketplace.

Health and Fitness Naturalism

A distinguishable yet closely related antifashion posture to that of the above is health and fitness naturalism. This form places much less emphasis on matters of economy, choosing instead to direct its ire at the deleterious health consequences of much fashion and at the unnatural demands it makes upon the human physique, especially that of women: shoes that pinch and do battle with the natural contour of the foot, and high heels that make walking unsteady and cause back pain; skirts and dresses that inhibit movement because they are either too short, too tight, or too voluminous; undergarments that constrict; fabrics that chafe and are either too warm in summer or too cool in winter; cosmetics and bleaches that damage the skin and hair; coiffures and jewelry that hamper head and arm movement; sports clothes designed more for bodily display than for the putative activity of swimming, skiing, bicycling, tennis, or whatever.[11] These comprise but a fragment from the litany of complaints laid at fashion's door over the centuries.

Similar complaints are by no means unheard of in the case of men's clothing: the physical confinement and weather unadaptability of the man's business suit, especially its three-piece version; button-secured collars and throat-grasping ties; at business

10. The Los Angeles designer Harriet Selwyn introduced such a line in the early 1980s. More recent attempts at marketing modular dress have come from designer-led firms variously named Singles, Multiples, and Units. According to Hochswender (1988c), these firms' collections "promise freedom from the ironing board as well as from the dictates of fashion."

11. As in the case, in the opinion of some (Janovy 1991), of the close-fitting spandex uniforms to be worn by the women players of the newly organized women's professional basketball league, the Liberty Basketball Association.

places, the mandated white shirt, which easily shows dirt and requires frequent laundering; abdomen-clenching trouser belts or, alternatively, tight shoulder-straddling suspenders to prevent pants from sagging; head cover of one kind or another (e.g., bowlers, homburgs, slouch and straw hats), which is generally too warm in summer and ill adapted to the inclemencies of rain, wind, and cold; etc. The list of health and fitness delicts is almost as long as that assembled for women's clothes. Revealingly, remedies that have appeared over the years have in large part been consigned to that special category of men's dress known as "leisure wear."

Yet, perhaps precisely because men's clothing has since the eighteenth century resisted the dictates of fashion to a much greater extent than women's, these objections have never acquired the ideological force that was evidenced, for example, in the women's dress reform movement of the mid-nineteenth century or in today's women's movement (Wilson 1985). For the nineteenth-century dress reformer,

> fashion was the enemy. They [physical culturists] lamented the dangers of long skirts and bemoaned styles that inhibited movement, but, most of all, they declared war on tightly laced corsets. "By far the most frequent difficulty with our women [according to a physical culturist of the time] arises from uterine displacement and . . . the utter disuse of the muscles . . . which are kept inactive by the corset." (Schreier 1989, 97–98)

It is as if the "cultural bargain" struck between the sexes during the late eighteenth and early nineteenth centuries—i.e., a fashion-exempted men's dress code attesting to work and sobriety; a fashion-driven women's code in behalf of sexual attractiveness, dependency, and, with marriage, domesticity (see chapter 3)—could come unstuck too easily were men, in search of greater comfort, to tamper self-indulgently with the terms enjoined by their side of the

12. It may be sociologically significant that less confining, environmentally adaptable clothing (e.g., open-collared short-sleeve shirts, jacketless business wear, loose fitting garments) is commonly worn by men in Israel, where an egalitarian ideology of socialist zionism placed great emphasis on the elimination of sexual stratification and segregation. Rejoinders to the effect that relaxed men's dress in Israel is due solely to the country's hot climate are contradicted by the maintenance of relatively rigid men's dress codes in much of British-influenced Africa and Asia.

contract.[12] Dominant groups are nearly always prepared to suffer some discomfort and inconvenience for the sake of the status quo. Not so, however, for subordinate groups who come to think themselves disadvantaged under the terms of the cultural contract. As modest and ladylike as surviving sketches of it look to late-twentieth-century eyes, the "radical" and "licentious"—and, of course, roundly condemned and markedly unsuccessful—(Amelia) Bloomer costume of the mid-1850s grew directly out of the reform movement against the confining, constricting, voluminous, and complicated apparel worn by middle-class women of the time (Lauer and Lauer 1981). As Foote (1989, 147) explains:

> This small group of reformers believed in the contemporary rhetoric about the innate natures of men and women. And they used these beliefs in their writings and lectures to gain support for dress reform among a larger audience. They stressed the unhealthy and unsuitable aspects of fashionable attire for women to fulfill their role as mothers. They contended that the Bloomer Costume made women healthier and, thus, better mothers. They also ascribed part of the mortality and sickness of newborn children to the unhealthy attire of their mothers.

Repeated attempts since Amelia Bloomer's time to revive wear like hers have intermittently proven somewhat more successful than did the original. At that, the tendency has been to segregate such attire to women's exercise and team sportswear. One is forced to conclude, then, that Bloomer's mid-nineteenth-century call for total reform of women's dress in the name of health and fitness has, at best, been only partially realized in the succeeding century and a half.

Health naturalism's advocacy of women's dress reform was, to be sure, part of a larger nineteenth-century, utopianlike social movement, which believed the corruptions, contaminations, and depredations of an expanding industrial order could only be overcome by a return to all things "natural": in food, clothing, shelter, recreation, the arts and crafts. Strong echoes of it were to be heard in the public hygiene movement at the turn of the century. Much nearer today, its lingering spirit infuses the post-1960s physical fitness vogue that has swept North America and parts of Europe with its associated life-style emphases on jogging, nonsmoking,

weight reduction, exercising, and nutritional asceticism (Glassner 1989; Gusfield 1987). Evocative of its earlier incarnation, the contemporary fitness vogue, too, has given rise to certain antifashion manifestations in apparel, albeit of a sometimes contradictory tendency: loose, baggy, and underdesigned (e.g., cotton sweats, baggy jeans, Chi pants with gusset inserts), on the one hand, and sleek, extremely close-fitting (i.e., "a second skin"), and vividly patterned, on the other (e.g., leotards, bodysuits, and bicycling pants made of synthetic Lycra stretch fiber). A main difference, however, between contemporary fitness-inspired antifashion and that of earlier eras is that nowadays its dissents and innovations are adopted much more quickly, even avidly, by fashion per se than was the case up until about the time of the second World War. Indeed, in the instance of certain apparel, spandex sportswear for example, it is almost impossible to say whether it began as antifashion or fashion. But that it is unmistakably "fashion" within a very short time there can be no doubt.

Wishing to signal an ideological attachment to health and fitness, many persons have, as Kron (1984) reports, taken to wearing such garments to work, to school, and in town. (In some quarters the running shoe has virtually replaced the dress shoe.) Devotion of this kind notwithstanding, it must be granted that the antifashion impact of contemporary health and fitness apparel is probably a good deal less than that registered by the "scandalous" Bloomer costume of a century and a half ago. Nowadays, fashion, as we have seen, stays in much closer touch with antifashion impulses abroad in the land. No sooner, then, had the health and fitness vogue begun to take hold in the mid-1970s than fashion appropriated, "styled," and claimed for its own the mishmash of apparel seen in gyms and on jogging paths and bicycle trails (Fraser 1981). With characteristic shamelessness, fashion represented itself as much beholden to health and fitness as would the most dedicated 10K runner and habitué of health food stores. So far has this trend gone that many fashion-conscious women now complain of fashion no longer affording them the bodily "little white lies," coverups, and distractions that once made them "look good" (Brubach 1990c).

Feminist Protest

The antifashion of feminist protest not only concurs fully with that of health and fitness naturalism, and nearly as much with utilitarian outrage, but carries its objections to fashion even further. Beyond considerations of economy, bodily health, and comfort, it sees in fashion and, for that matter, in the clothing code of the West generally, a principal means, as much actual as symbolic, by which the institutions of patriarchy have managed over the centuries to oppress women and to relegate them to inferior social roles. With polemical roots going well back into the nineteenth century, the arguments to this effect are many and, by now, quite familiar; it is only possible to touch on them here.[13]

Given fashion's invidiousness and conformism, women are constantly under pressure to supplant one wardrobe with another. The unending succession of styles devised for them (usually by male designers) is rarely functional. As a rule, fashion's garments and accessories call for great amounts of time and attention when dressing. They are costly to have cleaned and require much attention to keep presentable. All of this is seen as investing women's lives with a fastidiousness bordering at times on the comically frivolous (Foltyn 1989).

In addition, modern fashion's fixation on youth, slenderness, sexuality, and eroticism serves mainly to diminish other aspects of woman's person while reinforcing those favored by men, i.e., such traditionally sanctioned roles as sexual object, wife, mother, and homemaker. Large-framed and obese women in particular are made to feel the sting of fashion's obsession with the young and the lean (Millman 1980). Not only do the fashion media hide such women from view, but their chances for finding suitable "in fashion" garments in either regular apparel stores or those catering to "large sizes" are almost nonexistent given modern fashion's idealization of the slimmed-down, lean female figure. It might be noted that only very obese men encounter similar obstacles in finding appropriate apparel that can pass for being more or less "in fashion."

13. See Wilson 1985 and Steele 1985 for fuller discussions of feminism and fashion, although both take issue with a number of feminist arguments on the question.

The relative freedom from fashion's dictates granted men in contrast to the coercion they exert on women is further evidence of how aptly fashion serves the ends of male domination. In sum, fashion has in Western society been a quintessential component of the societal machinery—or ruling discourse, as Foucault (1980) would have it—by which women have been kept "in their place."

While feminists would, I suspect, agree in all essential respects with such an analysis, there appears to be less agreement among them on what can and should be done as far as women's clothing is concerned. Indeed, something approximating a condition of "structural strain" (Smelser 1963) in regard to the issue seems to have developed within the feminist social movement. Some feminists enjoin women to spurn fashion and its associated habits and attitudes altogether. They decry women's fear of not being in fashion, their absorption with the drivel of fashion magazines, their obsessive concern for proving oneself sexually attractive to men, their profligate purchase of advertised beauty products that perpetuate sexual and romantic stereotypes, etc. Advocates of this position often urge women to dress essentially as men.[14] This, it is said, would to a significant extent act to symbolically diminish the gender gap. It would encourage women to bring forth from themselves qualities and abilities customarily obscured, if not actually submerged, through the everyday activation of a patriarchal gender code.

Other feminists believe the adoption of men's clothing by women would lend tacit legitimation to the patriarchic representation of the world. Rather than sycophantic surrender to men's dress codes, they wish for some new, more fashion-resistant, dress for women, which neither perpetuates the role inferiorities and infirmities of traditional women's dress nor subscribes tacitly to the notion that men's construction of social reality, as symbolized in their dress code, is the only viable one. Implicit in this stance is the

14. As shown in the chapter on gender and fashion (chapter 3), women's fashions since the latter part of the nineteenth century have frequently traded, rather avidly at times, on the antifashion possibilities attaching to the borrowing of men's items of apparel. From the perspective of a strongly ideological feminist such cautious flirting with cross-gender dress has amounted to little more than what the political scientist Harold Lasswell once termed "defeat through partial incorporation."

conviction that Western society has systematically suppressed a range of distinctive values and attitudes anchored in *feminine* experience (Foucault 1980), which, if permitted to surface, could contribute greatly to human welfare. Women's clothes in this view should strive to symbolically represent such values and attitudes and by so doing help animate them in society at large. In light, however, of the alleged submergence of these values and attitudes in contemporary society, one has at this point only the vaguest inkling of what such clothes might look like. Quite possibly, harbingers have already appeared among us without our being quite aware of them. As with many cultural products, more time and social definitional processing may be required before they acquire a recognizable and distinctive form.

In the meantime, the fashion industry itself has, since the 1920s, not been altogether unresponsive to the complaints and protests issuing from feminist quarters. Certainly, the voluminous, elaborate, and physically burdensome clothing of the Victorian era has long since fallen prey to women's demands, led in large part by turn-of-the-century feminists, for more functional clothing. Since Chanel some seventy years ago down to the present, designers have been proclaiming their belief in the "modern active woman" who has neither the patience nor the means to loll about all day in elaborate finery. Since the 1950s they have even come to laud the woman who earns her own living, who picks up and travels near and far on her own unencumbered by chaperons or overly solicitous males, who eschews coquetry and feigned frailty and is as straightforward in her romantic pursuits as men are in theirs.

Two designers I interviewed (one a woman well known in California, the other a man of international reputation) expressed revulsion over the frou-frou and other frilly impediments that traditionally have been part of women's dress. The man was known for his advocacy of unisex clothing. The woman went on to say she foresees the "end of fashion" due to the changing social position of women brought about by the contemporary women's movement. Although the woman designer qualified her opinion somewhat later in the interview, their attitudes reflect the degree to which feminist views have, I believe, penetrated the ranks of fashion creation itself. Even though wary of translating feminist precepts into

actual women's clothing designs—as, indeed, the fashion industry by and large still shows itself to be—no designer of stature nowadays can pretend indifference to the antifashion sentiments emanating from feminist quarters.[15] Short of an "end to fashion," these sentiments, too, shall in time have to be accommodated within fashion's symbolic sphere.

Conservative Skepticism

While perhaps the blandest from an expressive standpoint, the form of antifashion that I have termed conservative skepticism is economically, through its sheer massiveness, the most powerful. By the term I mean that sort of garden variety resistance to a new fashion millions upon millions of women exercise from time to time, often to the point of killing off the new fashion altogether or causing it to be so modified as to greatly neutralize its symbolic intent and visual impact. The examples, as noted in several connections, are many and are known to have wreaked financial havoc throughout the women's clothing industry: e.g., the mid-1920s attempt to drop hemlines to pre–World War I heights, the midiskirt of the mid-1970s, the abrupt 1987 try at reintroducing sixties-style miniskirts.

What is noteworthy about conservative skepticism is that it is not ideologically driven, as is, for example, health and fitness naturalism or feminist protest. And unlike these other forms, it posits no dress alternatives other than remaining wedded to the established style of the day. The conservative skeptics are women not against fashion per se, only against that which the fashion industry, the fashion press, and other assorted "authorities" are trying at a particular time to foist on them. On the contrary, they believe in remaining "in fashion" and worry lest what they deem objectionable will soon "triumph" and require them to overhaul their wardrobes. Their resistance derives usually from some ill-defined sense that the new fashion "is not them" and would, if adopted, entail so pronounced a redefinition of presentational self as to

15. Even Yves Saint Laurent, probably the most famous designer alive today, is credited with a feminist coup by some feminists because in the late 1960s he legitimated pants as high fashion for women.

clash with what they feel to be more enduring, less malleable images of self.[16] Their skepticism is buttressed by a belief, half hope and half conviction, that a great many others feel as they do and that the propaganda of the fashion industry will fail to convert a number sufficient to put the style over, thus sparing them the disgrace of being thought unfashionable.

It is mainly at these women that the batteries of fashion publicity are aimed: promises, enticements, reassurances, and consolations, etc., all designed to detach resistors from the view the new fashion "is not them." This makes for a style of discourse I refer to elsewhere as the rhetorical consolations of fashion. Illustrative of such rhetoric are the many statements, blatant contradictions notwithstanding, one comes across in fashion media to the effect that the proffered fashion is "not nearly so extreme as it first appears"; or that it will "highlight the fascinating you obscured by the reticent styles of yesterday"; or that it is "meant for everyone" because it offers "a new freedom to be your real self, unshackled from others' ideas of who you are and can be." The quotes, I confess, are made-up paraphrases of a thousand and one statements of this genre I have encountered in the fashion press. Those that follow, though, are actual:

> "It's a wonderful new balance," says Ronaldus Shamask [a New York designer], whose spare, clean collection combined Oriental and architectural elements. "People don't want to be fashion victims or classic. The only way to dress now is to look like it just happened," he says. "It's a more nonchalant fascination. Pomodoro [another New York designer] calls it "a not-thinking-about-clothes-attitude." (Gross 1988)
>
> "Clothing is a visual feast," he [Geoffrey Beene] continued. "Fashion should be beautiful, not necessarily newsworthy. Changes should evolve slowly. I have never admired revolutionary changes."
> Esthetically, Mr. Beene feels comfortable with two different styles: ornate and simple.
> "Both are wonderful," he said. "There is no need to make a choice; that is what freedom is all about."

16. Almost by definition, a new fashion, as noted in chapter 6, nearly always triggers some clash of presentational and more or less fixed images of self (Stone 1962). The social psychological issue for clothes wearers is more one of degree than of occurrence per se.

He believes it does not matter whether jackets are short or long, or whether clothes are fitted or full. Those are details. What is important is individual style. (Morris 1988a)

The writer Jamie Wolf (1980, 44), in her biting appraisal of fashion's late-1970s "retro look," manages to parody this rhetorical genre to a turn.

In this land of fashion-ese, after all, last year was always the year when things were in flux, clothes lacked a certain element of fantasy, clothes had perhaps a touch too much fantasy, styles were a little overpowering, styles were a little dull; and this year is always the year when the dust has settled, fantasy has finally returned but in appropriate measure, the kinks have been worked out, there is a whole new spirit of finesse and refinement, and the new clothes are once more exciting—as exciting as they've ever been—but above all, eminently wearable.

At first conservative skeptics are, I suspect, as disinclined to attend to the rhetoric as they are to accept the new fashion itself. Still, should resistance cave in, the rhetoric allows the rationalization that the switchover, while perhaps not welcome, was inevitable.

Minority Group Disidentification

Yet another kind of antifashion that, in America at least, has come to the fore with the rise of ethnic consciousness, the gay movement, and the women's movement is that of minority group disidentification. Varying from group to group in the degree of deliberate consciousness entailed in the construction of a distinctive group identity, the intent of this type of antifashion is quite straightforward: to differentiate via clothing and other behaviors one's subgroup from the culturally dominant segments of a society. In disidentifying thus with the cultural mainstream, members of such groups also mean to proclaim a newfound sense of pride in those very attributes (e.g., blackness, homosexuality, fatness) mainstream society devalues and denigrates, as indeed had many from the minority group itself before having their "consciousness raised" or before "coming out of the closet."

In some special cases of minority group disidentification, as, for

example that of Hassidic Jews living in large American cities, the group's distinctive dress has remained essentially unchanged for hundreds of years. In these instances, as with such separatist, rural-based religious denominations as the Amish and Mennonites, not only does dress serve as testimony to the group's solidarity and oneness with their religious beliefs, but it quite purposefully erects a barrier to interaction with others in the society, thus keeping the group relatively isolated and safe from secular and other forms of moral contamination.

This subspecies of antifashion, however, is at best a marginal case. Hassidic Jews, for example, are much less interested in challenging the dominant dress codes of a society than they are in guarding their own, well-delineated, historic identity. This is not quite the case, however, with other racial and ethnic minorities who lack the same sort of self-imposed barriers to assimilation and whose ethnic identities, therefore, are less well fortified against the onslaught of mainstream cultural influences. In such cases, differentiating dress styles have to be invented, or possibly resurrected from a nearly forgotten group past. The Afro hairstyle and dashiki of militant, racially conscious blacks in America is a good example of the latter; the zoot suit, dangling trouser chain, and exceptionally wide-brimmed slouch hat of young Mexican-American men in the 1940s is an example of a more or less indigenously invented ethnic dress style.[17] Both these styles carry more of a (perhaps transitory) aura of cultural challenge about them than does the dress of such insular religious groups as the Amish, Mennonites, and Hassids. Perhaps because of this—i.e., their sociological proximity to the mainstream allows them to enter into the fashion/antifashion dialectic more readily than can the dress styles of insular religious groups—the styles emanating from black and various Hispanic enclaves in the American city have been known to "float upward" (in modified form, to be sure) into

17. Though not concerned with dress as such, the recent vogue among West Coast Chicano youth for converting used, factory model Detroit cars into baroque "low rider" automotive chariots, replete with antiqued velvet interiors and chain-link steering wheels, can be counted as an identity-defining equivalent of the 1940s zoot suit. As might be expected, the "low rider" creation derives much of its symbolic force from the fact that it stands in exact opposition to the "high rider" vehicular conversions popular among non-Hispanic white youth.

mainstream fashions (Field 1970). Today's gay subculture lies in still closer proximity to branches of the fashion world.[18] This allows its particular antifashions (e.g., men's earrings, exaggerated western wear, certain leather stylings, tight T-shirts) to be assimilated even more readily into mainstream fashions.[19]

The tacitly ideological imposition of distinctive antifashion dress styles can, of course, pose numerous problems of identification for some members of the minority group or subculture. It poses related problems of identification and interaction for majority group members as well. For the former the problem hinges on the issue of whether the identity sustained by some distinctive dress style will at the same time result in others "keeping their distance,' thus denying minority group members the equality of access, recognition, and recompense that, in democratic society, they are likely to regard as their due (see Davis 1961). For some majority group members the problem is the obverse: overcoming the social distance and "strangeness" implied by the other's distinctive ethnic dress and interacting with him or her "as an equal."

Given, then, the interactional tension experienced in these not unfamiliar encounters, it may be the case that even diluted borrowings of minority group and subculture antifashions by mainstream social groups can help further a democratization of social relations. (At the same time, of course, it may also attenuate the distinctive social identities that other minority group members seek to promote.) Many years ago George Herbert Mead (1934) wrote

18. Tragic evidence of the close linkage is that the death toll from AIDS in the fashion world is believed to be especially high. It is not surprising, therefore, that since the mid-1980s the American and French fashion industries have been exceptionally active in fund-raising for AIDS research and in extending help and support to those suffering from the disease.

19. Andrew Kopkind (1979) supplies a particularly vivid example of one such manifestation: "When Ralph Lauren introduced his hardcore western clothes collection earlier this month, several stores constructed complete western environments to complete the mystique of the designs. Bloomingdale's version for Lauren's western women's wear was done in rough pine boards, decorated with harnesses and yokes for horses and cattle, ropes, spikes in the wall, and antique posters from California fruit and produce companies. Boots were placed at random as adornments; there was a colorful display of western kerchiefs in an array of colors. No store anywhere in the real West ever looked like that: in fact, the Bloomingdale's boutique was a perfect replica of a "western" gay men's bar, from the spikes to the colored kerchiefs. What was the message conveyed? Perhaps only the store's set designer can tell."

of how the sharing of significant symbols among diverse groups and peoples could in time bring about an enlightened democratic world order. In that quest, dress constitutes as much of a significant symbol as do law and language and much else that is culture.

Counterculture Insult

Moving beyond the stance adopted by racial, ethnic, and certain other minority entities, the antifashion of a counterculture aims at more than just designating via dress a distinctive identity for some self-defined subcultural group. Counterculturists seek as well to distance themselves from, diminish, and even scandalize society's dominant cultural groups, i.e., those usually, if somewhat vaguely, referred to in modern times as the bourgeoisie or the middle classes (Davis 1971). Fifties beatniks, sixties hippies, and present-day punkers (with their various stylistic subdivisions of skinheads, hard rockers, heavy metalists, etc.) are the most obvious recent examples of the category, although *épater le bourgeois* unconventional dress and other forms of outrageous behavior have been generally associated with bohemianism in Europe and America for the better part of the last two centuries.

The long hair, beads, bracelets, floral prints, fringed garments, and other folkloric allusions of hippie ware were in their way as determinedly oppositional to middle-class dress (Davis 1967) as are the torn jeans, heavy leather, chain-festooned jackets, pierced cheek, and spiked and pastel-color-dyed hair of the 1980s punker. Both proclaim a disdain for the middle-class values of the workaday world, although whereas the former accomplished this through a kind of romantic pastoralism the latter is more partial to dystopian postures of sadomasochistic nihilism. In either case, as intended, many "ordinary people" respond with revulsion to the outlandish representations of self that hippie and punk dress parade before them.

Of the various forms of antifashion tolerated in modern Western democracies, that of the counterculture is symbolically the most potent. The reasons for this appear to be several. First, of the several antifashions it most directly confronts and challenges the symbolic hegemony of the reigning fashion. It injects itself headlong into the dialogue of fashion by attempting through its

iconoclasms to debunk and deride the dominant mode rather than to merely propose some group-specific alternative as do other antifashions discussed here.

Second, while counterculture antifashion often originates with working-class, ethnic, socially deviant, and other more or less disadvantaged and disenfranchised groups in society, its main thrust typically comes from disaffected and rebellious middle-class youth (Levine 1984). The hippie and punk counterculture manifestations afford dramatic evidence of this (Kopkind 1979; Hebdige 1979).

Despite, then, the condemnation such blasphemous behavior elicits from middle-class parents and other authorities, the fact remains that these youths exist on closer terms with mainstream culture than do, for example, members of ethnic minority or socially deviant marginal groups. This means that the antifashion affront of wayward middle-class youth carries with it more cultural point and poignancy than that issuing from other quarters. (It smacks more of subversion from within than opposition from without.) But, given the close social proximity of counterculture youth to mainstream middle-class society, it should not be surprising, for example, that certain select hippie paraphernalia (e.g., men's beaded necklaces, granny glasses, embroidered jeans, high-top shoes) had by the early 1970s come to be worn by adult middle-class men and women as well. Similarly, modifications of certain punk modes (e.g., men's earrings, disheveled and spiked hair, "black everything") have already made their way into mainstream fashions (Gross 1987c). Counterculture "purists" are likely to look askance at these borrowings and at those from within their ranks who cater to this sort of "bourgeois frivolity"; charges of "selling out" and "commercialism" are promptly leveled.[20] How-

20. The outcry from the faithful is structurally the same as that from members of ethnic minority groups who take umbrage at the easy borrowing of their distinctive identity tags by mainstream elements. Reporting on a symposium held at New York's Fashion Institute of Technology on the topic of punk-style dress, Hochswender (1988b) writes: "The 300 or so students who packed the auditorium seemed to care deeply about the issues raised, which ranged from modern merchandising to the 'commodification' of art to clothes as a form of free speech. When Mr. [Stephen] Sprouse, who synthesizes influences from punk rock and pop

Counterculture antifashion become fashion in the world of professional tennis.
Edward Hausner/NYT Pictures

ever, from another vantage point the borrowings do represent a kind of symbolic appeasement of the severe intergenerational strife that periodically engages Western society.

A third reason for the special saliency of counterculture antifashion for mainstream fashion was alluded to earlier: Parts of the fashion world have since about the turn of the century come more and more to overlap with demimonde, arty, bohemian, socially

art in his clothes, showed a video with excerpts from his past collections, he was criticized by an F.I.T. student who said he commercialized punk and had shown an 'advert' for his own fashions. Mr. Sprouse replied: 'I have a big company behind me, which is great. I'm no authority on punk. I just think it's cool the way it looks.' Mr. Sprouse's business is owned by CSI Associates."

deviant, radical, and other counterculture formations.[21] Simmel had already astutely noted this in his famous 1904 essay on fashion. The interweaving of the worlds of fashion and the arts was especially pronounced in Paris during the period 1910 to 1940, roughly. Friendships and work ties between the pre–World War I designer Paul Poiret and the ballet master Diaghilev, between Chanel and the poet-dramatist Jean Cocteau, between Schiaparelli and the surrealist painter Salvador Dali are extensively recorded in chronicles of the time. The important synchronist painter Sonia Delaunay also designed fashionable clothing during the 1920s and 1930s.

This is not to say that the influence flowing between prominent fashion designers and leading artists of an era is the same as commanding special access to the antifashions of counterculture groups. Still, as accounts of artistic avant-gardes since the late nineteenth century attest (Poggioli 1968), the boundaries separating various "nonconventional" groupings in present-day Western society are quite fluid and permeable.

Either, then, through firsthand experience of the dissenting currents of thought and practice that flow through these sectors, or through peripheral, though not infrequent, association with persons from within them, designers, especially younger ones wishing to make a name for themselves by "doing something different," will draw upon the off-beat cultural products and attitudes that germinate in an era's countercultures. Add to this modern fashion's near-institutionalized tendency to accord a place for antifashion in its very own domain—conspicuous in the case of such contemporary designers as Jean-Paul Gaultier, Franco Moschino, and Vivienne Westwood; more subdued in that of Claude Montana and Romeo Giglio—and the resort to counterculture antifashion is almost inevitable.

CONCLUSION

The interaction of fashion and antifashion is, then, more intensive and, in light of the many sources of antifashion in the modern

21. The coterie that formed around the late Andy Warhol is a well-publicized instance of the overlap of fringe elements from mainstream culture and counterculture groups.

world, more extensive than the stark polarity of such oppositional terms would at first suggest. Although one certainly cannot speak of some synthesized fusion of the two that has or is about to occur—to claim such would be to vitiate the very dynamic of their relationship—it is nonetheless evident that each needs the other for what we have spoken of as the fashion process, with its endless renewals and reformulations, to endure. Yet it is probably equally amiss to anticipate the relationship of fashion and antifashion continuing as it has in the past. For antifashion to fulfill its cultural role of negation and subsequent partial incorporation into the main fashion system, it requires strongly marked, well-entrenched mainstream fashions to stand against. However, with the growth and diffusion of fashion pluralism since the 1960s such is becoming, as I have noted in several places, less and less the case. This, incidentally, poses as much of a problem for fashion, as Brubach (1990a) perceptively notes, as it does for antifashion:

> If anything goes—if a woman can wear any color, any hemline, any style at any time—then nothing ever looks new. A fashion magazine could [in the past] tell its readers to "think pink" one season, because they'd been thinking blue or yellow or aqua the season before, and suddenly pink looked fresh again. But with no consensus to react against, designers have a harder time than ever coming up with a direction. No wonder fashion doesn't loom as large as it used to in the average person's everyday life. No wonder designers and editors and art directors and advertising copywriters are at a loss to know how to make fashion seem important once again.

Amid today's cacophony of acceptable fashions, it is difficult to register a riveting antifashion message. What is being opposed? What can opposition mean when from within the spectrum of mainstream fashions there already is to be found a reasonable facsimile of the antifashion gesture? The sepulchral aura of punk black soon looks hardly any different from that stepping out of the smartest boutiques; proletarianized jeans, faded by years of hard wear and vigorous washing with brown laundry soap, find their manufactured acid-dyed equivalent at the nearest Gap store.

Thus, as fashion itself is driven toward more polycentric and polymorphous expressions by the pluralisms of modern life, so too is antifashion. We may, though, be approaching that point at which the segmentalization of styles has gone too far and is no longer

functional for the dialectical adjustments and corrections that fashion and antifashion have effected between them over the past two centuries. The useful opposition, insult, and outrage registered by the antifashion of clothing may henceforth have to seek other, possibly less benign, channels through which to exercise its ire.

9 Conclusion, and Some Afterthoughts

I have in this book argued: Clothing does indeed communicate, but not in the manner of speech or writing; what it communicates has mostly to do with the self, chiefly our social identity as this is framed by cultural values bearing on gender, sexuality, social status, age, etc.; Western society, whence the fashion cycle sprang some seven centuries ago and in which it still thrives, has encoded into its elaborate representational repertoire certain strategic ambivalences, an overarching one being the polar opposition of, on the one hand, a secularly legitimated endorsement of invidious display and personal acclamation and, on the other, a Judeo-Christian ethic of humility and distrust of riches; the identity tensions engendered by this and similarly encoded cultural ambivalences are what has fueled the endless and repetitive cycle of fashion change in the West, particularly, though not exclusively, with respect to issues of gender, sexuality, and social status. Further, I have sought to describe the phased movement of the dress fashion cycle, pointing to the numerous interests and social processes that come into play as it unfolds while at the same time noting the alterations the cycle has undergone in recent decades. Last, I endeavored to delineate some significant sources of anti-fashion in contemporary society and to show how very dependent it and fashion per se are on each other. Here too, however, I point to how fashion pluralism and the rapid globalization of the fashion marketplace have begun to disrupt and deflect the once-neat dialectic obtaining between them.

These arguments and their supporting data, both those presented here and those that could yet be turned to were time no obstacle, are, of course, of varying degrees of complexity. In the end, however, the facts I have tried to establish and the points I have tried to make reduce themselves for the most part, if not in all cases straightforwardly, to empirical questions. As such they involve occurrences, conditions, contingencies, and developments

capable in principle of confirmation or refutation or, as is more typical of complex assertions in the cultural sciences, an interpretative synthesis of the two. But the likelihood that the assertions and conclusions of the preceding paragraph may be disconfirmed, perhaps even soon, bothers me a good deal less than does the nagging sense of having, for the sake of getting on with the book's main points, sidestepped or only glancingly engaged several key issues of a more elusive sort.

These are neither so minor as to warrant neglect nor so obviously empirical as to justify escape via some vapid plea for further research. Rather, the issues I have in mind touch on the very heart of the fashion phenomenon, albeit from vantage points and contexts that to this point have made dealing with them unwieldy. And while not altogether lacking in empirical substance, the issues I refer to present themselves in more paradigmatic, interpretative, and morally evaluative terms. They have to do with fashion's range in today's world, the cultural enhancements and debasements that result from the prominent place fashion has come to occupy in contemporary society, and, last, the paradigms, and their sociopolitical contexts, by which we are to study fashion. Clearly, these domains interweave and overlap. It is, then, with a certain frustration that for clarity's sake I yield to the artificiality of discussing them separately.

THE BREADTH OF FASHION

Is everything subject to fashion? One would hate to think so. Yet in many talks I have given over the past decade to one and another audience describing how fashion works in the apparel field, how there is a constant, if not always consummated, yearning to displace what *is* with something else—often apparently for no "good reason" other than for change itself—how what seemed fit and attractive yesterday strikes today's public as wrong, quaint, and even downright ugly, etc., listeners would invariably remark, "You know, the same is true of my field," or words to that effect. And the fields from which these persons came were by no means confined to the decorative or fine arts or some branch of popular culture. Endocrinologists, computer specialists, legal scholars, and theologians were every bit as likely to venture the same opinion.

Now, to be sure, it is a real question whether the phenomenon observed by them in their respective fields is altogether "the same" as that which occurs in the realm of dress fashions. Whatever the sources of the changes occurring in these other fields, it is at once clear, as has been pointed out here in many different connections, that no field of modern endeavor has so institutionalized and structured its very survival on the managed exercise of change as have apparel design and, to a lesser extent, the other decorative arts and trades. A fixation on fashion, which up to a point may act as background in the design of personal computers, the menu listing of trendy Italian restaurants, and, more certainly, the art displayed in avant-garde SoHo galleries, is of the unabashed essence—an insistent foreground, as it were—when it comes to clothing, cosmetics, and the other devices of adornment.

It may well be, then, that when scientists, for example, complain of the "whims of fashion" having inundated their field, they are experiencing certain effects from what Kuhn (1962) has termed a "paradigmatic shift" in the field, i.e., the displacement of one conceptual scheme by a rival scheme. Although bearing a superficial relationship to fashion change, this is hardly the same thing. Much as designers like to talk at times as if they were revolutionizing the ways we think about dress, dress fashions as a rule are not concerned with resolving fundamental conceptual issues arising from the wearing of clothes. Not that paradigmatic shifts in the sciences preclude the presence of associated fashion motifs during a period of transition; in science, as in the domains of pure fashion, there will always be those who "jump aboard" simply because that is what leaders in the field are doing (Fujimura 1988). Further, some of the sense of adventure generated by fashion's abandonment of the old in pursuit of the new is likely to accompany paradigmatic shifts in the sciences as well. Similarly, the summary dismissal as "old hat" of previous explanatory models smacks of a posture we associate with fashion. All this granted, one still would be hard-pressed to make the case that a fashion-driven taste for change is all, or even the better part of, what is involved in theoretical change in the sciences. (One need not be a scientific positivist to flinch from such a claim; the social constructionist is likely to find its rashness equally unpalatable.)

Hence, while I agree with Blumer (1968, 342) that "any area of

social life that is caught in continuing change [as today's sciences certainly are] is open to the intrusion of fashion," it must at the same time be acknowledged that criteria of utility, parsimony, functionality, and objective measure continue to count for a great deal more in science and technology than they do in domains like dress, interior design, architecture, and the fine arts where subjective taste is accorded much greater free reign. On balance, then, as an analytical matter it would be as wrong to fully equate "paradigmatic shifts" (or even lesser theoretical and methodological modifications) in the sciences with fashions in clothing as it would be to overlook altogether the occurrence of fashionlike manifestations in them.[1]

FASHION: BENEFACTOR OR RAVAGER OF CULTURE?

But to be circumspect in regard to assigning too commanding a role to fashion in today's science and technology is to barely address the question of its influences, for better or ill, in those many other realms of culture where its presence can, sometimes disconcertingly, be detected. Almost any extended contemporary discussion of the arts (both popular and "highbrow"), art markets, leisure in its many facets, nutrition and health practices, political sentiments, religious practices, psychotherapies, family celebrations and rituals, funeral customs, etc., is bound at some point to record (and usually to lament) the sheer force of fashion in that segment of culture. Typically, fashion is charged with furthering the superficial and spurious while undermining the substantial and genuine. (The role of villain in this baleful plot is usually assigned to the mass media, TV in particular.) One can almost view

1. A better case for the play of fashion in nondecorative, nonartistic realms can be made for the applied sciences, medicine, and the other health fields in particular (Burnum 1987; Herzlich and Pierret 1987; Sigerist 1960). I recall early in my career visiting convalescent hospitals where over the decades successive waves of patients recovering from paralytic poliomyelitis had been treated. Walking through the treatment rooms and wards was very much like visiting museums devoted to the storage and display of successively abandoned polio rehabilitation therapies, from hydrotherapy pools to electro-stimulation apparatuses, to bizarre exercise machinery, to elaborate installations for muscle massage.

this as a favorite trope of modern criticism, so much so as to approximate a recurring fashion in its own right.

Of course, this critical posture enjoys a long history that goes back at least as far as the industrial revolution and the lamentations of the Romantic poets. In the two centuries since it has, at different times, been greatly in vogue among both conservative critics of democratic populism and, on the left, Marxist critics, most notably the Frankfurt school, who bemoan the seductions of capitalist consumerism. Its current efflorescence can in large part be traced to several French structuralist and poststructuralist thinkers (e.g., Barthes, Baudrillard, Lyotard, and Jameson) who alternately seem bemused and outraged by fashion's alleged displacement in the postmodern era of "the real" and the seriously committed. An especially trenchant rendition of this critique comes, ironically enough, from one of the most astute contemporary commentators on dress fashions, the writer Kennedy Fraser (1981, 157). Decrying the intrusion of a culturally omnivorous fashion sensibility into domains far removed from its *natural home* of dress and adornment, she writes in a paragraph illustrative of the essay's overall tone:

> The new, thoughtful-looking, lifelike breed of fashion has been fostered by a generation (linked in common cultural impulses, if not necessarily in age) whose perceptions are attuned to and often blunted by the transient images of television and the movies but who also have college educations that have left a taste for the sensation of intellectual activity and a nostalgia for the literary enthusiasms of studenthood. . . . Here is the natural market for surfaces, fashions, and the patina of culture. In literature, this market picks out work furnished with appealing objects it can fantasize about possessing, "atmospheres" to which it can surrender itself and in which it can happily bathe. Just as this market is willing to accept the decor of its living room as an expression of its inner self, it is inclined to accept the decorative parts of art as art's essence.

While the figure Fraser projects is recognizable enough and is among intellectuals found to be detestable, a host of unanswered and possibly unanswerable questions remain to cast doubt on the vivid, not altogether snob-free, portrait painted by Fraser and nu-

merous critics before her.[2] Granted that a fashion sensibility has radiated to more areas of the culture than was the case prior to the era of post–World War II affluence, how wide and unrelieved an encroachment has this been? Have all areas, from culinary art to new computer graphic arts, succumbed equally, or do some by their very nature, or perhaps because of unique historical circumstances affecting their practice, resist, tame, or educate that impulse said to substitute superficial attachment for serious engagement? And in those nonapparel quarters where fashion is virulent, is it invariably or even typically the case, as many critics imply, that a kind of cultural Gresham's Law takes hold, with "bad fashion" driving out "good art"?

Again, such questions, difficult as it is to secure definitive data on them, touch for the most part on factual matters that are in principle capable of being answered. And to the extent that questions of this order have been addressed empirically rather than ideologically, be it from the left of right, it is, as Herbert Gans (1974) has so tellingly documented, by no means evident that the cultural debasement alleged to take place has in fact occurred.[3] Indeed, there is much evidence to the contrary. Rather than displacing a high-culture activity, its practitioners, and its audiences, it is sometimes the case that the aesthetic challenge posed by the influx

2. Especially egregious in the eyes of Fraser (much more so with ideologically driven critics of fashion) is the ad- and media-promoted inflation of a fashion sensibility made to range well beyond clothing, home furnishings, vacation spots, etc., to some more global conception of "life-style," as if the demeanor, manners, and conduct of a mythologized elite could be acquired overnight via the purchase of some prescribed ensemble of goods and services. (Oscar de la Renta's and Ralph Lauren's ads, for example, claim not to be selling clothes and accessories but, respectively, a "life style" and a "way of life.") Parenthetically, it might be noted that the popular appropriation of the term *life-style* is not the first time a concept spawned in the professional discourse of social scientists—"charisma," "Protestant work ethic," "other-directed" (usually misconstrued as *outer*-directed) and the very word *culture* itself are some others that come readily to mind—has come back to haunt them.

3. In his book *Popular Culture and High Culture* Gans (1974), to be sure, is concerned mainly with assessing the validity of accusations directed as popular culture via-à-vis its impress on high culture. As can be inferred from the Fraser quotation above, many of the same accusations are directed at fashion as well. Although the two, fashion and popular culture, are clearly not the same thing, inasmuch as the manner in which they are seen to corrupt the products and processes of high culture is so similar I think it not amiss to follow the line of Gans's rebuttal here as well.

of popular audiences with their "uncultivated" tastes serves to re-invigorate the activity.[4]

Typically, though, in today's advanced capitalist, consumer-oriented societies it is more a matter of simply adding additional taste strata to those already present. In the process a more complex latticework of working artists and audiences takes shape. The resultant juxtapositions and overlappings of craft and taste at the producer and consumer ends help facilitate greater openness and movement between taste strata. Thus it is not uncommon in the modern era for serious artists about whose attachment to high aesthetic standards there can be no doubt to display both a high-culture and more popular side in their work.[5] Similarly, many audience members whose initial level of appreciation could be termed "popular" or "commercial" will, on the basis of aesthetic insights gleaned from slightly more elevated popular work, opt in time for more subtle and complex artistic choices.

To this point the discussion has touched mainly on questions of magnitude, namely, the breadth of fashion's sway in contemporary culture and the size of the public allegedly victimized by its supposed substitution of surface for substance. As regards audiences, it should in passing be noted that mass culture critics, in their bemusement over a media-spawned apocalypse in the not too distant future, are given to greatly exaggerating the number of persons seduced by fashion's incursions into high-culture realms. Fashion aside, vast numbers of Americans, for example, including legions of the college-educated, continue to display a robust disregard for highbrow culture altogether, preferring instead spectator sports and "hands-on" leisure pursuits like hunting and fishing.

More difficult to assess are questions bearing on the functions and societal consequences of an enlivened fashion sensibility in today's world. That it now actively extends to many life realms be-

4. Some art historians claim this is what happened when in the 1960s and 1970s that which was soon to become gallery and museum "pop art" turned for inspiration to the banalities of popular illustration and entertainment. Similar infusions from rock music (and, before that, jazz) are also believed to have enriched the composition of serious music and dance.

5. The late Aaron Copland and Kurt Weill are two obvious examples.

yond that of dress and adornment can for all practical purposes be assumed. But does this necessarily mean it has subverted and come to totally dominate them? Is a vanity-induced predilection for the superficial all that a weakness for fashion leads to? Could it not be serving other, or perhaps different, purposes for individuals as well? And beyond the boundaries of individual psychology, at the societal level, does its incursions into other realms—the fine arts, politics, religion, education, etc.—accomplish nothing besides cheapening and corrupting their moral and aesthetic contents?

By their very nature these questions are difficult to answer with any certainty, despite the occasional availability of public opinion and market research data touching on one or another of them. Let it be taken as a given, then, that from time immemorial, wherever it interjects itself, fashion has obediently served purposes of vanity and invidiousness. But again, is this all? Our shared cultural experience of fashion alone, as well as any balanced review of the place it has occupied in our lives, would, I believe, suggest it has at times also introduced us to practices, attitudes, and concerns we might otherwise not have encountered, which have had important consequences for our lives.[6] Some of this can be attributed to the circumstance that the molders of fashion, whatever area they work in, are persons who often are, as was suggested in an earlier chapter, in close contact with leading creative and progressive elements in the arts, sciences, politics, and culture generally. In setting the trend for what is fashionable with their respective publics, they are also willy-nilly exposing them to the substratum of thought and feeling that breaks through in places to the more easily assimilable surface. Much as fashion seduces, therefore, it can also initiate persons into realms of thought and experience that would otherwise have bypassed them.

This dissenting—from both Marxist and conservative critiques—alternate perspective on the collective significance of fashion is, it should be noted, not of such recent vintage as might be inferred from the favor it has found of late among certain critics (Lipovetsky 1987; Wilson 1985). While springing from a very dif-

6. The current, occasionally derided as "trendy," preoccupation with ecology and the environment is a conspicuous case in point.

ferent tradition of social analysis than that to which it is currently linked, namely poststructuralism and deconstructionism, the main outlines of the perspective were presciently sketched by Herbert Blumer in his now-classic 1969 paper "Fashion: From Class Differentiation to Collective Selection." There Blumer speaks of fashion "detaching the grip of the past in a moving world" and as "orderly preparation for the immediate future."

[Fashion] nurtures and shapes a body of common sensitivity and taste. . . . This body of common sensitivity and taste is analogous on the subjective side to a "universe of discourse." Like the latter it provides a basis for a common approach to a world and for handling and digesting the experiences which the world yields. The value of a pliable and re-forming body of common taste to meet a shifting and developing world should be apparent. (Blumer 1969a, 290)

That more than vanity and a sterile fixation on surfaces are implicated in this profoundly social process should also be apparent.

Also to be assessed is how much the fashion impulse has, in the past but now especially, served as a vehicle for individual and group expressiveness, as a frame for improvising upon, for freshly recombining and splintering, the increasingly standardized emblemata of a global consumer culture. Writers (Appadurai 1990; Hebdige 1979), including some from the left, view this as one of the few remaining channels for resisting the bureaucratic, manipulative, and conformist prescriptions emanating from a multinational corporate culture interested primarily in realizing the economies attendant to the standardization and suppression of diversity. Ironically, fashion has furthered such expressive possibilities for many individuals and groups (see chapter 8) notwithstanding the fact that many of the materials employed in the quest are the very same ones (e.g., jeans; Mickey Mouse; iconic brand names like Coca-Cola, McDonald's, and Nike; bomber jackets; American flags; oversized Detroit autos) produced and promoted by the multinationals themselves. What is different, of course, is the symbolic uses to which such materials are put and, accordingly, the meanings they acquire in more local and diversified cultural contexts.

STUDYING FASHION: THE
FASHION SYSTEM MODEL
VERSUS A POPULIST MODEL

The altered landscape of fashion behavior brings us to the crucial question of how we are to study fashion. What is the phenomenological terrain to be encompassed? What metaphors are most apt for capturing its movements and manifestations? What assumptions are to be discarded, what new ones encouraged? Which disciplines and subdisciplines are best equipped to probe fashion's many forms and faces?

The study of fashion in the twentieth century, including major portions of the present work, has for the most part been framed in terms of what I am inclined to call the "fashion system" model.[7] No matter how much scholars have disagreed on the sources and consequences of fashion (again, consider on one side Veblen and Simmel, and on other sides Flugel, Blumer, and Barthes) the underlying, taken-for-granted trope informing their arguments is that of a relatively distinct center whose innovations and modifications radiate out toward a periphery. Sometimes the diffusion of influences from center to periphery is, as with Veblen and Simmel, conceived of in hierarchical terms (*vide* trickle-down theory); at other times, as with Blumer, it is seen to follow more of a horizontal course. But in either case, the core image of an innovating center, archetypically Paris with its highly developed haute couture establishment, surrounded by sociologically sedimented and differentially receptive bands of fashion consumers—whatever the basis of that sedimentation was thought to be—remained securely in place. With this imagery there went along the tacit assumption of a fashion-consuming public, international in scope, whose tastes and standards were located essentially within the vast shadow and penumbra of a Eurocentric culture. Moreover, in the realm of dress, that to which the word *fashion* is still primarily at-

7. My employment of the term *fashion system* is very different from that of Barthes (1983), for whom it designates a set of sign relations deriving from the various combinations and substitutions possible among items of apparel. My own usage means to point to the more or less established practices of the complex of institutions (design, display, manufacture, distribution, sales, etc.) that processes fashions as they make their way from creators to consumers.

tached, the movement and monitoring of fashion was seen to refer almost exclusively to *women's* fashions. Not that writers were unaware of or indifferent to its manifestations in other realms, but for numerous reasons dealt with throughout this book, fashion as a category of popular thought had by the mid-nineteenth century come to mean, first and foremost, women's fashions.

Can contemporary fashion movements, even those circumscribed within the sphere of dress, be comprehended by this fashion system (one is tempted to say *classic*) model? It is, after all, the very same model that at root has framed the universe of discourse for fashion research and scholarship in the twentieth century, including, as already acknowledged, much of the present work.[8] I write "much of the present work" because at numerous places I find need to refer to the growing polycentrism and polymorphism of the fashion field. In particular, I draw attention to fashion's pre-1960s fixation on women's hem lengths, silhouettes, jacket widths, etc. What these were constituted the style fashion-aware women everywhere were expected to attend to. Today such details are not nearly as important for fashion consumers as they once were. Does this mean the fashion system model is to be dispensed with? If so, totally or only in part?

The question is half empirical and half paradigmatic, perhaps even political, in the sense that inquiries framed in terms of the fashion system model tend to obscure and marginalize phenomena not easily assimilated into the center-to-periphery framework. It thus can be argued that, even at the sacrifice of certain data and explanations generated by the fashion system model, it might prove both illuminating and socially beneficial to abandon that model in favor of some other. This would in theory be one that rescues phenomena formerly thrust to the margins while at the same time uncovering tendencies and connections rendered unobservable by the then-reigning model.

The alternate model that has begun to emerge from fashion studies, although far from clearly outlined as yet, is one I am inclined to call—for want, perhaps, of a better term—a "populist"

8. See especially the chapters on the fashion cycle and the fashion process (chapters 6 and 7). My formulations there would hardly make sense were it not for their underpinning by a fashion system model.

model. The term, familiar from other contexts, seems apposite in that writers who either explicitly, or more often implicitly, take a non– or anti–fashion systems model approach to fashion phenomena (see Evans and Thornton 1989; Kaiser 1990; Jasper and Roach-Higgins 1987; Wilson 1985) are likely to regard the dress and appearance innovations of lay individuals and social groups as constituting the analytical stuff of fashion study. What issues from Paris and Milan or how it diffuses through fashion-buying publics is of much less interest to them—possibly because the world itself has become less interested—than, for example what teenagers, feminists, retirement community senior citizens, surfers and skateboarders, gays, promoters of ethnic consciousness, Third World peoples, etc., are doing with and to clothing, cosmetics, jewelry, their bodies and public postures. What is the dress of these groups "saying," and how do the changes they regularly fashion in their appearances reflect the shifting tensions and ambiguities of their "lived worlds"? How, these students ask, do such groups and coteries negotiate their identities so as to better profile themselves against the increasingly uniform backdrop of consumer wares marketed in the global economy? Moreover, the fact that these very same wares are often turned into instruments of identity negotiation and symbolic profiling—as, for example, when teenagers bedeck themselves in Coca-Cola and Mickey Mouse logos—is not seen by populist critics as faulting their interpretative approach. The suggestion is put forward that, analogous to pop art, it is in the very bracketing of the banalities of an excessively familiar surface—for purposes of irony, satire, or metaphoric inversion—that the identity-defining fashion creativity of these individuals and groups is to be located.

For these writers the conceptual scope of fashion is not what, to the accompaniment of media fanfare, is proclaimed by a world celebrity designer in Paris, Milan, or New York. Neither are they particularly concerned with the phenomena of style diffusion that may or may not follow in its wake. Rather, their attention is drawn to what clothes-wearers at the grass roots level are doing with their dress. Attuned to what I earlier termed the newly emerging polycentrism and polymorphism of fashion, populist critics are given to detect a veritable babble of dress "discourses" in the postmodern society. Some are seen as talking past one another, while others

are thought to be engaged in symbolic identity construction exchanges of one kind and another.[9] That certain famous designers have from time to time sought to build upon and commercially exploit spontaneous fashions from the street is not overlooked by populist critics. But the fact of such borrowings is not thought by them to justify continued conceptual dependence on the fashion system model, which, they claim, has outlived its usefulness.

In light of these observations, how warranted is it at this stage in the continuous evolution of fashion to abandon, more or less in toto, the "classic" fashion system model that took conceptual shape in the decades bridging the nineteenth and twentieth centuries? (In fairness to the authors cited above and numerous others who write seriously on fashion, I should say I see the abandonment of the fashion system model as constituting a pronounced tendency in their work rather than a fixed doctrinal position emanating from any "school" as such. There is no such school, as far as I am aware.) In my own view—despite having noted throughout this book numerous changes, some major, which have taken place in the world of fashion since about midcentury—it is as yet much too premature to abandon the fashion system model, most certainly not in toto or, for that matter, in very large part. Pointing, as I have, to the gender-skewed, Eurocentric, hierarchically layered provenance of the fashion system paradigm is one thing; inferring thereby its essential inapplicability to a welter of phenomena that still make for fashion in the contemporary world is quite another. More reasons than can be gone into here exist for not yielding to this fallacy; I mention only the most compelling.

There is, to begin with, the undeniable vast economic power and global scope of the international fashion conglomerates with their multi-billion-dollar annual revenues: the St. Laurents, Chanels, Armanis, Kleins, Laurens, Kawakubos, etc. These could hardly survive were it not for the continuing relevance of the center-to-periphery fashion system model, notwithstanding major internal changes that have taken place in the economic configuration of that model. Thus, whereas prior to the Second World

9. Certain of the stylistic exchanges referred to in the chapter on antifashion between and among the gay, punk, and mainstream cultures could serve as cases in point.

War famous designers also acquired reputations of international scope, the ability of their firms to market and exploit their designer brand name on a global scale was nowhere near as complex and economically sophisticated as it has become since.[10]

In any case, on a scale vastly greater than before World War II, fashions in clothing, cosmetics, jewelry, fragrances, and accessories still radiate out from the West's fashion capitals, and now Tokyo as well, to the hinterlands of both the economically developed and developing worlds. In the process of doing so their fate in the marketplace is still affected by the same contingencies of fashion acceptance, rejection, and modification by consumers as were operative during the period many in the trade now look back upon as the fashion cycle's classic era, roughly the first half of this century. Their nostalgia, however, derives less from the breakdown of the cycle than from the infinitely more complex, variegated, and unpredictable forms it has assumed.

Again, the fact that a single women's fashion from Paris no longer preempts fashion awareness as it once did should not lead one to conclude that what issues from there and sister fashion capitals is of little consequence for understanding fashion behavior in the mass. Moreover, while it is certainly true that famous designers have since the 1960s taken more and more to borrowing from street fashions, this by itself hardly signals the extinction of the creative spark emanating from the fashion capitals (which, conceptually, must be seen as residing at the core of the center-to-periphery fashion system model). Stravinsky, Milhaud, Poulenc, and other twentieth-century composers borrowed from the ragtime, jazz, tango, and cabaret music of their day. Does this

10. I have in mind the complex subcontracting, name licensing, franchising, branch outleting, and subsidiary product line arrangements by which prominent fashion houses manage to produce, distribute, and market their brand name products to nearly all parts of the world (Lardner 1988). According to Hochswender (1991d), the firm of Calvin Klein, for example, currently has three fragrances on the market, each of which is closely linked in advertisements to the designer's name. They are produced, however, not by Klein's own company but rather by "a wholly owned subsidary" of the international conglomerate Unilever, "which is licensed by Mr. Klein to use his name." Not only does Klein receive handsome royalties, estimated at $300 million for 1990, from Unilever's sales of "his" fragrances, but the "halo" effects from an estimated $40 million in Unilever advertising that redound to Klein's own product lines are thought to be considerable.

make the music they composed on the basis of such borrowings any less creative or original?

Last, while a good case can be made for men's fashions having come more to the fore in recent decades, possibly as an offshoot of the intense scrutiny of gender roles initiated by the women's movement, few probably would go so far as to claim that this development has attained nearly the same popular breadth or, more prosaically, the same range of capital investment as is still devoted to women's fashions. To the person on the street, and only slightly less so to the student of dress, the word *fashion* is more likely still to evoke images of women rather than men.

In sum, too many phenomena that come to mind when one thinks of fashion in today's world make it nearly impossible for students to dispense with the fashion system model in anything like its entirety. This is not to say that calls for more culturally diverse, non-Eurocentric, gender-balanced approaches to the study of fashion are without point. Indeed, there is much abroad in dress today, some of which has been alluded to in these very pages, that does accord with the spontaneous and populist strains in fashion the alternate paradigm means to represent. There remains, though, much more afoot, especially in what one would view as mainstream fashions, that cannot be comprehended by the populist model and that mandates the theoretical grounding afforded by the traditional fashion system model.

In a paradoxical way the juxtaposition of the two models, albeit of disproportionate applicability, speaks, I would hold, to what numerous commentators have noted about the apparently contradictory relationship of world economy and cultural identities in the postmodern period generally (Mehan 1991). There is, on the one hand, the rapidly growing, and at times desperately exigent, global interdependence of peoples in the economic, environmental, informational, and technological realms that play so large a part in their lives. On the other hand, there is the apparently irrepressible outcropping of localisms, regionalisms, and particularisms of every sort—from the purely ideological to the ethnic, subcultural, and religious—which throws into question the very rationale of the modern nation-state. Yet one has the distinct sense the latter could not have come to pass were it not for the former. Whether this is due to some unavoidably antagonistic re-

action on the part of weakened extremities to the encroachments of globalizing centers, or whether it is evidence of the evolution of some higher sociopolitical logic wherein the flexibility of the center is sustained by a greater diversity of outlying parts, is difficult to say. Most certainly it is a question far beyond the scope of this book.

In any case, the formal resemblance of this development to contemporary fashion phenomena is at once obvious. On the one hand, we see the emergence of very powerful, highly integrated corporate units creating and propelling a global marketplace for fashion commodities. On the other hand, we encounter a veritable cacophony of local, sometimes exceedingly transient, dress tendencies and styles each attached, however loosely, to its own particularity, be it a subculture, an age grade, a political persuasion, an ethnic identity, or whatever. Whether, as in the case of the parent global sociopolitical paradox, this points to some irreversible transition from a center-to-periphery fashion system model to a still largely nascent populist model or whether it attests to some symbiotic relationship of the two governed by a "higher logic" is equally difficult to know. For the time being, then, it seems wise to keep both models near at hand.

References

Abrams, Gary. 1983. "Lore Caulfield: Sexy Lingerie the Antidote for Career Dressing." *Los Angeles Times,* April 29.

Anspach, Karlyne. 1967. *The Why of Fashion.* Ames: Iowa State University Press.

Appadurai, Arjun. 1990. "Disjuncture and Difference in the Global Cultural Economy." *Public Culture* (Fall): 1–24.

Ashley, Iris. 1972. "'Coco.'" In Lynam 1972.

Auden, W. H., and Louis Kronenberger. 1962. *The Viking Book of Aphorisms.* New York: Dorset.

Back, Kurt W. 1985. "Modernism and Fashion: A Social Psychological Interpretation," in Michael R. Solomon, ed., *The Psychology of Fashion.* Lexington, Mass.: Heath.

Barber, Bernard. 1957. *Social Stratification.* New York: Harcourt, Brace & Co.

Barthes, Roland. 1983. *The Fashion System.* Translated by Matthew Ward and Richard Howard. New York: Hill and Wang.

Batterberry, Michael, and Ariane Batterberry. 1977. *Mirror, Mirror.* New York: Holt, Rinehart and Winston.

Baudrillard, Jean. 1984. "La Mode ou la féerie du code." *Traverses* 3 (October): 7–19.

Becker, Howard S. 1982. *Art Worlds.* Berkeley: University of California Press.

Belasco, Warren A. n.d. "Mainstreaming Blue Jeans: The Ideological Process, 1945–1980." Unpublished.

Bell, Daniel. 1976. *The Cultural Contradictions of Capitalism.* New York: Basic Books.

Bell, Quentin. 1947. *On Human Finery.* London: Hogarth Press.

Berger, Arthur Asa. 1984. *Signs in Contemporary Culture.* New York: Longman.

Bergler, E. 1953. *Fashion and the Unconscious.* New York: Brunner.

Bernstein, Basil. 1964. "Elaborated and Restricted Codes," in J. Gum-

perz and D. Hynes, eds., "The Ethnography of Communication." *American Anthropologist* 66 (2): 55–69.

Blumberg, Paul. 1974. "The Decline and Fall of the Status Symbol." *Social Problems* 21 (4): 480–97.

Blumer, Herbert. 1968. "Fashion." *International Encyclopedia of the Social Sciences.* New York: Macmillan.

———. 1969a. "Fashion: From Class Differentiation to Collective Selection." *Sociological Quarterly* 10 (Summer): 275–91.

———. 1969b. *Symbolic Interactionism, Perspective and Method.* Englewood Cliffs, N.J.: Prentice-Hall.

———. 1984. Letter to author, Aug. 14.

Bogart, Anne. 1989. "Lid Edelkoort, Trend Forecaster." *New York Times,* Oct. 30.

Boodro, Michael. 1990. "Art and Fashion, a Fine Romance." *Art News,* Sept.

Bordo, Susan. 1990. "Reading the Slender Body," in Mary Jacobus et al., eds., *Body/Politics.* New York: Routledge.

Bourdieu, Pierre. 1984. *Distinction.* Translated by Richard Nice. Cambridge, Mass.: Harvard University Press.

Bourdieu, Pierre, and Yvette Delsaut. 1975. "Le Couturier et sa griffe." *Actes de la recherche en sciences sociales* 1 (Jan.): 7–36.

Brantley, Ben. 1984a. "Gaultier: Court Jester of Paris." *W* magazine, May 18–25.

———. 1984b. "On the Wild Side, on the Seine Side." *W* magazine, Oct. 19–26.

Brenninkmeyer, Ingrid. 1963. *The Sociology of Fashion.* Winterthur, West Germany: Verlag P. G. Keller.

Brubach, Holly. 1986. "The Hunger for Hermes." *Atlantic,* Dec.

———. 1988. "In Fashion." *New Yorker,* Sept. 10.

———. 1989a. "In Fashion, School of Chanel." *New Yorker,* Feb. 27.

———. 1989b. "In Fashion, between Times." *New Yorker,* April 24.

———. 1989c. "In Fashion, Visionaries." *New Yorker,* Aug. 28.

———. 1990a. "In Fashion, Forward Motion." *New Yorker,* June 25.

———. 1990b. "In Fashion, a Certain Age." *New Yorker,* Nov. 5.

———. 1990c. "In Fashion, Retroactivity." *New Yorker,* Dec. 31.

———. 1991. "In Fashion, the Eye of the Beholder." *New Yorker,* June 10.

Burke, Kenneth. 1959. *Attitudes toward History.* Boston: Beacon Press.

Burnum, John F. 1987. "Medical Practice à la Mode: How Medical Fashions Determine Medical Care." *New England Journal of Medicine* 317, no. 19 (Nov. 5): 1220–22.

Bush, George, and Perry London. 1960. "On the Disappearance of Knickers: Hypotheses for the Functional Analysis of Clothing." *Journal of Social Psychology* 51 (May): 360–61.

Calvino, Italo. 1985. *Mr. Palomar.* San Diego: Harcourt Brace Jovanovich.

Chambers, Ian. 1986. *Popular Culture, the Metropolitan Experience.* London: Methuen.

Cocks, Jay. 1985. "The Man Who's Changing Clothes." *Time,* Oct. 21.

Coleridge, Nicholas. 1988. *The Fashion Conspiracy.* New York: Harper and Row.

Cone, Edward, and Lisa Scheer. 1990. "Future Chic." *Avenue,* Jan.

Culler, Jonathan. 1976. *Ferdinand de Saussure.* Glasgow: William Collins Sons.

Cunningham, Bill. 1988. "Couturist Class." *Details,* Nov.

Davis, Fred. 1961. "Deviance Disavowal, the Management of Strained Interaction by the Visibly Handicapped." *Social Problems* 9 (2): 120–32.

———. 1967. "Why All of Us May Be Hippies Someday." *Transaction,* Dec.

———. 1971. *On Youth Subcultures, the Hippie Variant.* New York: General Learning Press.

———. 1979. *Yearning for Yesterday, a Sociology of Nostalgia.* New York: Free Press.

———. 1982. "On the 'Symbolic' in Symbolic Interaction." *Symbolic Interaction* 5 (Spring): 111–26.

———. 1991. "Herbert Blumer and the Study of Fashion, a Reminiscence and Critique." *Symbolic Interaction* 14, no. 1 (Spring): 1–21.

Davis, Murray S. 1983. *Smut, Erotic Reality/Obscene Ideology.* Chicago: University of Chicago Press.

De Gennaro, Ralph. 1986. "The Tuxedo, One Hundred Years of Elegance." *New Yorker,* Sept. 8.

Descamps, Marc-Alain. 1979. *Psychosociologie de la mode.* Paris: Presses Universitaires de France.

Dionne, E., Jr. 1983. "A Salute to Saint Laurent, the Man behind the Mystique." *New York Times Magazine,* Dec. 4.

Dior, Christian. 1957. *Dior by Dior.* London: Weidenfeld and Nicolson.

Donovan, Carrie. 1983. "A Question of Self-expression." *New York Times Magazine,* Dec. 18.

Duka, John. 1984. "Skirts for Men? Yes and No." *New York Times,* Style section, Oct. 27.

Dyansky, G. Y. 1985. "Lagerfeld, Baroque to his Bones." *Connoisseur,* Dec.

Eco, Umberto. 1979. *A Theory of Semiotics.* Bloomington: Indiana University Press.

Empson, William. 1953. *Seven Types of Ambiguity.* London: Chatto and Windus.

Enninger, W. 1985. "The Design Features of Clothing Codes." *Kodias/Code* 8 (1–2): 81–110.

Evans, Caroline, and Minna Thornton. 1989. *Women and Fashion.* New York: Quartet Books.

Field, George A. 1970. "The Status Float Phenomenon, the Upward Dif-

fusion of Fashion," in George B. Sproles, ed., *Perspectives of Fashion*. Minneapolis: Burgess, 1981.

Flugel, J. C. 1930. *The Psychology of Clothes*. London: Hogarth Press.

———. 1945. *Man, Morals, and Society*. London: Penguin.

Foltyn, Jacques Lyn. 1989. *The Importance of Being Beautiful*. Unpublished Ph.D. dissertation, University of California, San Diego.

Foote, Shelly. 1989. "Challenging Gender Symbols," in Claudia B. Kidwell and Valerie Steele, eds., *Men and Women, Dressing the Part*. Washington, D.C.: Smithsonian Institution Press.

Forty, Adrian. 1986. *Objects of Desire: Design and Society, 1750–1980*. London: Thames and Hudson.

Foucault, Michel. 1980. *Power/Knowledge: Selected Interviews and Other Writings*. New York: Pantheon.

———. 1985. *The History of Sexuality*, vol. 1. New York: Vintage.

Fox-Genovese, Elisabeth. 1978. "Yves Saint Laurent's Peasant Revolution." *Marxist Perspectives* 1, no. 2 (Summer): 58–93.

Fraser, Kennedy. 1981. *The Fashionable Mind*. New York: Knopf.

Freud, Sigmund. 1918. *Totem and Taboo*. New York: Moffat, Yard.

Friedmann, Daniel. 1987. *Une Histoire du blue jean*. Paris: Ramsay.

Fujimura, Joan. 1988. "The Molecular Biological Bandwagon in Cancer Research." *Social Problems* 35:261–83.

Gans, Herbert. 1974. *Popular Culture and High Culture*. New York: Basic Books.

Geertz, Clifford. 1973. *The Interpretation of Cultures*. New York: Basic Books.

Glassner, Barry. 1989. "Fitness and the Postmodern Self." *Journal of Health and Social Behavior* 30, no. 2 (June): 180–91.

Goffman, Erving. 1951. "Symbols of Class Status." *British Journal of Sociology* 2 (Dec.): 294–304.

———. 1959. *The Presentation of Self in Everyday Life*. Garden City, N.Y.: Doubleday.

———. 1963. *Stigma*. Englewood Cliffs, N.J.: Prentice-Hall.

Goldern, Tim. 1991. "Raiders Chic: A Style with Sinister Overtones." *New York Times*, Feb. 4.

Goldstone, Nancy Bazelon. 1987. "Hers: Reclothing the Woman in the Gray Flannel Suit." *New York Times*, Jan. 22.

Goodwin, Betty. 1989. "Screen Style: A Thrifty Woman's Guide to the Sexy and Sensual." *Los Angeles Times*, Nov. 8.

Gottdiener, Mark. 1977. "Unisex Fashion and Gender Role Change." *Semiotic Scene* 1, no. 3 (Sept.): 13–37.

Gray, Francine du Plessix. 1981. "The Escape from Fashion." *The Dial* 2, no. 9 (Sept.): 43–47.

Green, Peter. 1985. "Fashion Forecasters Flirt with the Future." *New York Times*, July 9.

Grindering, M. P. 1981. "The Trouble with Fashion Is . . . ," in George B. Sproles, ed., *Perspectives of Fashion*. Minneapolis: Burgess.

Gross, Michael. 1986a. "Moschino: A Designer of Impertinence in Milan." *New York Times*, Oct. 9.
———. 1986b. "Notes on Fashion." *New York Times*, Oct. 21.
———. 1987a. "Notes on Fashion." *New York Times*, March 17.
———. 1987b. "Notes on Fashion." *New York Times*, Oct. 20.
———. 1987c. "Effervescent Betsey Johnson." *New York Times*, Nov. 3.
———. 1988. "Changing of the Guard." *New York Times*, Nov. 28.
Gusfield, Joseph. 1963. *Symbolic Crusade*. Urbana: University of Illinois Press.
———. 1987. "Nature's Body, Metaphors of Food and Health." Unpublished.
Harris, Ron. 1989. "Children Who Dress for Excess." *Los Angeles Times*, San Diego County section, Nov. 12.
Hawkes, Terence. 1977. *Structuralism and Semiotics*. Berkeley: University of California Press.
Hawkins, Timothy. 1978. "For Men." *Los Angeles Times*, Fashion 78 section, Dec. 8.
Hebdige, Dick. 1979. *Subculture, the Meaning of Style*. London: Methuen.
Herzlich, Claudine, and Janine Pierret. 1987. *Illness and Self in Society*. Translation of *Malades hier, malades d'aujourd'hui* by E. Forster. Baltimore: Johns Hopkins University Press.
Hochswender, Woody. 1988a. "Patterns." *New York Times*, April 3.
———. 1988b. "Punk Fashion Revisited." *New York Times*, Sept. 27.
———. 1988c. "The Multiple Choice Answer to the Question, 'What to Wear?'" *New York Times*, Oct. 18.
———. 1988d. "Patterns." *New York Times*, Oct. 25.
———. 1988e. "Patterns." *New York Times*, Nov. 1.
———. 1989a. "In Paris, the Sultans of Style Twiddle and Twitter." *New York Times*, March 23.
———. 1989b. "Patterns." *New York Times*, April 18.
———. 1989c. "Patterns." *New York Times*, Oct. 24.
———. 1989d. "Patterns." *New York Times*, Nov. 14.
———. 1991a. "Patterns." *New York Times*, Jan 1.
———. 1991b. "Patterns." *New York Times*, Jan. 8.
———. 1991c. "An Earthy, Outdoors Look for Men's Clothes." *New York Times*, Feb. 6.
———. 1991d. "Patterns." *New York Times*, March 5.
———. 1991e. "Patterns." *New York Times*, June 4.
Hockett, C. F., and S. A. Altmann. 1968. "A Note on Design Features," in T. A. Sebeok, ed., *Animal Communication*. Bloomington: Indiana University Press.
Hofmann, Deborah. 1990. "New Urbanity for Denim and Chambray." *New York Times*, Sept. 24.
Hollander, Anne. 1980. *Seeing through Clothes*. New York: Avon.
———. 1985. "Dressed to Thrill." *New Republic*, Jan. 18.

Horowitz, R. T. 1975. "From Elite Fashion to Mass Fashion." *Archives Européenes de sociologie* 16 (2): 283–95.

Janovy, Jena. 1991. "The Spandex League." *New York Times*, March 6.

Jasper, Cynthia R., and Mary Ellen Roach-Higgins. 1987. "History of Costume: Theory and Instruction." *Clothing and Textile Research Journal* 5, no. 4 (Summer): 1–6.

Joseph, Nathan. 1986. *Uniforms and Nonuniforms*. New York: Greenwood Press.

Kaiser, Susan B. 1985. *The Social Psychology of Clothing*. New York: Macmillan.

———. 1990. "Fashion as Popular Culture: The Postmodern Self in the Global Fashion Marketplace." *The World and I* (July): 520–29.

Kidwell, Claudia Brush. 1989. "Gender Symbols or Fashionable Details," in Claudia B. Kidwell and Valerie Steele, eds., *Men and Women, Dressing the Part*. Washington, D.C.: Smithsonian Institution Press.

King, Charles W. 1981. "Fashion Adoption: A Rebuttal to the 'Trickle Down' Theory," in George B. Sproles, ed., *Perspectives of Fashion*. Minneapolis: Burgess.

Kinsley, Michael. 1983. "Dressing Down." *Harper's*, Feb.

Klapp, Orrin. 1969. *Collective Search for Identity*. New York: Holt, Rinehart and Winston.

Konig, René. 1973. *A la Mode*. New York: Seabury.

Kopkind, Andrew. 1979. "Dressing Up." *Village Voice*, April 30.

Kovats, Edith. 1987. "Couture et création." *Sociétés* 13 (March–April): 17–20.

Kroeber, A. L. 1919. "On the Principle of Order in Civilization as Exemplified by Changes in Fashion." *American Anthropologist* 21 (July): 235–63.

Kron, Joan. 1984. "Sneakers Gain as a Symbol of Commuting." *Wall Street Journal*, Oct. 17.

Kuhn, Thomas S. 1962. *The Structure of Scientific Revolutions*. Chicago: University of Chicago Press.

Kunzle, David. 1977. "Dress Reform as Anti-Feminism, a Response to Helene E. Roberts's 'The Exquisite Slave: The Role of Clothes in the Making of the Victorian Woman.'" *Signs* 2, no. 3 (Spring): 570–79.

———. 1980. *Fashion and Fetishism*. Totawa, N.J.: Rowman and Littlefield.

Lang, Kurt, and Gladys Engel Lang. 1961. *Collective Dynamics*. New York: Crowell.

Lardner, James. 1988. "Annals of Business, Global Clothing Industry," parts 1 and 2. *New Yorker*, Jan. 11 and 18.

Lauer, Robert, and Jeanette Lauer. 1981. *Fashion Power*. Englewood Cliffs, N.J.: Prentice-Hall.

Laver, James. 1937. *Taste and Fashion, from the French Revolution until Today*. London: George G. Harrap & Co.

———. 1969. *A Concise History of Costume and Fashion*. New York: Scribner's.

Le Bon, Gustave. 1896. *The Crowd*. London: Ernest Benn Ltd.

Levine, Bettijane. 1984. "Tale of Two Cities: Who Wears What?" *Los Angeles Times*, View section, April 1.

Levine, Donald N. 1985. *The Flight from Ambiguity*. Chicago: University of Chicago Press.

Lipovetsky, Gilles. 1987. *L'Empire de l'éphémère*. Paris: Editions Gallimard.

Lofland, Lyn H. 1973. *A World of Strangers*. New York: Basic Books.

Los Angeles County Museum of Art. 1983. Guide to the exhibit *An Elegant Art, Fashion and Fantasy in the Eighteenth Century*.

Louie, Elaine. 1987. "In Schools, Fashion Is Whatever Is 'Fresh.'" *New York Times*, Sept. 22.

Lowe, Elizabeth D., and John W. G. Lowe. 1985. "Quantitative Analysis of Women's Dress," in Michael R. Solomon, ed., *The Psychology of Fashion*. Lexington, Mass.: Heath.

Lurie, Alison. 1981. *The Language of Clothes*. New York: Random House.

Luther, Mary Lou. 1990. "The Long and the Short of It." *Memories*, Feb.–March.

Lynam, Ruth, ed. 1972. *Couture*. Garden City, N.Y.: Doubleday.

MacCannell, Dean, and Juliet Flower MacCannell. 1982. *The Time of the Sign*. Bloomington: Indiana University Press.

Massachusetts Institute of Technology. 1982. Catalogue for the exhibition *Intimate Architecture, Contemporary Clothing Design*. Hayden Gallery, May 15–June 27. Cambridge, Mass.

McColl, Pat. 1982. "Designers Look to Past for Inspiration." *Los Angeles Times*, View section, July 29.

McCracken, Grant. 1985a. "Clothing as Language: An Object Lesson in the Study of the Expressive Properties of Material Culture," in Barrie Reynolds and Margaret Stott, eds., *Material Anthropology*. New York: University Press of America.

———. 1985b. "The Trickle-Down Theory Rehabilitated," in Michael R. Solomon, ed., *The Psychology of Fashion*. Lexington, Mass.: Heath.

Mead, George H. 1934. *Mind, Self, and Society*. Chicago: University of Chicago Press.

Mehan, Hugh B. 1991. "Global Economy and Local Identity." Talk presented at Multicultural Diversity Symposium, University of California, San Diego, April 12.

Meyersohn, Rolf, and Elihu Katz. 1957. "Notes on a Natural History of Fads." *American Journal of Sociology* 62, no. 6 (May): 594–601.

Milbank, Caroline R. 1990. "When Your Own Initials Are Not Enough." *Avenue*, Oct.

Millman, Marcia. 1980. *Such a Pretty Face*. New York: Norton.

Molloy, John T. 1977. *The Woman's Dress for Success Book*. New York: Warner.

Morris, Bernadine. 1986. "Viewpoints: Three Fashion Capitals." *New York Times*, Oct. 28.

———. 1987a. "Three Who Redirected Fashion." *New York Times*, Feb. 24.

———. 1987b. "In Paris, the Past Inspires Couture." *New York Times*, July 29.

———. 1987c. "Lighthearted Couture: Short, Sexy, and Shapely." *New York Times*, Aug. 4.

———. 1988a. "For Geoffrey Beene, 25 Years at the Top." *New York Times*, May 10.

———. 1988b. "Harvey Berin Obituary." *New York Times*, Dec. 1.

———. 1989a. "At Paris Shows, Shorter Was Better." *New York Times*, March 28.

———. 1989b. "For Spring, Patches of Strategically Sited Bare Skin." *New York Times*, Nov. 21.

———. 1990a. "Lagerfeld Camouflages Fur with Silk, Velvet, and a Twist." *New York Times*, March 8.

———. 1990b. "Armani: Classic and Sensual." *New York Times*, March 9.

———. 1990c. "Kaleidoscope of Styles as Designers Search for a Look for the 90's." *New York Times*, March 27.

———. 1990d. "In Versace Shop, Theatre Lives." *New York Times*, April 24.

———. 1990e. "In London, 60's Return, but Softer." *New York Times*, Oct. 16.

———. 1991. "Uneasy over Hems, Designers Mingle the Short and Long." *New York Times*, Feb. 5.

Moulin, Raymonde. 1984. "Les Intermittences économiques de l'art." *Traverses* 3. (October): 64–78.

———. 1987. *The French Art Market, a Sociological View*. New Brunswick, N.J.: Rutgers University Press.

New Yorker. 1989. "Franco Moschino." Jan. 9, 18–19.

Nietzsche, Friedrich. 1967. *The Will to Power*. New York: Random House.

O'Hara, Georgina. 1986. *The Encyclopedia of Fashion*. New York: Abrams.

Paoletti, Jo B., and Claudia B. Kidwell. 1989. "Conclusion," in Claudia B. Kidwell and Valerie Steele, eds., *Men and Women, Dressing the Part*. Washington, D.C.: Smithsonian Institution Press.

Paoletti, Jo B., and Carol L. Kregloh. 1989. "The Children's Department," in Claudia B. Kidwell and Valerie Steele, eds., *Men and Women, Dressing the Part*. Washington, D.C.: Smithsonian Institution Press.

Park, Robert E., and Ernest W. Burgess. 1921. *Introduction to the Science of Sociology*. Chicago: University of Chicago Press.

Parsons, Talcott. 1951. *The Social System*. Glencoe, Ill.: Free Press.

Penn, Jean. 1982. "What Happened at Lincoln Jr. High?" *Los Angeles Times*, Fashion 82 section, April 2.

Peretz, Henri. 1989. "La Comédie de l'habit," in *Encyclopaedis, la vie au quotidien*. Paris.

Poggioli, Renato. 1968. *The Theory of the Avant-Garde*. Cambridge, Mass.: Harvard University Press.

Polhemus, Ted, and Lynn Procter. 1978. *Fashion and Anti-Fashion*. London: Thames and Hudson.

Pomerantz, Marsha. 1991. "Racy Drag." *Harvard Magazine* 93, no. 5 (May–June): 6–7.

Pond, Mimi. 1985. *Shoes Never Lie*. New York: Berkley.

Rimer, Sara. 1985. "New York Teen Agers Ever Seeking a New Look." *New York Times*, Oct. 17.

Robinson, Dwight E. 1961. "The Economics of Fashion Demand." *Quarterly Journal of Economics* 75 (3): 376.

Rosenblum, Barbara. 1978. "Style as Social Process." *American Sociological Review* 43 (June): 422–38.

Rosencranz, Mary L. 1972. *Clothing Concepts*. New York: Macmillan.

Sahlins, Marshall. 1976. *Culture and Practical Reason*. Chicago: University of Chicago Press.

Sapir, Edward. 1931. "Fashion." *Encyclopedia of the Social Sciences*, vol. 6. New York: Macmillan.

Schapiro, Meyer. 1978. *Modern Art*. New York: Braziller.

Schier, Flint. 1983. "Speaking through Our Clothes." *New York Times Book Review*, July 24.

Schmidt, William E. 1990. "A Growing Urban Fear: Thieves Who Kill for 'Cool' Clothing." *New York Times*, Feb. 6.

Schrank, Holly L., and Lois D. Gilmore. 1973. "Correlates of Fashion Leadership." *Sociological Quarterly* 14 (4): 534–43.

Schreier, Barbara A. 1989. "Sporting Wear," in Claudia B. Kidwell and Valerie Steele, eds., *Men and Women, Dressing the Part*. Washington, D.C.: Smithsonian Institution Press.

Schucking, Levin L. 1944. *The Sociology of Literary Taste*. London: Kegan Paul.

Settle, Allison. 1972. "The Birth of Couture," in Lynam 1972.

Sigerist, Henry E. 1960. *On the History of Medicine*. New York: MD Publications.

Simmel, Georg. 1904. "Fashion." Rpt. in *American Journal of Sociology* 62 (May 1957): 541–58.

———. 1950. *The Sociology of Georg Simmel*. Translated and edited by Kurt H. Wolff. Glencoe, Ill.: Free Press.

———. 1984. *Georg Simmel: On Women, Sexuality, and Love*. Translated by Guy Oakes. New Haven: Yale University Press.

Slade, Margot. 1987. "Relationships, the Allure of Longer Hair." *New York Times,* July 27.

Smelser, Neil. 1963. *Theory of Collective Behavior.* New York: Free Press.

Sproles, George B. 1985. "Behavioral Science Theories of Fashion," in Michael R. Solomon, ed., *The Psychology of Fashion.* Lexington, Mass.: Heath.

Steele, Valerie. 1985. *Fashion and Eroticism.* New York: Oxford University Press.

———. 1988. *Paris Fashion, a Cultural History.* New York: Oxford University Press.

Stern, Jane, and Michael Stern. 1990. "Decent Exposure." *New Yorker,* March 19.

Stone, Gregory P. 1962. "Appearances and the Self," in Arnold M. Rose, ed., *Human Behavior and Social Processes.* Boston: Houghton Mifflin.

Strauss, Anslem L. 1959. *Mirrors and Masks, the Search for Identity.* Glencoe, Ill.: Free Press.

Tarde, Gabriel. 1903. *The Laws of Imitation.* New York: Henry Holt.

Thom, Gary B. 1984. *The Human Nature of Social Discontent.* Totowa, N.J.: Rowman & Allanheld.

Totenberg, Nina. 1988. "Miniskirt, Maxi Blunder." *New York Times,* March 21.

Veblen, Thorstein. 1899. *The Theory of the Leisure Class.* New York: Macmillan.

W magazine. 1984. "Report on Giorgio Armani." Oct. 5–12.

Wax, Murray. 1957. "Themes in Cosmetics and Grooming." *American Journal of Sociology* 62 (May): 588–93.

Weber, Max. 1947. *The Theory of Social and Economic Organization.* New York: Oxford University Press.

Wiese, Leopold von. 1927. "Current Sociology., 2. Germany." *Sociological Review* 19:21–35.

Wilson, Elizabeth. 1985. *Adorned in Dreams.* London: Virago Press. Republished by University of California Press, Berkeley, 1987.

Wolf, Jaimie. 1980. "Retro Babble." *New West,* Jan. 14.

Young, Agnes B. 1937. *Recurring Cycles of Fashion.* New York: Harper & Brothers.

Index

Abrams, Gary, 50
Acceptance of fashion. *See* Failures in fashion; Public opinion and influence
Accessories, 6n, 22–23, 34, 48, 51
Adolfo (designer), 92
Adorno, T. W., 121
Aesthetic appeal of fashion, 145–46
AIDS and culture, 99, 133, 182n.18
Ambiguity and ambivalence, defined and compared, 21–23. *See also* Clothing as language: ambiguity of; Identity ambivalences
Androgynous dress, 35–37, 42–46, 48, 53–54, 170, 176
"Annie Hall" look, 42, 44
Anspach, Karlyne, 105, 138
Antifashion, 71, 77, 132–33, 148n.20, 161–88, 191, 202; activists and actors, 162–64, 166, 167, 169–71, 173, 177–78; ambivalence of, 164, 166, 167, 174, 181–82, 184–87; and bohemia, 185–86; in communist states, 166n; conservative scepticism theme, 178–80; counterculture themes, 183–86; definitions and analyses of, 161–62, 164, 165–68; feminist protest theme, 172, 175–78; health and fitness naturalism theme, 171–74; history of, 162, 168–69, 172, 173, 175, 177, 178; minority groups themes, 180–83; of religious sects, 180–81; social protest,

162; styles described, 164n, 165, 166n, 170–71, 174, 181, 182, 183–85; themes and motives, cultural and social, 168, 173, 175, 178, 180, 187–88; utilitarian outrage themes, 168–71
Appadurai, Arjun, 199
Apparel industry and market: competition, 115, 134, 136–37, 140n.15; department stores and other retailers, 114, 143, 152–53, 154; "industrial web," 26, 145–46, 152–53; investments, profit, and loss, 141–42, 149, 150, 203–4; modifications to moderate the line, 152, 153n, 154; public acceptance of merchandise, 10, 26, 107, 126, 136, 140–41, 148; similarities and consensus in design, 133, 135–36. *See also* Economic aspects of fashion; Professionals and craftsmen in fashion; Ready-to-wear clothes
"Appearential ordering." *See* Social differentiation
Armani, Giorgio, 45, 128, 141
Ashley, Iris, 64, 132
Assailly, Gisele d', 11n
Athletic and fitness attire, 26n, 171, 173–74
Auden, W. H., 109

Back, Kurt W., 76n
Barber, Bernard, 112

217

Pure design and fashion. *See* Formalism and fashion

Range of fashion in culture and society, 192–94, 206
Ray-Ban (firm), 6n
Ready-to-wear clothes, 139–42
Reich, Charles A., 68
Religion and clothes, 25, 26n
Renta, Oscar de la, 76
Restrictions and license in dress. *See* Clothing as language: coded consistency
Revivals. *See* Nostalgia as inspiration
Rhetorical consolation of fashion, 179
Rich-poor inversion in dress. *See* Symbolic imagery in dress and appearance: class and status
Rimer, Sara, 60, 108, 156
Rive Gauche (ready-to-wear label), 141
Roach-Higgins, Mary Ellen, 70, 202
Robinson, Dwight E., 112
Role of fashion in culture and society, 194–99, 206
Romantic values and dress, 93
Rosenblum, Barbara, 128n, 145
Rosencranz, Mary L., 11n
Roth, Christian Francis, 96n.10

Sahlins, Marshall, 6, 88n.4
Saint Laurent, Yves, 45, 76, 89, 141, 178n
Sand, George, 34n
Sapir, Edward, 5, 6, 9, 111n.8
Satorical dialectic. *See* Identity ambivalences
Saturation of fashion. *See* Process of fashion: decline and waning stage
Saussure, Ferdinand de, 5n
Schapiro, Meyer, 133n, 155n.24
Scheer, Lisa, 135
Schiaparelli, Elsa, 40, 68, 186
Schier, Flint, 6
Schlemmer, Oskar, 129n
Schmidt, William E., 61
Scholarship in fashion. *See* Sociology: fashion as a subject of study in
Schrank, Holly L., 148
Schreier, Barbara A., 172

Schucking, Levin L., 110n
Science, "fashion" in, 193–94
Selwyn, Harriet, 171n.10
Semiotics and fashion. *See* Clothing as language
Settle, Allison, 139
Sex appeal and fashion. *See* Identity ambivalences: sexuality and eroticism
Shamask, Ronaldus, 179
Shaw, George Bernard, 109
Shows (fashion), semiannual, 125n, 138n, 141–43, 152
Sigerist, Henry E., 194n
Signifier-signified relationship. *See* Clothing as language: variability
Simmel, Georg, 9, 23, 41, 59, 108, 110–12, 113–14, 134n, 146, 159, 200
Smelser, Neil, 176
Social controls, failure of, 61–62, 183–84
Social differentiation, 8–9, 33, 38–39, 51n, 58–60, 64, 110–12, 113n, 191
Social identity. *See* Identity ambivalences
Society, stratification of. *See* Social differentiation
Sociological analysis of fashion. *See* Sociology
Sociological attributes of person. *See* Identity ambivalences
Sociology: fashion as a subject of study in, 3, 5, 13, 16, 17, 23, 59–62, 81–83, 104, 105, 108, 109–20, 149, 182–83, 194–96; "fashion system" and "populist" models, 200–206
Sokol, Susan, 152
Spengler, Oswald, 105
Sproles, George B., 109, 123–24, 133, 154, 155
Sprouse, Stephen, 184n
Status claims and demurrals, 57, 62–63
Status markers, elite and populist, 72–73
Steele, Valerie, 17n, 28n, 36n, 81, 98, 138, 146n.19, 175n